A RotoVision Book
Published and distributed by RotoVision SA
Route Suisse 9
CH-1295 Mies
Switzerland

RotoVision SA, Sales & Editorial Office
Sheridan House
114 Western Road
Hove, BN3 1DD, UK

Tel: +44 (0)1273 72 72 68
Fax: +44 (0)1273 72 72 69
Email: sales@rotovision.com
Web: www.rotovision.com

10 9 8 7 6 5 4 3 2 1

ISBN: 978-2-940378-33-3

Designed by Fineline Studios
Art Director: Tony Seddon

Reprographics in Singapore
by ProVision Pte. Ltd
Tel: +65 6334 7720
Fax: +65 6334 7721

Printed in Singapore by Star Standard
Industries (Pte) Ltd.

MASTERING

ADVANCED PHOTOSHOP TECHNIQUES

FOR PROFESSIONAL PHOTOGRAPHY

MIKE CRAWFORD

RotoVision

CONTENTS

Digital technology has completely altered the way in which professional photographers work. It has changed not only how photographs are taken and processed, but also how they are supplied to clients, printed, and used for publication. In relative terms, these changes have been very swift. Professionals started to use digital cameras in the mid-1990s; since then, the photographic industry has moved from being film-based to predominantly digital. Although photographers have mostly welcomed the changes in technology, the popularity of digital has also been led by the expectations and demands of clients, as working digitally makes the process from design to print far smoother.

A related event predating digital photography was the emergence of desktop publishing. Photographs used for reproduction had previously gone through a photomechanical process that involved rephotographing a print or transparency through a dot screen, which was then etched onto metal to form a printing plate. With digital reproduction, the first stage of this process was replaced by a scanner. The digitized image could then be used directly in a page layout assembled on the computer screen and saved as a single file instead of being physically assembled by compositors on the print-room floor.

Adobe Photoshop was launched in 1990. Initially, its primary use was to prepare and improve scanned photographs ready for reproduction. A new industry quickly grew up around the program as its potential was realized. The cost of a high-quality scanner was prohibitive to most commercial photographers, so scanning had to be outsourced to reprographic houses and specialist photographic labs. By the mid-1990s, creative retouchers and photographers were using Photoshop and other graphic programs to combine photographs together, remove faults, and make any changes they wished to the original image.

As Photoshop expanded with each new version, photographers found that their responsibilities within the creative process changed. Previously, once prints or transparencies were accepted by a client, the photographer's duties were finished. From there, designers, layout artists, retouchers, editors, scanners, and finally printers would take over. However, as photography has become increasingly digitized, it is often the photographer's job to provide finished files ready for reproduction. Where previously an image could be improved or enhanced by careful work in the darkroom, this is now usually done in Photoshop. In addition, it is important for a photographer to understand how the image will be printed so the correct file size and resolution is delivered in the most suitable format.

Since its introduction to Photoshop in version 6.0, color management has become an important issue. This

ABOVE AND OPPOSITE
Whether a photograph is in color or black and white, shot digitally or scanned from film, Photoshop is the premier program used by photographers to process, manipulate, and print their images.

ensures that accurate colors are recognized by different computers and output devices. Photographers need to be able to produce work that appears tonally accurate when printed, either as an individual print or reproduced in a publication. All these important issues are considered in this book, from importing images, processing and manipulating photographs, through to preparing work ready for reproduction or producing fine prints. The quality of inkjet printing has increased rapidly in the last 10 years, as has the choice of specialist inks and papers, allowing prints to be made that are on a par with traditional photographic

processes. Many photographers produce their own prints, and with an understanding of color management and the use of color profiles, achieving accurate prints should be relatively straightforward.

One downside of digital for many photographers brought up shooting film has been the cost of buying new equipment. As a hobby, photography has never been cheap, but as a profession it has suddenly become far more expensive. While many film cameras give years, and sometimes decades, of service, the same cannot be said for digital equipment. This is partly due to the rapid development in the size and quality of the sensors used to record the photograph. A 6-megapixel camera was considered quite adequate for a digital SLR camera just a few years ago, whereas 12 is now more common, and this figure will undoubtedly go up in the future. Larger digital cameras and backs are currently available up to 39 megapixels, although due to their high costs, photographers often hire these cameras when required rather than buying them. Similarly, computers have increased in power, memory, and processing speed, and a top-range model from five years ago now seems slow compared to the latest models. Photography, however, is not just about cameras and computers, but the images produced with this equipment. Photoshop is a very powerful tool that enables us to get the best from our photographs and this book showcases its potential.

Photoshop has perhaps been the key element in the relatively short history of digital photography. It was developed by two American brothers, Thomas and John Knoll. Its development began in 1987 as part of Thomas' PhD research on digital image-processing. He was assisted in this by John, who at the time was working for Lucasfilm, one of the first film production companies to use computerized special effects. Combining their interests in photography and computers, the

brothers' first experiments led to further applications being added to the program. Convinced there was a market for their work, they approached the commercial software industry for further investment. After more development, many rejections, and a few changes of name (the first version was named "Barneyscan," after the scanner it was bundled with), the program was taken on by Adobe.

From its beginning, one of Photoshop's strengths was that a photographer did not require a deep knowledge of computers to use it successfully. Prior to the 1990s, computers had primarily been the tool of scientists, industry, and the military. At the time of Photoshop's launch, other available graphic applications were relatively complicated to use. In comparison, Photoshop appeared both simple and intuitive. This is still one of the program's main assets. There is usually never just one way to perform a particular function or effect, but several. The instruction book (and indeed this book) may explain how to perform a particular task, but it is probable that

there are other methods that also work. With just a little knowledge, and plenty of practice, a photographer will soon work out different ways of using Photoshop.

This book aims to explain all the main functions of Photoshop, and how they relate to the work of a professional photographer today. Although so much has changed in photography over the last few years, it should be emphasized that digital is just another in a long line of processes that enable us to take photographs. Film has not disappeared and retains an appreciative following. Although sales may have fallen, film is still popular with many photographers, and practically all the subjects covered in this book are as relevant to images scanned from film as those captured with a digital camera.

SECTION 1

CONTROLS, COLOR, AND CONTRAST

THE PHOTOSHOP WORKSPACE

The Photoshop workspace consists of several sections, all of which you will use when processing images. This short introduction highlights the uses of each section, although all are discussed in more detail later in this book. When you open a photograph, it appears in the Canvas window, above which are 10 dropdown menus containing the many commands and features of the program. Various smaller palettes can be opened on the right side of the screen (note that any item on the screen can be moved to a different position); these palettes offer further controls such as History, Layers, and Navigator. On the left is the Toolbox, which contains more than 50 tools for making selected corrections and changes to an image. Settings for each open tool are displayed in the Tool Options Bar below the menus.

The Photoshop workspace is similar in design and function to other Adobe programs such as Illustrator and InDesign, and it is simple to transfer and work on the same images in any of these programs.

The Canvas window

The Canvas window occupies the main part of the workspace. It has several features that improve efficiency, such as Rulers, which can be displayed at the edge of the Canvas window to show the image size. This is useful when making a crop to an exact measurement. You can hide this by selecting Units & Rulers from the Preferences submenu in the Photoshop menu. From the different formats available, inches, centimeters, and pixels are the most relevant.

More information about the image is found in the Preview Box concealed at the bottom of the window. This shows technical details on the file, which are updated with every change made to the photograph. This information includes the physical dimensions of the document, its size in megabytes, and how much memory the open image is using. At the top of the Canvas window is the file name next to a thumbnail icon of the image. If you click this while holding down the Option/Alt key, the folder in which the file is located is displayed, making it convenient to quickly locate other images from the same folder.

You can enlarge or reduce the image by holding down Option/Alt and selecting + or – (note that the Canvas size remains the same). When a section is enlarged, you can use the Hand tool (found in the Toolbox) to move the image around the window. This tool also presents three choices for viewing in the Tool Options Bar. Actual Pixels sets the image to its correct size as governed by its resolution; Fit Screen presents the full frame as large as possible on the screen; and Print Size displays it at the approximate size it will print as specified by Document Size in the Image Size box.

A convenient way to examine a section of the image in detail is to use the Navigator, which is opened from the Window menu. This palette contains a small version of the photograph; you use the slider to zoom in and out. A viewing box highlights the crop. You can move this with the cursor to show this section of the image in the Canvas window.

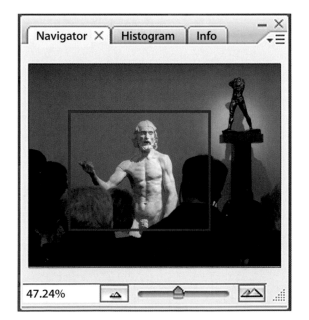

In this section, we give a rundown of Photoshop's 10 menus.

First is the Photoshop menu, which contains technical details and information. Preferences allows you to make changes to numerous Photoshop functions and to the program's general appearance (see pages 132–133). There is also a list of all the plug-ins installed; these are separate programs added to Photoshop to increase and complement its functionality. Be warned that selecting one will open a window, giving its description and copyright information, but will also freeze the screen. Press the Return key

to remove it. The Photoshop menu also contains a hidden code name, which is given to each version of the program by Adobe. To see a cartoon showing this, open About Photoshop while holding down the Command/Ctrl key. CS2 is revealed to have the alternative title "Adobe Space Monkey!"

The File menu is used for opening and saving files, printing images, preparing photographs for use online, and creating custom webpages. It also offers automated tasks such as processing and converting a batch of photographs, as well as browsing facilities for searching images with Adobe Bridge.

The commands for cutting and pasting are found in the Edit menu. In addition, this menu houses the Transform tools, which can change a photograph's perspective, scale, angle, and rotation (see pages 58–59).

The Image menu houses many of the important controls for changing contrast and color in addition to altering image size and resolution. It also governs which mode a file is saved in: RGB, CMYK, or Grayscale.

Layers are an integral part of Photoshop, allowing the photographer to work independently on different sections of an image, all divided into individual layers. This versatility is controlled from the Layer menu; here you can duplicate or add layers, and even export a layer from one photo to another if making montages.

ABOVE
Many of the Photoshop menus include submenus: for example, Adjustments, which is found under Image, contains important controls for color and contrast.

RIGHT
From the View menu, Show opens various aids such as the Grid to help compose and straighten an image. You can change the size and color of the grid via Preferences in the Photoshop menu.

Next is the Select menu, which features different ways to change, refine, and store selections made using the Select tools from the Toolbox (see pages 14–16).

The versatility of Photoshop is exemplified by the contents of the Filter menu. More than 100 filters are available to enhance or change images. Some radically alter a photograph, making it look more like an illustration, drawing, or painting; others increase the apparent

sharpness, or add a blur to soften and diffuse the image. Many of the filters started as plug-ins but have since been incorporated into Photoshop.

The View menu governs how the image is seen on screen and can replicate how the colors will look when printed. It offers helpful features such as Grid and Guides, which is useful for balancing a photograph's composition.

The individual palettes that are used on screen, such as Layers, Navigator, and History, are found in the Window menu. This also contains controls for the general appearance of the workspace; you can customize all 10 menus by hiding functions that you never use as well as listing different keyboard shortcuts.

Finally, there is the Help menu. This accesses Photoshop Help to give instant answers to any problems or questions, as well as providing many useful tutorials.

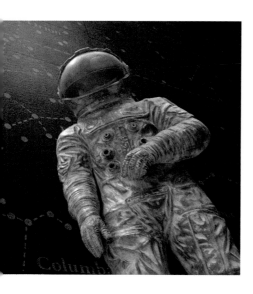

ABOVE AND RIGHT
The Filter menu contains more than 100 filters that you can use to add various effects and manipulations to your photographs.

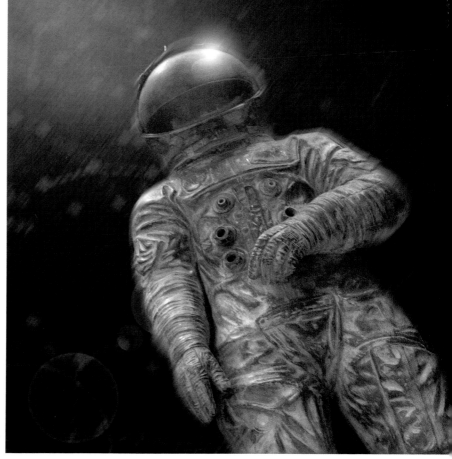

The main tools used for editing, cropping, retouching, and adding type are found in the Toolbox. Various tools are used throughout this book, and a concise explanation of each is useful. There are 24 tools displayed at any one time. Others are hidden behind each icon and are accessible by clicking on the small black corner triangle. You can place the Toolbox anywhere on the screen, although by default it appears on the left-hand side. At the very top is an arrow that you can click to change the Toolbox from a single column to two columns. A helpful shortcut for changing tools is

Selection tools

Marquee tools (M)

These are the two main tools used for drawing a selection. The Rectangular Marquee is the most common, and is used to make straight, rectangular selections. The Elliptical Marquee is used to make circular or oval selections.

Lasso tools (L)

There are three Lasso tools for selecting a drawn shape. The standard Lasso is for freehand selections (ideally made with a graphics tablet); the Polygonal selects only a straight line; and the Magnetic traces a defined outline, provided the selection is drawn close to the shape.

Magic Wand (W)

This tool selects a defined area providing it is of similar-colored pixels. Increasing the Tolerance lets other colored pixels be selected.

Quick Selection (W)

Quick Selection enables you to draw a selection within an area. As you drag the mouse, the selection expands outward, defined by the shape and tonality of the area. This is very useful for quickly making a selection for a complicated shape that can then be refined using other selection tools.

Navigation tools

Move (V)

Use this tool to move a selection or individual layer, even from one file to another.

Zoom (Z)

Zoom magnifies or reduces the image depending on whether the + or – icon is selected. When using this tool, whatever point of the photograph you click on becomes the center of magnification.

Hand (H)

When just part of an enlarged photograph is visible, you can use the Hand tool to move the image around its window by clicking and dragging with the mouse. This tool also has options for making the complete image fit the screen or to view it at its exact size as well as the print size.

to type the single letter that is given in brackets after each title (as seen in the examples illustrated below). When there is more than one tool in each box, hold down the Shift key and keep pressing the shortcut key until you find the correct tool.

Crop tools

Crop (C)

Use this tool to make exact crops and to correct perspective.

Slice tool (K)

Use the Slice tool to divide images for use on websites into segments.

Retouching tools

Healing Brush (J)

You can use this tool to retouch and correct parts of a shot. For example, if you need to remove dust marks from a scan, use this tool to select an area of pixels close to the mark to be retouched. Then brush the selection over the offending area.

Spot Healing Brush (J)

This is similar to the Healing Brush, but is easier to use. You need only draw over a small area to retouch it.

Red-eye removal (J)

This tool offers an easy way to remove the red-eye effect, which can occur when direct flash is used for a portrait and is reflected in the retinas of the subject's eyes.

Patch (J)

Like the Healing Brush, this repairs parts of a shot by using pixels from a different section.

Clone Stamp (S)

The Clone Stamp samples a small section of the image and repeats it where the mouse is clicked.

Eraser (E)

When an image has more than one layer, use the Eraser to rub out part of a layer to reveal the one underneath.

Blur, Sharpen, and Smudge (R)

These three tools selectively add their respective effects to the area being brushed. You should use these tools sparingly, and note that a blur or sharpen filter is often best applied to the full image.

Dodge, Burn, and Sponge (O)

Sponge is used to brush in an increase or decrease of color saturation. Dodge and Burn selectively lighten and darken parts of a shot, in a similar way to dodging and burning a traditional photographic print in the darkroom.

Brush, painting, and drawing tools

Foreground and Background Colors and Color Picker

These tools have many applications. Foreground is the color used by type, brush, and other coloring tools. By default, this is set to black foreground and white background, though clicking on either allows you to change this with the Color Picker. To return to black on white, click on the two small squares at the bottom left. To reverse the background and foreground color, click on the two top right-hand squares.

Eyedropper (I)

You can select foreground colors by using the Eyedropper to click within an image or in the Color Picker. Hold down the Options/Alt key to select a background color.

Brush (B)

This tool provides the main method for applying tone, and is styled after a conventional airbrush. You can control its size, shape, color, and opacity from the Options Bar.

Pencil (B)

Similar to the Brush but gives a harder-edged line.

Color Replacement (B)

Use Color Replacement to replace specific colors by painting over a selected color with a corrective tone.

History Brush (Y)

This brushes in the colors of a previous version of an image, saved using the Snapshot function in the History palette.

Art History Brush (Y)

This brush creates a painterly artistic style, and is best used with subtlety.

Paint Bucket (G)

Use this to fill a selected area or defined shape with the foreground color.

Gradient (G)

Use this tool to add a gradation, for example to fill in an empty sky or to darken areas of a shot to tonally balance a photograph.

Shape tools (U)

You can use these tools to make various preset shapes, and it is easy to change the dimensions and scale. The Foreground Color determines the color of each shape.

Pen tool (P)

The Pen tools draw lines and shapes; you can combine these with the Shape tools.

Type tools (T)

Add text with one of the four Type tools. Horizontal is for standard text, and Vertical for type running downward. The two Type Mask tools (Horizontal and Vertical) make a selection based on text.

Screen modes (F)

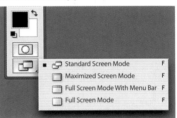

This section of the Toolbox changes how the Canvas is seen on screen. Standard Screen Mode is the normal default mode. This shows the image against a 50% gray background in the Canvas. Maximized fits the different palettes and the Canvas window together to fill as much of the available space on the screen. Full Screen Mode presents the image against black and hides the menu bar, while Full Screen Mode With Menu Bar fills the screen with the image (against gray), but includes the Menu Bar.

Internet link

At the top, the Adobe Photoshop logo directly accesses www.adobe.com if online.

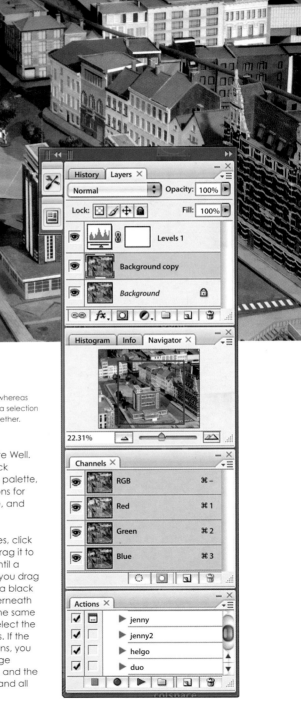

ABOVE AND RIGHT

The History palette lists all recent changes made to the image, letting you click back if you have made a mistake. If you wish to keep a copy before making any more changes, click the camera icon to make a Snapshot. Note, however, that this will be cleared (as will all the stages of History) when you close the file.

RIGHT

Some photographers prefer to open and close palettes as required, whereas others tile a selection neatly together.

Photoshop palettes

There are various palettes accessible from the Window menu; which ones you use will depend on how you work. The default workspace presents a cascade of four palettes locked together on the right-hand side of the screen; behind each are more that can be opened by clicking on the name tab. To place a palette elsewhere, simply click and drag on its top bar. To close it, click on the red button (situated on the top left on a Mac and the top right on a PC). You can enlarge or reduce a palette by dragging the bottom right corner. You can use the Palette Well, found at the top right of the Tool Options Bar, to store palettes; these are grouped together like folders in a filing cabinet. To add to this, click and hold a palette tab and drag it into the Palette Well. Alternatively, click on the black triangle at the top right of the palette, which provides different options for viewing and using the palette, and select Dock to Palette Well.

To create a new tile of palettes, click and hold a name tab, then drag it to the very bottom of another until a double black bar appears. If you drag it further into the palette until a black line appears around the underneath one, both palettes lock into the same space and you will have to select the name tab to change palettes. If the desktop is split over two screens, you can use one to show the image window at the maximum size, and the other to contain the Toolbox and all the various open palettes.

A B C

Pixels

A digital photograph, when examined in extreme closeup, appears as a mathematical grid consisting of millions of tiny colored squares known as pixels. When viewed together at the right magnification, these pixels convey the impression of continuous tone, much as a traditional photographic print is comprised of grain and a magazine reproduction of dots of ink. For each series of pixels, the computer (or any other storage device) records a code of basic digital information, which will be recognized and replicated in the exact same formation.

The information present in each pixel is described in terms of "bits." 1 bit is simply black or white, like the squares of a crossword puzzle. Tonal information increases with the number of bits used. To increase this level, the computer works mathematically by doubling the bits with each increment. This binary rise, referred to as "bit depth," takes the form of 2 to the power of 2, then 3, 4, and so on, each time doubling the number of pixels. In digital photography, we work in 8-bit (or, for increased quality, 16-bit). Expressed as a simple formula, this means 2 to the power of 8, or $2 \times 2 \times 2 \times 2 \times 2 \times 2 \times 2 \times 2$. This contains 256 levels of monochromatic tonal information, with 0 being pure white and 256 black. When viewed together, a "grayscale" image is seen.

RGB channels

To produce a color digital photograph, three grayscale images, colored red, green, and blue, are viewed together, all respectively showing the level of each color present in the photograph. We cannot visually differentiate between these channels; the eye will only see them combined. Different colors are formed by the depth of tone in each of the RGB channels. For example, a pixel that is part of a blue sky may show the following amount of information in each of its three channels: 140 Red, 185 Green, and 252 Blue. The sky may seem to be a pure blue, but there are other colors present that combine to produce a particular shade. However, in the example shown opposite of the photograph of a freshly painted door, the red is a far purer tone—the color values are 217 Red, 45 Green, and 42 Blue.

ABOVE AND BELOW
A. The simplest digital image has only two levels of information: black and white.
B. Grayscale increases this to 256 levels of tone.
C. RGB color files contain three grayscale channels that show the image's red, green, and blue levels.
D. The Channels palette divides the RGB image into these three primary colors.

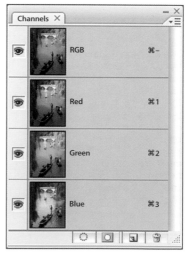

D

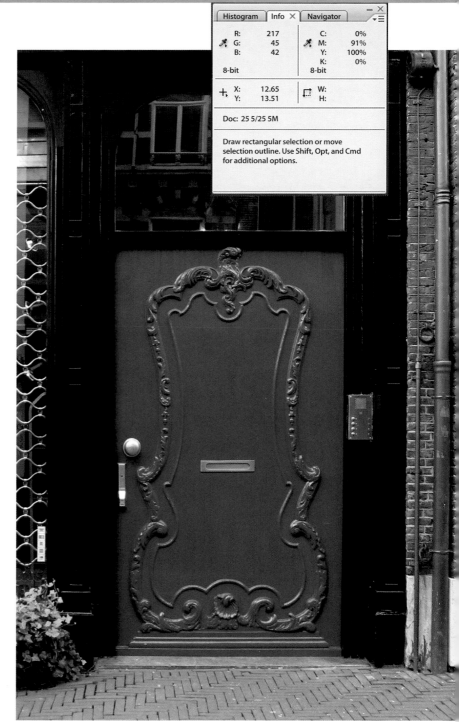

RIGHT
The Info palette displays the color values of each channel for the red door as 217 Red, 45 Green, and 42 Blue. The right-hand column indicates the percentage of CMYK ink used when printed.

Megapixels and megabytes

The capacity and size of an image recorded by a digital camera is described in terms of megapixels (M), meaning 1 million pixels. This is another simple mathematical calculation that determines the photograph's dimensions. The sensor in a 10M camera records about 10 million pixels with each shot taken. If such a photograph were enlarged enough so that each pixel could be counted, 3,872 would be seen on one dimension and 2,592 on the other. Multiplied together, we get an exact figure of 10,036,224 pixels, which for convenience is rounded down to 10 million. This figure should not be confused with megabytes (MB). A 10M image opens at a figure nearer to 30MB. "M" refers to the number of pixels, but as the image has three separate RGB channels, this figure is effectively tripled when recorded as megabytes.

Resolution

The resolution and image size are determined by the number of pixels recorded per inch (pixels per inch = ppi). The metric term "pixels per cm" is also used, although the imperial measurements have generally become the industry standard. A 10M image recorded at 300ppi, when printed at 100%, would measure 12.9 x 8.6in (32.78 x 21.95cm). However, the size and quality of a print alters when recorded at different resolutions. At 600ppi, it would change to 6.4 x 4.3in (16.39 x 10.97cm), and at 150ppi, 25.8 x 17.3in (65.57 x 43.89cm).

All digital files have a designated format that ensures that the information the file contains is saved in an electronic form that can be accessed and read by the correct application or platform. In Photoshop, a format is selected when an image is saved using the Save As command in the File menu. A destination for the file is requested as well as a format. In computing, there are several hundred formats; digital photography uses only five main ones. Photoshop recognizes many more and can save files in up to 20 formats depending on the origination of the image—many of these are primarily used in design, reproduction, and for creating webpages. The following are the formats most commonly used by photographers.

TIFF

The majority of files used for reproduction or for making prints are saved and distributed as TIFFs (Tagged Image File Format), recognizable by the three-digit code ".tif." There can be a degree of compression, but this should not show in the quality of the image—unlike JPEGs. TIFF is a cross-platform format and is recognized by most photographic, graphic, and publishing applications. "Tagged" refers to the attached profile that holds the digital information required for another computer or printer to correctly recognize and translate the contrast and colors. When you save an image as a TIFF, a dialog box presents you with several options. Image Compression offers a choice of LZW or ZIP, which compresses the

document size to a third without losing detail—useful when sending images by email or FTP. The Byte order refers to whether the file is formatted for Mac or PC. Both should be readable in Photoshop on any computer, although as Apple Macintosh predominates in professional photography and design, most photographers save as Mac.

JPEG

A TIFF is normally compressed to a JPEG (Joint Photographic Experts Group) format to greatly reduce the amount of digital information in an image, making it easier to use and send online. Save for Web, found in the File menu, makes high-quality JPEGs at the lowest resolution possible for use on websites at the standard screen resolution of 72ppi (see pages 142–143). This form of compression is known as "lossy," meaning that every time a JPEG is resaved there is a loss of quality. TIFFs use "lossless" compression, so a file can be resaved any number of times without a change in quality. This is why any photograph taken on a digital camera as a large JPEG should be converted to a TIFF if opened and saved in Photoshop.

RAW

The highest-quality digital photographs are shot as RAW files; these have no compression. RAW files require subsequent processing, either using the Adobe Bridge program that is supplied with Photoshop, or a separate program (see pages 26–29).

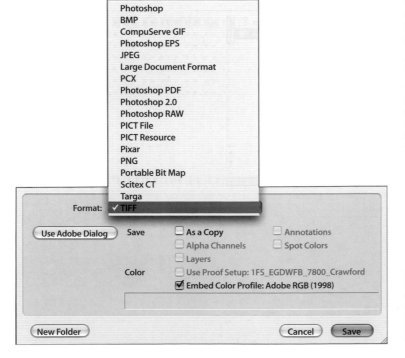

LEFT
The format in which a digital image is saved depends on its planned use. In general, a TIFF is best for supplying to clients, printing, and storing photographs. JPEG is the preferred option for displaying or sending online.

PSD

Although similar to a TIFF, a PSD (Photoshop Document) retains additional information such as all open layers and channels if these need to be read by another computer. When a TIFF is burned to disk, the image is flattened to one layer, therefore losing this information. This is important when a client needs to add or change any part of the image themselves that may be kept as a layer, such as text. Needless to say, these files are saved as larger documents.

PDF

Adobe's PDF (Portable Document Format) has become a universal standard for distributing compressed material, including images and text, which can be read by any computer providing it has the free Adobe Reader software installed. When you save a file as a Photoshop PDF, a dialog box appears offering different options for compression, from the smallest file size possible to the highest quality if required for printing or reproduction.

BELOW
Although a JPEG often appears satisfactory on screen, its quality deteriorates noticeably when it's enlarged.

Given the dominance today of digital cameras, it may seem incongruous to discuss the merits of shooting and scanning film. It is probable that some photographers have only known digital capture and may never have shot a roll of film in their lives. However, traditional film-based photography has not disappeared, and the scanner is still an important tool for many photographers. Although there are obvious advantages to shooting digitally, the option to scan film remains very relevant.

The merits of film

The amount of information that can be recorded on one frame of 6x7cm film is quite astounding—far more than most medium-sized digital cameras. While a 10M file, which opens up at 30MB in Photoshop, will easily produce a high-quality A3 (11¾ x 16½in) print or larger, a good scan from large-format (4x5in) film can produce prints five or six times bigger. Only the most expensive digital cameras or backs approach this quality, and the cost of such equipment is prohibitive to most photographers (it is more common for professional photographers to hire a top-end digital camera when necessary than to own one).

Most art photographers producing large exhibition prints still prefer to shoot film, even if it is then scanned and outputted as an inkjet print or a digital C-type. The humble 35mm can produce excellent results, and a 50-year-old Leica, providing it has a good lens, will still surpass many modern cameras. Film photographers also have less need to constantly upgrade equipment.

As well as retaining the option to make traditional prints in the darkroom, some photographers prefer the security of film. A negative can be filed safely and printed or scanned later; although it is possible to lose or damage this, many people like the assurance of a physical object rather than a digital file. (For added security, you can store scans made from important negatives.) Even if a photographer has gone completely digital, it is probable that he or she has an archive of work shot on film that could be given a new lease of life if scanned and processed in Photoshop.

On the other hand, professional photographers can now operate much faster with a completely digital workflow, much to the benefit of their clients. There is not the extra cost and time required for film processing, although the preparation and processing of digital files is now the responsibility of the photographer. Sadly, it is not always possible to charge the client for the time this extra work demands.

OPPOSITE AND RIGHT
The most popular film formats are 35mm, 120, and 5x4in. Needless to say, a 35mm frame requires scanning at a far higher level of pixels per inch than 5x4in.

The early days of digital

When Photoshop first appeared in 1990, there were only a few expensive consumer digital cameras available, and these had a limited capability for recording. Even when Kodak released the first professional device for digital capture a year later (a converted Nikon F3), it possessed only a 1.3M sensor, which was adequate for small newspaper reproduction but very little else. Digital scanning had been created particularly for the reprographic industry, capturing from either film or prints on a drum scanner, so it was already possible to create very high-quality files from traditional photographs to process in Photoshop. Computer memory at this time was very expensive, so digital imaging tended to be the domain of the professional. Computers designed for home use would be lucky to have 4MB of RAM. In the early 1990s, most photographers outsourced their digital work to a bureau or lab specializing in scanning for reproduction. There is always a period of adjustment to any new technology, and for several years digitization from film could involve several steps or generations before going to print. From an initial scan, Photoshop or Avid (another imaging program) was used to process the image. This would then be outputted as a large-format color transparency for client approval, which would have to be drum-scanned again for final reproduction.

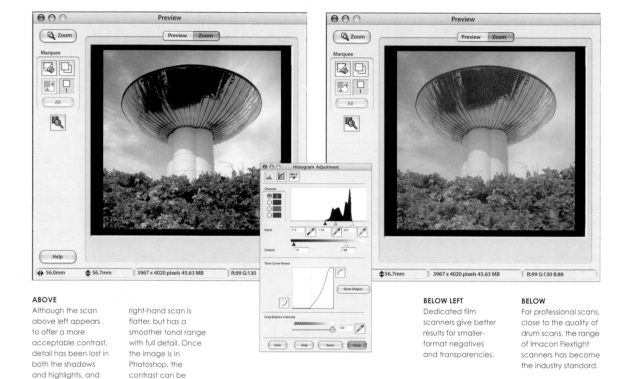

ABOVE
Although the scan above left appears to offer a more acceptable contrast, detail has been lost in both the shadows and highlights, and this will be very noticeable when the image is printed or reproduced. The right-hand scan is flatter, but has a smoother tonal range with full detail. Once the image is in Photoshop, the contrast can be increased using Levels or Curves while hopefully retaining detail throughout.

BELOW LEFT
Dedicated film scanners give better results for smaller-format negatives and transparencies.

BELOW
For professional scans, close to the quality of drum scans, the range of Imacon Flextight scanners has become the industry standard.

Film scanners
Drum scanners are very sophisticated and expensive machines, in which the film or print is stuck onto a transparent drum that rotates at high speed while being read and recorded by electronic sensors. These machines are still used for the finest possible scans, especially from 35mm negatives, but other, cheaper technology has been developed capable of similar results. Although still relatively expensive, the Flextight scanner is the preferred choice of professionals who regularly scan film. Even from 35mm it is possible to record files of more than 200MB that will allow exhibition-quality prints to be made up to A1 (23½ x 33in) in size. Smaller dedicated film scanners are also available at considerably less expense than a Flextight. If the purpose of the scan is just to produce relatively small prints, many of these models will be entirely satisfactory.

The most common scanner is the flatbed, which can scan flat artwork such as prints or illustrations up to A4 (8¼ x 11¾in); larger professional machines are also available. A flatbed usually has a transparency hood that allows negatives or slides to be scanned. The quality of these scanners has improved greatly while the cost has effectively been reduced. Even medium-format film can be scanned to an acceptable level. For high-quality professional work, however, it is best to invest in a dedicated film scanner or to outsource to a reliable lab.

RIGHT
A desktop scanner with transparency hood is useful for scanning flat artwork, and can produce reasonable results from film if not too enlarged.

Scanning requirements
A good scan is often compared to a good negative. If it has a full tonal range with detail present from the highlights to the shadows, you have a better chance of making a high-quality print. Many programs used for scanning offer features for improving the quality of the image, such as color and contrast, although it is usually preferable to make major adjustments in Photoshop. It is important to achieve sufficient detail that matches the contrast of the original.

A scanner—like all digital devices used in photography—will have a profile to ensure good color rendition. This should be set to the same working profile as Photoshop, usually Adobe 1998. If you make a contrast change

to the scan using Levels or Curves, it is important to discard these settings from the scanner each time to prevent subsequent scans recording at an inappropriate contrast.

Scanner software often has a device for sharpening. This may seem a useful tool, but sharpening is best applied as a filter in Photoshop as the last stage of the process, and used carefully to avoid oversharpening.

Suggested scan sizes
The chart below gives suggested sizes required when scanning from film or prints. Although the resolution (ppi) varies for each size, the resulting file

size in megabytes is the important figure. Once scanned, the file would usually be converted to 300 ppi, though when interpolated, the size of the file would remain approximately the same. Lower quality is adequate for very small prints or for preparing images that will just be seen on-screen or used on websites, though these would then be reduced further in resolution when converted to JPEGs. Medium quality is suitable for high-quality reproduction, certainly up to full page, and for prints up to at least 11x14 or A3, though depending on the quality of the scan, will probably print far larger. Higher-quality settings would be used when making large-scale exhibition prints.

RECOMMENDED SCAN SIZES

Print size	Lower-quality scan	Medium-quality scan	Higher-quality scan
35 mm	2,400ppi - 22MB	4,400ppi - 74MB	6,640ppi - 135MB
6 x 4.5 cm	1,200ppi - 17MB	2,200ppi - 58MB	3,750ppi - 160MB
6 x 6 cm	1,200ppi - 22MB	2,200ppi - 77MB	3,750ppi - 220MB
6 x 7 cm	1,200ppi - 25MB	2,200ppi - 86MB	3,750ppi - 250MB
5 x 4 in	600ppi - 20MB	1,200ppi - 77MB	2,000ppi - 214MB
10 x 8 in	300ppi - 20MB	600ppi - 82MB	1,000ppi - 228MB
A4 (8¼ x 11¾ in)	300ppi - 25MB	550ppi - 84MB	900ppi - 223MB

Downloading images from a camera to open them in Photoshop is a very simple procedure, with several options. Whichever method you use, it is imperative to organize these files carefully on your computer or external storage device.

An image can be opened straight from the camera as long as it is recognized by Photoshop. (Most cameras will be, although you may first need to download an update from the Adobe website.) Once you have connected the camera to the computer via a USB lead, an icon should appear on the desktop. This can be chosen from Photoshop's Open palette (see pages 30–31), which shows the images contained on the memory card. Alternatively, you can use Bridge to search through the files in the camera (see pages 118–119). Remember to turn off the camera correctly when finished. This usually requires dragging the icon to the trash before switching the camera off or disconnecting it from the computer.

This method is fine if you need to access a single image quickly, but it is usually better to download the complete contents into a new folder. Your camera will come with the necessary software. Each brand has its own idiosyncratic software, but all the programs work on a similar principle. Once your images are safely stored on the computer or external hard drive, you can delete the memory card. The software often has processing tools for manipulating the image, although these will not be as sophisticated as Photoshop's tools.

Alternatively, you can use a card reader to download images from a variety of media. These simple devices are sometimes found on domestic inkjet printers.

Downloading RAW files

Digital cameras can record images in different formats, the main two being JPEG and RAW. JPEG compresses the image, removing pixels to allow more files to be stored on the memory card, whereas RAW uses no compression. RAW is the choice for professional photographers, as it allows complete control and produces a finer image containing more information. Shooting JPEGs can be useful if a smaller file is sufficient, especially if the work will only ever be viewed on screen. The camera offers different levels of compression, and this noticeably increases the capacity of the memory card. Some cameras have the option to record a file in RAW and as a JPEG. This could prove useful if smaller files are required to be emailed directly to a client for approval or editing, although this option would take up valuable space on the card.

RAW conversion with Adobe Bridge

Once you have downloaded the RAW files from your camera, they can be processed using Adobe Bridge. Double-click to open a file to process it, or highlight it and select Open In Camera Raw from the File menu. You can select multiple images if you want to edit them as a batch; these will appear as thumbnails in a scrolling bar to the left of the highlighted image.

Above the image is a small toolbar with options for cropping (although it is usually best to make crops in Photoshop in case you make mistakes), rotating, and moving the image. The main controls for changing the photograph are in eight panels to the right of the image, each accessible by clicking on the relevant icon. Basic is used to adjust White Balance, convert to grayscale, and to make simple changes to exposure, contrast, and tonality. Tone Curve is similar to the Curves command in Photoshop, but uses sliders to control the tonal range instead of directly manipulating the Curve. Detail makes adjustments to the sharpness and can reduce noise. HSL/Grayscale has

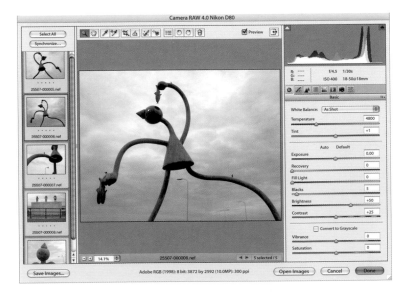

LEFT
Adobe Bridge is a powerful RAW processor that is provided with Photoshop and some versions of Photoshop Elements. If more than one image is selected for processing, a scrolling bar appears on the left-hand side; any number can be highlighted to be processed simultaneously.

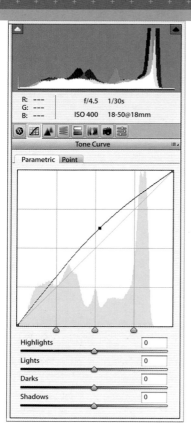

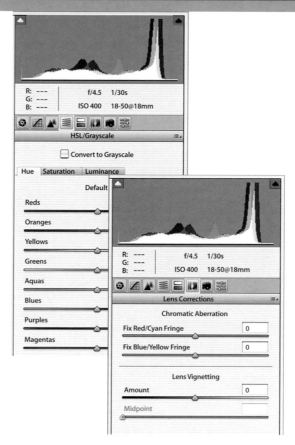

sliders to give fine control to Hue, Saturation, and Luminance, and can also be used to convert to grayscale. You can use Split Toning to add different-colored tones to an image to create similar effects to split-toning monochromatic images. Lens Corrections can be used if there is any obvious lens distortion such as vignetting or colors shifting between channels. Camera Calibration allows further control to the Hue and Saturation of the red, green, and blue channels. You can save any particular calibration in Presets by clicking on the Create New Preset icon.

The purpose of Bridge is to process files from RAW to another format such as TIFF, which can then be worked on further in Photoshop. (As explained on pages 20–21, TIFF files can be recognized and read almost universally and have very little compression compared to a JPEG, so are an ideal format for saving and distributing work.) Although the controls available in Bridge are quite sophisticated, it is not recommended for making major changes to an image; this is better done in Photoshop. Instead, a processor such as Bridge is useful for tasks such as quickly converting a batch of RAW files to TIFFs or JPEGs.

It is possible that a shoot may need very little manipulation, but when there is an obvious fault throughout, such as a color cast from tungsten lighting, you can apply an adjustment to the complete folder of images. To process one photograph, choose Save 1 Image at the bottom right of the RAW window and select a destination folder. To process a batch, make the adjustments to one image and then tick Select All in the top left; this highlights all the photographs in the scrolling bar. Save 1 Image changes to show the number of images requiring

processing. Once underway, a status report indicates the number of files still to be converted.

Before making the conversions, you can change the image size, resolution, color space, and bit depth via the smaller panel underneath the window titled Show Workflow Options. If you are likely to make the same conversion to other photographs in the future, you can save the settings underneath the Histogram in Settings. Click on the black arrow to the right, select Save Settings, and name the adjustment.

In the future you can choose this from the dropdown menu and apply the adjustment to other images or batches of images.

BELOW

Capture One is another RAW processor favored by professionals. Often a digital camera is tethered to the computer via

Capture One so photographs can be viewed on screen while shooting and instantly downloaded to the hard drive.

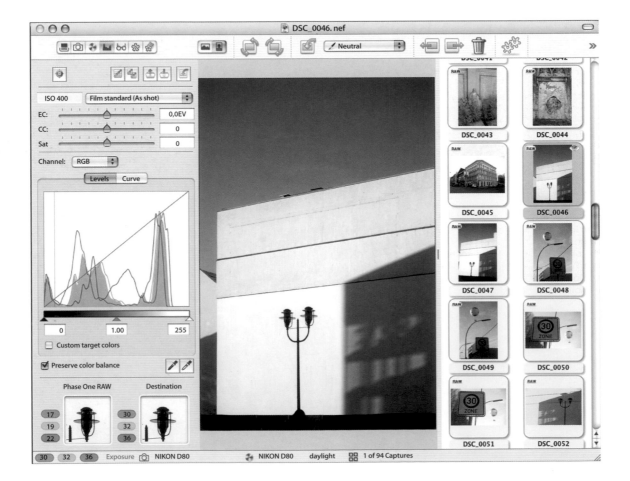

✓ Canon EOS-1D daylight V3

Canon ▶	Nikon D1H generic V2
Fuji ▶	Nikon D1X generic V2
Nikon ▶	Nikon D2H generic V2
Olympus ▶	Nikon D70 generic V2
Pentax ▶	Nikon D80 generic V2
Phase One ▶	Nikon D100 generic V2
Other Profiles ▶	
Show Recommended	
Edit this list...	

ABOVE

Capture One supports a number of camera models. The settings are constantly updated and are available online as new cameras are released.

Other processors

Many professional photographers prefer to use a dedicated program such as Capture One to download and convert their RAW files. As well as being a powerful tool for converting images to TIFFS and JPEGS, either individually or as a batch, this program also offers other useful features. When a folder is created for each set of downloaded images, the program generates a subfolder into which it places all the processed photographs from this batch. It also allows a processing program such as Photoshop to be nominated so that when a RAW file has been processed it automatically opens, if required, in Photoshop.

Opening an image

You can open any file that is recognized by Photoshop by selecting Open from the File menu. From here, you can search the computer's menus and submenus, as well as any connected storage device. There are two viewing formats possible: the computer's operating system (such as Mac OS), or Photoshop's own format, selected from the Use Adobe Dialog tab on the bottom left. In this format, the file icon on the top right provides four viewing modes. One of these displays images as thumbnails, which makes searching for images easier (Bridge is recommended for an extensive search—see pages 118–119).

Once you have found the image you want, press the Open tab or double-click the icon to open the image. A window may appear titled Embedded Profile Mismatch, which asks if the image should be converted to the working profile—usually Adobe RGB (1998). You should select this if prompted. (The importance of profiles and color management is covered on pages 154–159.) Another way to open a file is to simply drag and place it on top of the Photoshop icon. Alternatively, the File menu offers the Open Recent option, which lists the last 10 images opened in Photoshop.

Image Size

The Image Size palette, opened from the Image menu, controls the size a photograph will print at and its resolution. This is expressed by the number of pixels that make up the image as well as its physical measurements. Files from a digital camera will open at a preset size, whereas scanned images are determined by the settings on a scanner. The top section lists the width and height in pixels as well as showing the size of the file in megabytes. Confusingly, this is not listed as "MB" but "M," which is really the abbreviation for "megapixels." Underneath this is Document Size, which is the actual size of the image. Of the seven choices, inches, centimeters, and, millimeters are the most useful. Also listed is the Resolution of the image, either in pixels per inch or pixels per centimeter. Resolution is sometimes expressed as dpi, standing for "dots per inch." However, this should only be used in reference to an actual print (either inkjet print or a printed reproduction), as it refers to the number of ink dots used per inch to create the impression of continuous tone.

ABOVE
The Open dialog box, when set to Adobe, can search for images in a variety of viewing formats.

RIGHT
If prompted by the Embedded Profile Mismatch box, it is generally best to convert the document's colors to the working space—usually Adobe RGB (1998).

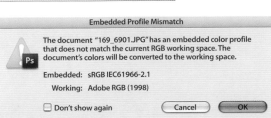

Interpolation

You can use the Image Size palette to change both the dimensions and the resolution of a digital photograph. This process is known as interpolation. Highlight one of the measurements in the palette, either under Pixel Dimension or Document Size, and enter a new size. The figure for the other dimension automatically changes in proportion, providing the Constrain Proportions box is ticked (this is shown by a chain symbol joining the Width and Height measurements). The number of megabytes will alter accordingly. If you double the length, which would make the image four times its original size, the number will quadruple.

You can also change the resolution depending on the quality of file required. RAW files are usually captured at 300ppi, which is the standard resolution for most reproduction and printing applications. If a digital file is shot at a lower resolution, it is advisable to interpolate it up to 300ppi. Some very high-quality publications may require 600ppi, whereas JPEGs are compressed to 72ppi, the resolution of a computer screen. When an image is interpolated, the computer adds pixels to the document, by analyzing the grid of pixels and attaching similar ones next to them as it is enlarged. This works quite successfully if the change is not excessive, although the photograph will suffer in quality if it is increased too much. The Resample Box, which needs to be ticked, has five options for interpolation. Bicubic is the default, and should provide the most accurate results.

```
Image Size

Pixel Dimensions: 26.9M (was 12.0M)

    Width: 3543      pixels
    Height: 2658     pixels

Document Size:

    Width: 30          cm
    Height: 22.51      cm
    Resolution: 300    pixels / inch

[✓] Scale Styles
[✓] Constrain Proportions
[✓] Resample Image:  Bicubic

                                OK
                                Cancel
                                Auto...
```

LEFT AND BELOW
The Image Size palette is used for changing a document's measurements and resolution.

We usually crop our photographs to improve the composition and remove unwanted or obtrusive parts of the shot, or to change the image size so it fits exactly into a designated space. This should not be a problem when only a slight change is required or when the photograph can stand to lose unwanted peripheral detail. It can be frustrating for a photographer who has specifically shot a rectangular image to see it cropped and reproduced as a square, or vice versa.

Some film-based photographers adopt the belief of legendary French photographer Henri Cartier-Bresson (1908–2004) that a photograph is created in the viewfinder and that any subsequent cropping is an abhorrent disregard of their art. Although this purist stance may be admirable, not many of us have the skill or uncompromising self-assurance of Cartier-Bresson, so cropping usually forms part of the photographic process.

The Crop tool

You can make a simple crop by using the Rectangular Marquee tool (see pages 54–55); however, the Crop tool, found in the Tools palette, gives more control. Use the Crop tool by clicking and holding on a point within the image, and then dragging the mouse to make a rectangular shape within the photograph. The area outside of the crop will become darker. To adjust the shape of the crop, move the small white boxes at the edge. Dragging the boxes on the middle of each length adjusts the height and width. The corner boxes can be used to rotate the crop. Place the cursor above one of these boxes and, when two curved arrows are displayed, move the mouse in either direction to rotate the crop. When correct, make the crop by hitting Return or Enter.

LEFT AND BELOW
The tone outside the area to be cropped shows by default as a midtone gray. This tone can be changed to any color (or removed entirely) via the Tool Options Bar.

The Tool Options Bar provides several fine controls to change or adjust the crop. If you require an exact width, height, or resolution size, enter this in the appropriate box before making the crop. The new crop will adjust to these dimensions. If only one size is entered, the other will change in proportion to the new crop. However, if both the width and height are selected before cropping, which may be necessary if an image has to fit an exact size for a page layout, the crop can only be made in proportion to these new measurements. When the crop has been selected, the Tool Options Bar changes to allow different adjustments. The area outside the crop, known as the Shield, appears darker so that the crop can be seen easily. By default it appears as gray; the color and opacity can be changed or, if the Shield icon is unticked, removed completely.

Correcting perspective

You can also use the Crop tool to make simple changes to perspective. This is useful for correcting converging verticals, often seen when shooting upward. Make sure the Perspective icon is ticked in the Tool Options Bar, then, using the corner boxes, move the shape of the crop so it is in line with the incorrect perspective. Hit Return to make the crop and correct the perspective. You could also use this method to deliberately add an exaggerated perspective to a photograph. Other ways of controlling perspective are to use the Lens Correction filter (see pages 88–89) or the Perspective Transform command (see pages 58–59).

Crop rotation

If an image requires a slight adjustment to ensure it is straight in the frame, which is often necessary when scans are made at a slight angle, a simple way is to use the Measure tool. This is in the Toolbox, underneath the Eyedropper. Use it to draw a line at the same angle as the slant. From the Image menu, select Rotate Canvas and then Arbitrary. This should show the degree of rotation that is required. Press OK and the image will correct itself. The window will be enlarged slightly to show the full rotated image within a new box, which you will then need to crop.

ABOVE AND RIGHT
You can use the Crop tool to correct perspective. Tick the Perspective box in the Tool Options Bar, then set the lines of the crop, adjacent to the verticals or horizontals that are not straight. Press Return to make the crop.

Photoshop offers several methods to modify and correct contrast and alter depth of tone. These are used to ensure that tonality is either as close as possible to the original scene, or to enhance the image by reducing or increasing its inherent contrast. Before looking at these controls in depth, it is worth considering the differences between how a photograph is viewed as a print and how it is seen on a computer screen, which may affect the changes made to contrast.

Perception

No matter how accurately our equipment is calibrated, a print never looks precisely the same as the image seen on screen. This is due to the differences in perception between reflected light, which is how a print is viewed, and the transmitted light of a monitor. Transmitted light appears brighter, with more contrast, as it has a greater tonal range from the darkest shadow to the brightest highlight. A white tone seen on screen appears more vibrant than the base white of a paper. While we soon become used to this discrepancy (or may not even consider it), it shows the importance of assessing the image on screen with consideration as to how the tones will print.

The Toolbox offers a choice of three viewing modes. The first is the standard setting, which presents the image in its own canvas on a separate window; the second mode turns the whole screen to gray with the image centered; and the third makes the screen black. Although photographs can appear visually very strong against black, it is advisable not to work in this mode—the image within this frame will look slightly contrastier to the eye than it really is and you may compensate for this effect by reducing the contrast.

It can be helpful to open a new document with a white background larger than the current image. You can then drag and place the image onto this empty space. This allows you to see how the image appears against white, which will probably be the paper color onto which the photograph is printed. The contrast range will look less exaggerated, and it will be easier to tell if any lighter edges of the photograph need to be darkened so they do not blend into the print border.

High key and low key

Our perception of an image may change depending on the photograph's lighting conditions and how this affects the contrast. "High key" and "low key" are terms used for two extremes of illumination. A high-key photograph consists primarily of lighter tones with far fewer midtones and shadows. A low-key image is the opposite, containing only a few highlights and midtones. This is used effectively in moviemaking as well as in still photography to convey different moods and emotions through the choice of lighting. The genre of film noir, as its name suggests, utilized low-key lighting, thereby emphasizing an atmosphere of mystery and suspense. In Photoshop, we should consider aesthetic as well as technical differences that are made when changing and manipulating the contrast and tonality of an image.

ABOVE AND RIGHT
A low-key image has very few highlights, whereas a high-key photograph has the opposite tonal values.

Photograph above © iStockphoto.com/ AVTG. Photograph on right © iStockphoto.com

LEFT
Framing an image in black makes it appear slightly contrastier than framing it against white. Photoshop sensibly uses a mid-gray background in the Canvas window.

It can be useful to move a photograph to a document with a white background to get a sense of how the image will look against the white border of the paper it will be printed on.

Contrast controls are found in the Adjustments submenu, under the Image menu. Levels and Curves are the two most popular methods of making contrast adjustments, and both offer precise manipulation to tonality. Both can be applied as an Adjustment Layer (see pages 72–73), which leaves the original document untouched. There are other contrast commands: Auto Contrast automatically sets the file to an average contrast based on the levels of shadows and highlights, (otherwise dark and light pixels), but this never gives the precision or accuracy that personal adjustment provides. Likewise, Brightness/Contrast, which uses two simple sliders, makes alterations quickly but appears crude compared with the dexterity of Levels and Curves.

The Levels palette features a graph known as the histogram. This is a visual representation of the levels of tone from the darkest to the brightest, which, described numerically, ranges from 0 to 255 pixels. There are three sliders beneath the histogram used to control (from left to right) the shadows, midtones, and highlights. Above the histogram are three windows showing the Input Levels, which change as each slider is moved. The left box displays shadows, 0 being the deepest tone. The right-hand box displays the highlights, up to a maximum level of 255. The middle box displays the gamma level, which increases if the middle slider is dragged toward the shadows and decreases when moved toward the highlights. In other words, moving it to the left makes the image brighter, and to the right lighter. However, the contrast will depend

on the set levels of shadow and highlight, and how the middle slider is adjusted between the two.

A histogram should ideally show a smooth gradation of tones that rises and falls depending on the tonality of the image. A low-key photograph features far higher levels on the left, whereas a bright high-key image has little activity in the shadow levels, but rises increasingly to the right of the graph.

Shadows and highlights

When adjusting the histogram, it is usual to set the levels of shadow and highlight first, which is done by moving the left and right sliders to their respective ends of the graph. This may be necessary when there are areas of pure black or white containing no visual information (known as clipping),

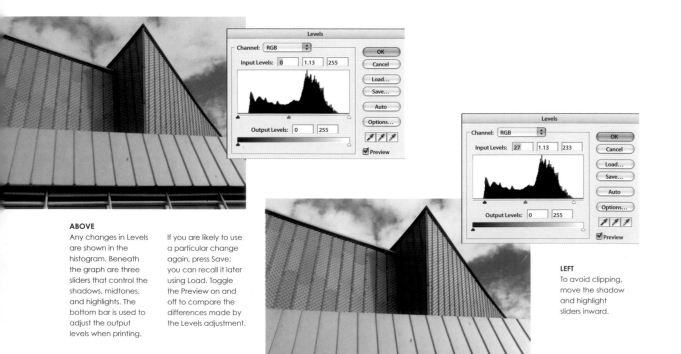

ABOVE

Any changes in Levels are shown in the histogram. Beneath the graph are three sliders that control the shadows, midtones, and highlights. The bottom bar is used to adjust the output levels when printing.

If you are likely to use a particular change again, press Save; you can recall it later using Load. Toggle the Preview on and off to compare the differences made by the Levels adjustment.

LEFT

To avoid clipping, move the shadow and highlight sliders inward.

appearing at the ends of the histogram as empty spaces. This is not so common with images shot digitally, but can occur with scans. Maximum shadow and highlight areas can also be set with the Eyedropper tools found in the Levels window. Click on the left icon to choose shadows, and the right for highlights. Then select the area of the photograph that is meant to be either the darkest shadow or the brightest highlight.

Balancing the midtones

With the shadows and highlights set, move the middle slider to balance the rest of the tonal range. Often, very little adjustment is required, and whatever changes you make must be done very carefully. Further application of the left and right slider may be necessary, as the overall contrast will change with each movement. Any alterations can be compared to the original by clicking the Preview option on and off.

You can make further modifications by adjusting the Output Levels bar beneath the histogram. Moving the right-hand slider adds tone to the highlights; moving the left-hand one brightens the shadows. Although this is designed to correct any discrepancy when printing, it can be used subtly to bring just a slight tone to the highlights or provide more shadow detail. If this is overused, very flat-looking prints will result.

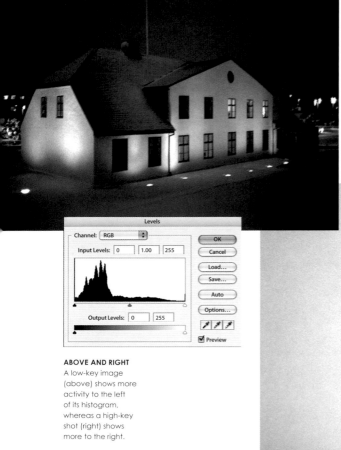

ABOVE AND RIGHT
A low-key image (above) shows more activity to the left of its histogram, whereas a high-key shot (right) shows more to the right.

Many photographers prefer to use Curves when correcting contrast, as it provides the option of changing up to 14 points throughout the tonal scale instead of the three offered by Levels. While this increased flexibility sounds attractive, it may be overcomplicating the issue, as in reality not many images require such careful manipulation.

The notion of Curves is based on the "Characteristic Curve," a plotted graph devised in the 19th century to show the contrast and tonality of a photographic negative when processed in a particular developer for a given time. Seen as a rising S-shaped line, contrast is determined by how steep its angle is. A shallow angle signifies less contrast; a steeper angle indicates higher contrast. Density

depends on the height of the curve; the higher it rises, the more tone there is on the negative. A similar principle is applied to Photoshop Curves, although normally it refers to a positive image.

The Curves palette, like Levels, is a mathematical representation of the complete tonal range. In a square grid, a line runs from the bottom left corner, representing the shadows, to the top right, representing the highlights. Again, the tones are set on a scale of 0 to 255 and a numerical value can be seen as an Input Level when the cursor is moved horizontally over the grid. (Output Levels are shown from dark to light by moving the cursor vertically.)

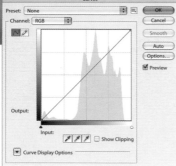

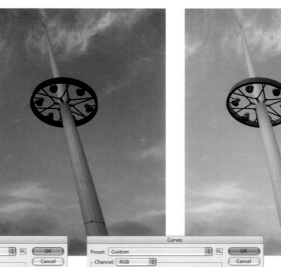

ABOVE AND RIGHT
Curves are a very intuitive way to control contrast, but should be used carefully to prevent different tones clashing. Often just a slight lift is required to adjust contrast. When opened, the "curve" is straight. Bending it downward darkens the tone selected; bending it upward brightens it.

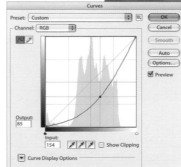

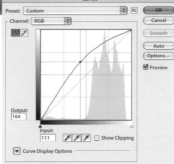

You make changes to the tonality by clicking on a particular area of the curve and moving it diagonally upward to the left to brighten it, or downward to darken it. If the middle of the line were moved, this would predominantly affect the midtones, although as it changes, the straight line becomes curved. As this moves, the shadows and highlights are affected to a certain degree. To prevent this and apply the changes only to a set area, you can click different points of the line. These will show as empty circles; the point currently being changed will appear black. If three points were selected along the line, with one placed in the center of the midtones, this could be moved and the other two points would stop the highlights and shadows from changing. As only a slight adjustment will make a noticeable difference, it is advisable to click on the icon at the bottom right of the palette to make a bigger grid. Alternatively, instead of dragging the chosen point up and down with the cursor, which might make subtle changes difficult, use the up and down arrows on the keyboard (page up to lighten and page down to darken); this gives finer control.

Shadow/Highlight control

A further contrast control, also found in the Adjustments submenu, is the Shadow/Highlight command. This lightens shadows and subdues highlights, although, like the Brightness/Contrast command, it is not recommended as a primary means of contrast control. However, it does have its applications, especially lifting the backgrounds of shots lit directly with a flashgun. By default, when it opens it is set to brighten the shadows by 50%. This will be far too much adjustment; usually 10 to 20% will be the very maximum required. For finer controls, tick Show More Options.

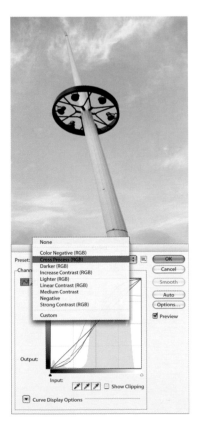

LEFT
In Photoshop CS3, the Curves palette is more sophisticated than in previous versions of Photoshop; it shows the image's tonality as a histogram as well as a Curve. You can also apply several different presets, and make individual adjustments to the RGB channels. This example shows Cross Process (RGB), which simulates the effect of processing color film in the wrong chemistry. You can save a Curve to use again by selecting Save Preset from the Preset Options icon next to the dropdown Preset menu.

RIGHT AND ABOVE
The Shadow/Highlight command can be useful for bringing out detail from flashlit photographs when the background has fallen off.

Many experiments with color photography were made in the 19th century, but the process did not become fully viable until the early 1900s with the invention of Autochrome. It took another 30 years for color photography to become more accessible, with the arrival of Kodachrome film. From this point, color started to replace black and white as the dominant method of photography, both professionally and for the millions of family snapshots taken every year. Digital photography, not being burdened with such a long history and tradition, has always been regarded as a color process, although monochrome is of course possible. Whichever process is used, the perception and theory of viewing color images remains the same. Whether shot and printed traditionally or digitally, a photograph is always about light.

LEFT
White light contains all the colors of the visible spectrum. Digital color images comprise a mixture of three channels: red, green, and blue. (Photograph © iStockphoto.com/ Michel de Nijs)

BELOW
When printed, the three secondary colors together make black. The three primary colors are formed with the following mixes: magenta and cyan make blue; cyan and yellow form green; and yellow and magenta make red.

ABOVE
When all three primary colors are projected together, white is formed. Otherwise, the combination of red and green makes yellow; green and blue makes cyan; and blue and red forms magenta.

Sir Isaac Newton discovered in 1666, with the aid of a prism, that white light is not a color on its own, but a combination of all the projected colors in the visible spectrum. This is seen in "nature's prism," the rainbow. It was then determined that white light can be broken down to three primary colors: red, green, and blue. All other colors can be derived from varying combinations of these three. These are the colors to which the different layers of color film are sensitive. They are also the basis of how a digital camera sensor records an image, using separate red, green, and blue channels. When a photograph is displayed on a computer monitor, the light is formed by only these three colors. Most controls used in Photoshop for correcting color use only the primary and secondary colors.

Although digital cameras and scanners can be very accurate in their capture and recording of color, it is inevitable that some adjustments are necessary. We tend to correct the levels of color in a photograph for one of three reasons. First, we may need to recreate the exact colors of a scene or object for reproduction—for example, paintings or artworks reproduced for a catalog or book need to be carefully balanced so the colors are true. Second, when the quality of light is poor, such as when a landscape is photographed on a dull, flat day, or an interior is shot under tungsten lighting, color controls can be used to boost the intensity of color, or correct a cast, so it appears more natural. The colors are not accurate to the original, but they are more pleasing to look at and may be how

we preconceived the photograph, or how we remembered the scene. Third, we may want to change the atmosphere of a photograph, which is partly determined by the range of colors, even if this is knowingly false. For example, adding a subtle combination of red and yellow to a portrait increases its warmth and affects the viewer's response to the subject. Alternatively, using higher levels of blue makes an image appear colder and more austere. In other cases, very strong, vibrant colors could be added for extra impact and graphic effect, or the saturation could be lowered to create a sense of nostalgia. Using Photoshop, it is possible to convert and change color to help convey the atmosphere you wish your images to impart.

There are various methods to control color, most of which are found in the Adjustments submenu (accessed from the Image menu or opened as Adjustment Layers from the Layers palette). Often an image requires only a minimal change, but sometimes extensive correction is necessary, using a combination of different controls. To achieve the correct color, it is imperative that your computer monitor is accurately calibrated (see pages 156–157).

Any given color has an exact opposite. Therefore, if a color photograph has an incorrect tint or color bias, you add the opposite color to remove the cast. You can make such a correction using Color Balance, which consists of a palette with three sliders. Each slider controls the level of one of the three primary colors on the left-hand side, while their secondary opposites are found on the right. When opened, all sliders are positioned centrally. If the Red/Cyan slider is moved toward Cyan, the image takes on a cyan cast. Move it in the opposite direction and the overall tone changes to red. If a photograph contains too much red, increasing the cyan reduces it.

Sometimes a cast that needs to be removed will not fit conveniently into the six colors in the palette. In this case, you need to apply a combination of different tones. A purple cast that could contain both blue and magenta would need a combination of green and yellow to remove it, whereas an orange cast would need the addition of cyan and blue (the opposites of red and yellow).

As well as correcting a photograph so it contains what we perceive as a normal color range, you can use Color Balance to deliberately add color to influence a shot's mood and atmosphere. A sunny beach may be enhanced by an increase in yellow

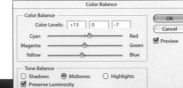

ABOVE AND RIGHT
This photograph was slightly lacking in warmth, as the camera had recorded the darker clouds as a strong blue color. Adjusting the Color Balance in only the highlights by the addition of 13 Red and 7 Yellow removed this cast and gave a warm glow to the rest of the image.

to give the sand a golden glow, while a night shot could benefit from a slight addition of blue in the shadows. You can use this feature to great effect by adding a tone to a monochrome image (see pages 98–101). Color Balance is also useful for correcting color aberrations when printing. Different parts of the tonal range may need separate adjustments, so beneath the three sliders are options for Shadows, Midtones, and Highlights.

Casts on digital images usually occur when a photograph is taken under lighting that conflicts with the setting of the White Balance, which controls the neutrality of color. Given the sophistication of most modern cameras, a noticeable overall cast rarely occurs, although often a slight change is required. A strong cast is more common with photographs scanned from color film (both negative and transparency), especially with shots taken under tungsten light on daylight-balanced film.

LEFT AND BELOW
Here, adding blue and cyan to the midtones not only made the color bias colder but changed the atmosphere of this shot. Photograph © iStockphoto.com/ Chris Schmidt.

This command has two main uses: to control the tone of color in a photograph (Hue), and to adjust its strength and intensity (Saturation). As with Color Balance, it is best used as an Adjustment Layer so the original image is left unaltered. This tool is particularly useful for controlling vibrancy when making a print, even though the image may look correct on screen. Despite careful calibration of the monitor and inkjet printer, a very high-gloss paper may make some (or all) colors appear too strong, so a very slight reduction of Saturation will be required. Alternatively, if using a matte surface, and specifically a noncoated fine-art paper, any resulting dullness could be improved by adding Saturation.

The top slider in the palette adjusts Hue. When moved, the bias changes through all the colors in the visible spectrum. Even a slight alteration makes a noticeable difference, so it is best used with great care. Below Hue is Saturation. When this slider is moved to the left, the intensity and content of color is reduced until, at the end of the scale (–100), the image is completely

RIGHT AND BELOW
Hue/Saturation can be used throughout the whole color range, or to change individual colors. In this instance, the saturation was increased in the Greens by 31 to intensify the color of the trees.

black and white. When pulled to the right, the strength of color increases, making it appear more vibrant. If overused, very graphic, strong tones appear that soon start to pixelate. Additionally, there is a slider for Lightness, which darkens or brightens colors. This should be used sparingly, if at all, as better control can be obtained with either Curves or Levels.

By default, Hue/Saturation is set to Master in the dropdown Edit menu, which adjusts the complete range of colors. Within this menu it is possible to choose any of the six primary or secondary colors to make individual alterations. This is particularly useful when the quality of a photo suffers by just one color being noticeably the wrong shade, too vibrant or too subdued in tone. For example, foliage photographed on an overcast day may appear slightly dull. Selecting Green from the Edit menu slightly increases the Saturation. Likewise, if the color is too intense to begin with, which can occur with skin tones, you would need to decrease Saturation.

An even finer degree of control can be acquired by using the three Eyedroppers above the color bars when working in one of the single-color modes. Use the first Eyedropper to select the initial color. The small sliders between the color bars (notifying which color range is being changed) will then move, placing the selected tone in the center. You can then drag these sliders to either increase or decrease the color range that the changes made in Hue/Saturation will affect. Alternatively, you can use the + and – Eyedroppers.

RIGHT
You can oversaturate colors purposely for graphic effect.

A digital color photograph when viewed on screen consists of three superimposed black-and-white images (grayscales). Each one separately displays the intensity of red, green, and blue, the respective colors through which each channel is projected. You can view the tonal difference between each channel from the Channels palette, opened from the Window menu. You can look at each grayscale separately (or together), depending on which channel is open. Do this by clicking the eye symbols at the side on and off.

Manipulating individual color channels
With an understanding of how the three separate channels combine to make a full colored image, it is easy to see why manipulating separate channels can be a useful way to make corrections or enhance the color range. You can do this by adjusting the degree of contrast and brightness within each of the three RGB channels using Levels or Curves. Both palettes contain a dropdown menu to specify the channel to be altered; by default this opens at RGB. Otherwise all changes are made simultaneously to

ABOVE AND RIGHT
The shot here contains an RGB image, shown next to blocks of pure color added using the Color Picker from the Toolbox. The relevant colored block In each channel is recorded as white—when the individual channel is seen on the monitor, the projected (or emitted) light is made of this basic color. On a grayscale, it will be at a level of 255, where 0 is absolute black and 255 pure white. You can confirm this by using the Eyedropper from the Info palette. If you check the level of each red, green, or blue block separately in its own channel, they should all be this amount. In the white block, they will also be 255 in each channel as, when the three primary colors are projected together, they form pure white light. Likewise, if you check the levels of black in each of the grayscales, all will record 0 in each channel.

each channel. Once you have selected a channel, contrast and tonal changes will affect only this color. However, this also affects the intensity of colors in the other channels. Obvious examples would be to increase the intensity of red in the highlights to convey warmth, or to strengthen blue in the shadows to create a colder atmosphere. You will notice that when you work in a separate color channel, very little manipulation is required to make a significant difference.

RIGHT AND BELOW
This photograph consists primarily of magenta and blue, so color and tonal changes can be made by manipulating individual channels with Curves. After selecting the red channel, the curve can be raised to increase red, or reduced, as in this example, to add blue. You can also achieve this effect with Levels.

Curves

Preset: Custom

Channel: Red

OK
Cancel
Smooth
Auto
Options...
Preview

Output:
113

Input:
166

Show Clipping

Curve Display Options

Color Range (found in the Selections menu) is the ideal tool to use for manipulating separate channels. It uses an Eyedropper to pick an individual tone, which is then formed into a selection (this is similar to the method used for highlighting a particular color when using Replace Color; see pages 46–47). You can then change this area with one of the color or contrast controls, an Adjustment Layer, or with a filter from the Filter menu.

To pick a color, make sure the Color Range preview window is in the positive Image mode, then use the Eyedropper to click on the required tone. Alternatively, you can select the tone directly from the Photoshop

window. Then tick Selection to show the image as negative (similar to Replace Color); the areas sampled will show as white. Adjust the Fuzziness to increase or decrease the level of sampled color. Click on OK, and this area will appear on the main image as a selection. You can make any

subsequent changes just to this area. You can now treat this as any other selection; for example, you can adapt its size, combine it with another selection, change the rate of feathering, and save it in the Select menu so you can use it again.

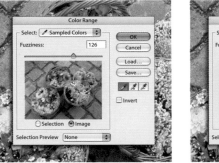

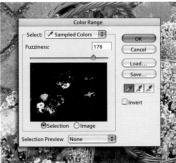

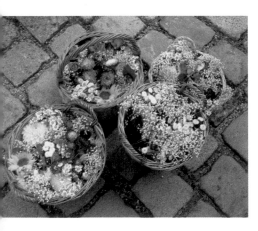

ABOVE AND RIGHT
Using Color Range, a selection was made of the yellows. This was then given a feather of 15 pixels. When this selection was manipulated in

Levels, it not only brightened the color, but the softening of the edge of the selection also gave the flowers a soft glow.

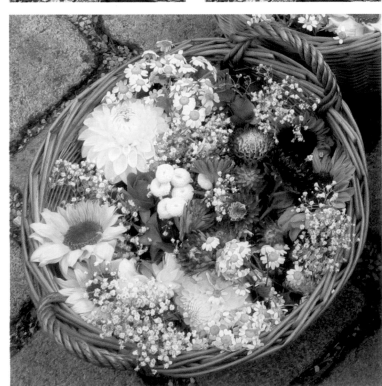

The Color Range palette has some interesting additional features. If you need to make a selection of an exact color or tone, you can choose this from the dropdown menu under Sampled Colors—although the color has to be relatively pure to register. Use the other menu at the bottom of the palette to preview which areas will be selected in the main Photoshop window. You can examine this closely while adjusting the Fuzziness to ensure the selection is correct, especially at the edges. Grayscale converts the image to the same negative view seen in the palette, while Black Matte overlays black on the areas not being sampled. White Matte performs the same function but instead in white, while Quick Mask places a colored overlay over the selected part of the shot. All of these previews disappear from the window, and the selection is made, when you tick OK.

Selective Color
This is a simple way of converting any of the main colors, as well as whites, neutrals, and blacks. It is designed for correcting problems in CMYK conversion and reproduction, but can also be used as a general means of color conversion. Open this tool from the Adjustments submenu (or as an Adjustment Layer) and choose a color from the dropdown menu. Use the four sliders to change the color by increasing or decreasing the level of cyan, magenta, yellow, and black. You have a choice of two Methods beneath these controls: Relative is for more subtle changes, whereas Absolute gives a far stronger shift when bold, strong colors are required within a graphic design.

ABOVE AND RIGHT
With this photograph, the yellow wall appeared slightly too vibrant, so the color was changed using Selective Color. From the nine choices, yellow was chosen and 25% Blue (otherwise -25% Yellow) and 18% Magenta added.

Channel Mixer

You can adjust the overall level of each of the RGB channels by using the Channel Mixer, which can be found in the Adjustments menu, or used as an Adjustment Layer. This tool increases or reduces information in the three grayscales, which then appears as a color change. The Channel Mixer has limited uses, as in most circumstances it is advisable to leave all the channels at the default setting of 100% for each and manipulate color with one of the many other tools. However, it can prove useful when there is one color that is easy to correct, such as a dark blue sky at night, especially after applying a selection with Color Range. The Channel Mixer is also useful for converting color images to monochrome (see pages 94–95).

ABOVE
The Channel Mixer allows individual changes to be made to each separate RGB channel.

Variations

At the bottom of the Adjustments submenu is Variations. This offers an easy method to compare the effect of adding different colors to correct a bias. The original image appears in the main window. This is surrounded by six variations, showing how the tones would change with the addition of red, green, blue, cyan, magenta, or yellow. This can be considered as a visual representation of how Color Balance works, as it also changes the highlights, the midtones, or the shadows.

Select one of these tonal values initially and then click the relevant color box to increase that particular color. You will see the changes in the top window, labeled Current Pick, as well as the central window. To increase the color being added, click the same box again and again. A slider setting adjusts the intensity of correction from Fine to Coarse; it is prudent to keep this toward Fine to maintain a better degree of control. If the color has been changed too much—which is very easy to do—click on the Original box, at the top left of the palette, to reset everything. Further changes can be made to the brightness (again from Coarse to Fine) by using the three boxes at the right of the palette. To save any changes made using Variations, click OK. The corrections will be applied to the original file.

As the windows in Variations are relatively small, it is difficult to see in any great detail how such an alteration will affect the image, especially when adjusting the highlights. Unlike Color Balance, there is no numerical scale, nor can it be used as an Adjustment Layer, so corrections have to be made by going back in the History palette and starting again. What is useful

about this tool is the ability to determine where a color bias is occurring by having possible adjustments in all the primary and secondary colors displayed around the original image. You can then correct this with the Color Balance command. If using Variations in this way, it is also helpful to make a selection of only part of the original photograph using a Marquee tool (see pages 54–55), so only this closeup is shown in the windows.

RIGHT AND ABOVE
The Variations palette shows previews for adding different levels of primary and secondary colors to the shadows, midtones, or highlights.

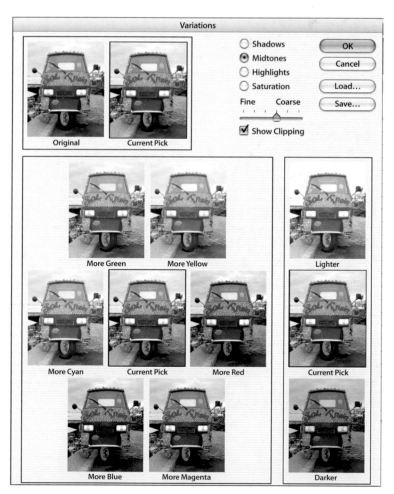

Selection tools are used to isolate and separate a designated section of an image so any changes made, or tools and effects used, will alter only this chosen area. It appears on the screen as a moving black-and-white line, (known as "marching ants") with a sharp, clean edge. This edge can be softened or faded by setting a designated rate of "feathering." The amount of softening is set in the Tool Options Bar, measured in pixels ranging from 0 (no feathering) upward. To create a slightly softened edge, you can use 1–10 pixels, although note that the effect will depend on the resolution of the image, and on how many pixels are set per inch.

ABOVE AND RIGHT
A selection appears as a moving black-and-white line. The area within this can then be manipulated separately, moved within the image (or to another frame), or have a Transform, filter, or Adjustment Layer applied.

RIGHT
The marquee tool provides four options via a pop out menu, including options to select a single row or column of pixels.

Ps		
■	⬚ Rectangular Marquee Tool	M
	◯ Elliptical Marquee Tool	M
	⋯ Single Row Marquee Tool	
	⋮ Single Column Marquee Tool	

Marquee tools
These tools make a selection by tracing either a straight or a curved shape. You hold the cursor down at a set point, and drag it to form the required outline. The most useful tools are the Rectangular Marquee, used to select a rectangular or square area, and the Elliptical Marquee, which will form a circular or oval shape. There is a dropdown menu in the Tool Options Bar to change the style of how the selection is made. In Normal, the rectangular or circular shape changes proportion depending on the angle in which it is dragged, while Fixed Aspect Ratio requires a set proportion. It will then make a selection only to this ratio, but at whatever size is required. 1 to 1 makes an absolute square (or circle when in Elliptical mode), whereas 2 to 3 fits the format of 35mm film. Fixed Size requires you to enter an exact measurement in pixels. It makes a selection to this size when you click the mouse on the screen.

Lasso tools
There are three Lasso tools you can use to make selections that have been drawn by mouse or graphic pen. Freehand lets you draw any shape on screen; Polygonal is used for straight lines; and Magnetic automatically adheres to an outline providing there is enough edge contrast. When you make a selection by hand with any of the lassos, it is completed when the two ends meet together.

Magic Wand
This will form a selection when clicked within an area of even tone, providing there is clear definition between the edges. The level of Tolerance is set in the Tool Options Bar. When increased, this allows pixels of similar colors to become part of a selection.

Quick Selection
You can draw a selection with the Quick Selection tool using the mouse or a graphics pen. How exact the shape will be depends on the different tonalities within the area being selected. In the Tool Options Bar are

three modes: New Selection starts a selection; Add to Selection is used to extend the selection to other areas; and Subtract from Selection removes part of the selection.

Making selections in stages

Making a complicated selection in one step is tricky; it is best to do it in several stages. The Tool Options Bar has four modes to add to a selection or remove from one, and can work with a combination of any type of selection. The first mode, New Selection, is the starting point. This is the only one you need if making a simple selection that requires no additions. Once you have made the selection, you can move it by clicking and holding within the selection, then dragging it with the mouse. Clicking outside it deletes it. To add to the selection, click on the second mode, Add to Selection, and then make another selection. This can be separate from the first, though if it is to adjoin, simply touch the two together by drawing the line of the second into the original selection. The next mode, Subtract from Selection, is similar, except it takes away part of the original selection. This is ideal for correcting mistakes. The last mode, Intersect with, forms a shape by removing parts of the original selection where it is crossed. The second and third modes are the most useful and allow for very intricate work. As an additional guide, the Toolbox has a Quick Mask mode. When clicked, this turns the selected area to a strong color to check that the selection, and its feathering, is correct. When the Lassos are used, the cursor is shown as an icon representing each tool. For finer control, press the Caps Lock key; this turns the icon into a small cross that is easier to use when tracing an outline.

Using different select tools

When using the different select modes, you can apply a combination of different tools. For example, you could make an initial rough selection with Quick Selection in the New mode. You could tidy and refine this with a Lasso tool while switching between the Add and Subtract modes. You can use the Navigator to quickly zoom in and out of areas to make sure the changes made to the selection are exact.

LEFT
The four selection modes (found on the left-hand side of the menu) are essential for making complicated selections in stages. From left to right, the modes are: New, Add To, Subtract From, and Intersect With.

BELOW
Feathering is applied to help the selection blend into the background. A has a value of 0, B is 20, and C is 40 pixels.

A
B
C

Save Selection

Destination
Document: london dragon.psd

Channel: *New*

Name: outline

OK
Cancel

Operation
● New Channel
○ Add to Channel
○ Subtract from Channel
○ Intersect with Channel

The Select menu

Selections can be further refined, modified, and stored from the Select menu. If you are likely to use a selection again, choosing Save Selection keeps it as an Alpha Channel; this can be recalled via Load Selection. This is useful when you need to make separate changes to part of an image, such as contrast followed by saturation. Give the selection a name that will make it easy to find when you need it. To identify which selection is which, open the Channels palette and toggle on the eye symbol. This shows the selection in the Image window as a colored mask. The Load Selection palette also has an option for inverting the selection.

There are four choices in the menu for modifying a selection. Expand and Contract will enlarge or reduce its shape by the number of pixels entered in the palette. Smooth blends the edge of the selection to give it a more flowing line. Border adds another selection larger than itself that can act like a border. The size of this is also set by the number of pixels entered. Next to Modify is the option for Feather, which changes the amount of feathering a selection is set to. You may take several goes to find the correct level, so a stored selection can be recalled and a different feather applied each time to find the correct rate. The largest amount possible is 250 pixels, which will give a very soft edge. Often between 50 and 100 is fine for a smooth blend. You can set the rate in the Tool Options Bar when you make the selection, but it is often more efficient to make it with no feathering and then set the rate afterward.

Select	Filter	Analysis
All		⌘ A
Deselect		⌘ D
Reselect		⇧ ⌘ D
Inverse		⇧ ⌘ I
All Layers		⌥ ⌘ A
Deselect Layers		
Similar Layers		
Color Range…		
Refine Edge…		⌥ ⌘ R
Modify		▶
Grow		
Similar		
Transform Selection		
Load Selection…		
Save Selection…		

Border…
Smooth…
Expand…
Contract…
Feather… ⌥ ⌘ D

LEFT
With Modify, you can change the selection if it is slightly too big or small by using Contract or Expand. Feathering can be adjusted from the Select menu.

ABOVE
Further refinements can be made from the Select menu. You can also save selections.

Expand Selection
Expand By: 10 pixels
OK
Cancel

Color Range is another method of making selections based on the color of pixels. Again, this can be combined with other types of selection and then modified. Another way to alter a selection is to use Transform Selection. This changes its shape by using a Transform. This is different from making a normal Transform (see pages 58–59), as it changes only the selection and not the actual image. A box appears surrounding the selection; change its shape, size, and rotation by moving the side and corner handles. Press Return to carry out the Transform. You can apply other Transforms to the selection by choosing from the list in the Edit menu.

ABOVE

Refine Edge is a new feature of Photoshop CS3. It opens the selected area in a new window, next to a panel that contains the main controls for modifying the selection, such as Feather, Expand, and Contract. By default it shows the selected area against white, (without the marching ants), and any modifications made will be displayed in the window. There are four other viewing modes that you can use; choose one via the relevant icon or by scrolling through by pressing F. These modes are: Standard, Quick Mask, On Black (shown above), and Black Mask.

To quickly alter the perspective, angle, size, and rotation of a selection, you can use various Transforms from the Edit menu. These have many uses, such as correcting the straight lines of buildings and interiors shot at an angle, enlarging or reducing part of an image, or deliberately emphasizing a distortion for graphic effect. You have to make a selection first; this can be just a section of the photograph or the whole image (do this quickly by going to All in the Select menu, or using the shortcut Ctrl/Command A). When working in Layers, any complete layer, except for the original Background, can be transformed without making a selection.

The most basic commands are found in two sections at the bottom of the Transform submenu. The complete image or selection can be rotated by 180˚ or 90˚ in a clockwise or counterclockwise turn, while Flip Horizontal and Flip Vertical reverses the image on either a horizontal or vertical axis.

Above these are six Transforms that have more exact uses. Each is applied in the same manner. Make a selection, and then choose a Transform: a bounding box will appear around the selected area. This box has eight small handles, one on each side and corner;

depending on the nature of the Transform, you drag these to form the required shape. When correct, press Return to complete the Transform. You can also make the Transform by double-clicking inside the box, or by selecting the tick symbol from the Tool Options Bar. Sometimes you will need to make different Transforms to the same selection; you can do these in turn before hitting Return. You can also use the Tool Options Bar to control the Transform; it contains boxes in which to enter exact percentages, sizes, and angle of rotation.

ABOVE AND RIGHT
Transforms are very useful for correcting architectural photographs that have been shot at unsuitable angles.

This photograph needed to have a combination of Perspective and Skew Transforms applied.

BATTERSEA @ 12.5% (Background copy, RGB/8)

12.5% Doc: 26.0M/26.0M

The first Transform in this list is Scale. Use this to alter the height and length by dragging any of the side handles. To change both dimensions in proportion, use the corner handles instead. If using the Tool Options Bar, the dimensions can be linked to make the same percentage change to both sides. Use Rotate to spin the selection to any degree by placing the cursor above a handle and turning at the correct angle. These Transforms are combined in the Free Transform tool (Ctrl/Command T.)

The next three Transforms change perspective and different angles of separate elevations. Use Skew to slant a selection on only one side by dragging a corner box, or make the whole selection slant to the left or right (or bottom or top) by moving a side handle. Distort is similar, but includes the action of Scale to increase or decrease the amount of distortion. Perspective is a very useful Transform as it corrects diverging or converging angles, a distortion that often occurs when photographing a building, either looking upward or downward. You can also use this tool to increase perspective to give an intensified impression of scale. Finally, Warp gives a selection the appearance of being wrapped round a three-dimensional object. As well as corner handles, it uses two antennae connected to each handle to twist the four corners into different shapes and positions. When working with any Transform, especially Scale and Perspective, it is useful to use the grid found in the View menu; this provides straight reference lines for aligning the sides and corners of the Transform. Its size and style can be changed in the Photoshop menu under Preferences.

BELOW
Once the Transforms were applied, the building looked larger and more impressive within the frame. The image was cropped to fill the frame more to further emphasize the presence of the building.

RIGHT
The bottom right-hand corner was still not in proportion, so a selection was made of this area, and Skew applied. As this shortened the building, it was slightly lengthened using Scale.

SECTION 2

TOOLS AND TECHNIQUES

Many of the corrections and manipulations made in Photoshop are done with a "brush," which creates a similar action on the screen as using a conventional brush on paper. Brushes have countless uses, such as coloring in tone, retouching, selectively darkening and lightening parts of an image, and even sketching original artwork. Using a graphics pen rather than a mouse makes the action of a brush feel more natural. When using any brush, its characteristics are set from either the Brush Preset Picker at the top left of the Tool Options Bar or from the Brushes palette.

Open the Picker by clicking on the small window next to Brush; this displays the default list of brush styles in a scrolling menu. Each brush has a name that is displayed by holding the cursor over each symbol. The first brushes have relatively hard edges. These are followed by softer-edged brushes, and then brushes with various airbrushing effects. Pastel, charcoal, and chalk are next. At the bottom of the list are brushes in the form of shapes such as stars, grass, and dry leaves. These brushes have limited and esoteric uses.

You can change the size and hardness of any brush by using the two sliders at the top of the palette. In most instances, softer edges are more pliable and have more applications than those with harder edges. Clicking the small arrow at the top right of the box brings up a list of even more specialist brushes for effects, artwork, and calligraphy. To return to the main set, choose Reset Brushes. The way in which the brushes are illustrated and described can also be changed in this list. The default setting of Stroke Thumbnail is probably the most practical as it shows an example of the brush's action.

Opening the Brushes palette from the Window menu brings up even more choices. The choice of presets currently in use is displayed on the right, while the left-hand column allows even more refinement to the style of the brush. You can change the edge effects and the brush tip, or add noise. Texture allows you to incorporate a preset motif held in the Pattern Picker as part of the texture of the brushstroke.

BELOW
The Brush Preset Picker has numerous choices of brush types. Click on the arrow on the top right to access even more choices.

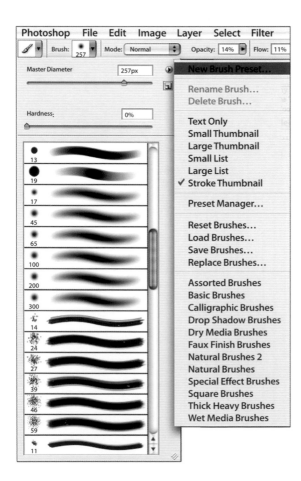

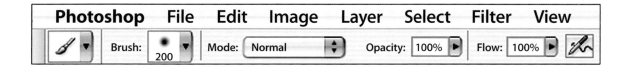

ABOVE
You can change Opacity and Flow via the Tool Options Bar to modify the strength of brush. You can also select different blending modes to alter how the brush is applied.

RIGHT
These four brushes have very different edges, although they are all the same size, at 200 pixels. From left to right: Hard Round, Soft Round, Spatter, and Soft Elliptical.

Important settings in the Tool Options Bar govern the level of brush Opacity and Flow as well as the Blending Mode—that is, how the brush is applied to the image. Setting the Blending Mode to Normal, and then adjusting the rates of Opacity and Flow is the most popular method. (See pages 80–81 for more on blending options.) If you need to brush a very precise area, making a selection and then applying the brush within this gives you more control. Changing the rate of feathering for the selection can also produce different edge effects.

Custom Brushes

If you are likely to require a particular brush's settings again, you can save it as a Custom Brush via the Tool Preset Picker at the very far left of the Tool Options Bar. Click on the Create New Tool Preset icon and then save the brush you are using. This tool lists the exact definition of the brush, followed by its size and hardness percentage, such as "Brush Tool Soft Round 199 1,"—although you can enter any memorable name for the brush. You can also save the color of the brush if required. You can recall the Custom Brush from the Tool Presets whenever you need it again.

ABOVE
When saving a Custom Brush, its exact description will be offered, though this can be changed to any memorable name.

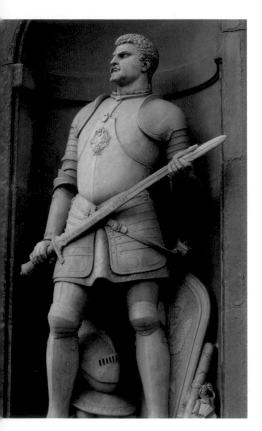

The Dodge and Burn tools, named after traditional film-based printing processes, are used to selectively lighten and darken parts of an image. A traditional printer working in the darkroom exposes a negative projected onto photographic paper for a set time; this is then processed to make a positive print. The skill of printing is to selectively shade part of the exposure to reduce the density in the darker parts of the image ("dodging") by covering up the shadow areas. This can be followed by "burning"—giving more exposure to the brighter midtones and highlights. These actions are usually done with a combination of pieces of card, cupped hands for burning, and a dodging tool—a thin wire with a cutout shape held beneath the enlarging lens. These last two explain the icons used for the Dodge and Burn tools in the Photoshop toolbox.

There are three main reasons for dodging and burning. The first is to achieve as much detail on the photograph as possible so information is not lost in the shadows, while darkened highlights such as bright open skies become less distracting. The second is to produce a particular style or effect. Many photographers deliberately burn in areas of the print to make it appear more dramatic, especially toward the edge of the frame so the eye is drawn to the center, or so the subject stands out from the background. This can produce very good results if done carefully, although it can often look overdone. Third, and perhaps most importantly, dodging and burning is used to give a photograph "balance." This does not refer to the composition within the frame, but rather how the tones relate to each other so that the viewer looks at the complete picture and "reads" the image. To do this, we may subtly darken or lighten some areas so they are not so distracting and lead the eye away from the main elements of the shot, especially at the edges and corners.

ABOVE AND RIGHT
This image was desaturated and the contrast slightly increased with Levels. Burning was then applied to add more tone to the midtones and shadows.

FAR RIGHT
The highlights were brightened with the Dodge tool to give far more depth to the tonality.

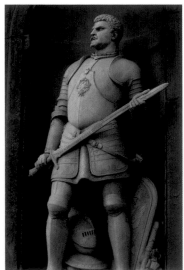

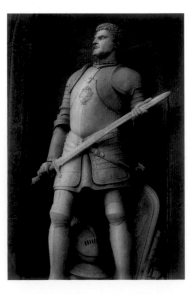

ABOVE
Further burning and dodging was applied, especially around the edges of the frame and in the shadows to make the sculpture stand out. The eye was dodged at a small brush size set to Highlights.

There are several ways to achieve these effects digitally, but Dodge and Burn are probably the simplest tools to use. They are used like any other brush, but are normally applied with a very soft edge, with the size depending on the area being worked on. The tools need to be delicately brushed over an area to lighten when dodging and to darken when burning; this technique may require some practice. The intensity of the action is set in the Tool Options Bar as a percentage of exposure. This goes up to 100%, although it is rare to apply a dodge or burn over 5%. Even this may be too strong; between 1 and 3% is normally enough. The action should be done gradually, building the dodge or burn up piece by piece rather than trying to achieve it in one movement. Keep the History palette at hand to instantly correct any bad moves.

A great advantage of dodging and burning in Photoshop rather than in the darkroom is that you can set a tonal range in the Tool Options Bar so only the highlights, midtones, or shadows are affected by any action; this allows for very precise work.

ABOVE
The final image was given a slight blue tone to emphasize coldness, as if the statue were made of metal rather than stone. Photograph © Huw Walters.

The term "Photoshop," besides being a registered trade name, is commonly used to describe the excessive retouching applied to photographs of celebrities in magazines. This is hardly new, however: retouching has been used since the earliest photographic portraits were made. Between the 1920s and 1940s—the golden era of Hollywood portraiture—teams of retouchers were employed to smooth and blend the features of movie stars. They worked with scalpels, pencils, ink, and gum arabic, usually directly onto the glass-plate negatives, so scores of publicity prints could be printed without the need for further retouching.

The retouching tools in Photoshop are used for the same effect, although they have many uses besides correcting cosmetic flaws. The most basic retouching is to remove dust and scratches on negatives caused during scanning, or to take out blurred spots caused by a dusty camera sensor. When using these brushes, it is advisable to use the Navigator to enlarge a section of the image, retouch this, then use the Navigator to move to the next section, work on this part, and so on.

ABOVE AND RIGHT
Repairing the damage done to this sculpture was quite simple using a combination of Healing Brushes and the Patch tool.

BELOW
The cracked nose was smoothed out by sampling areas near to the crack with the Healing Brush.

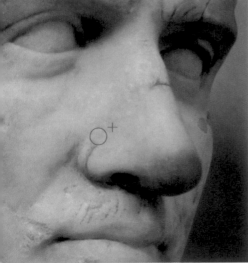

Healing Brushes

There are four Healing Brushes in the Toolbox. The standard brush corrects imperfections by sampling an area of a photograph, which is placed over another. This is then dissolved into the surrounding image. The tool blends the color and texture of the sampled pixels with those being healed. To take a sample, place the cursor over the area that will replace the fault and hold the Alt key while clicking and releasing the mouse. Move the cursor to the offending part of the photograph and then click again, this time without using the Alt key. The sample should now be blended into the new area.

Adding the sample can be done with a single click, moving one area to another. Otherwise, you can use the Healing Brush as a normal brush to paint in a whole area to diffuse into another, such as cleaning up lines and wrinkles. Give careful consideration as to which area is copied. It is usual to take the sample from as near as possible to the mark so it blends in more seamlessly. You need to set the Alignment in the Tool Options Bar; this changes the distance between the source and the destination of the sample. If Aligned is not ticked, this tool continues to sample the same source point until you click a new one with the Alt key. When Aligned is ticked, the angle and distance between these two points remain the same until another point is sampled. It is usual in both instances to keep clicking on a new source point. This tool does not use the standard range of Photoshop brushes, but instead has a small palette to change the size and hardness. It is usual to have a very low percentage of hardness to ensure a smooth blend. Size will depend on the area being retouched; it is best not to go too large as the retouch, especially if applied as a sweeping brushstroke, will show repetitive patterns that will not look very convincing.

Also in the Tool Options Bar is a list of blending modes. Normal will suffice in most instances. For the choice of Source, Sampled is usually ticked; this is the standard blending mode. Clicking Pattern makes this a very different brush, one that will blend in a premade pattern over the original image. This is usually employed for more extreme effects such as adding animal fur to human skin.

Spot Healing Brush

The Spot Healing Brush is similar in action to the Healing Brush, but is simpler to use. It does not require you to store a sample, but instead is simply drawn over the offending area. It takes sampled pixels from around the area being retouched, blends it together, and then replaces on the same point. This makes removing small marks from a large area much faster, as the brush can quickly go from point to point without stopping to store samples with the Alt key. This tool is best applied to very small areas, as it has difficulty in blending a large space that contains different tones or textures. If the image is examined closely, retouching may be more obvious than when applied with the standard Healing Brush—although this also depends on the size of enlargement or quality of reproduction.

BELOW

Very simple marks can be removed with the Spot Healing Brush.

This simply requires the brush to be drawn over the area.

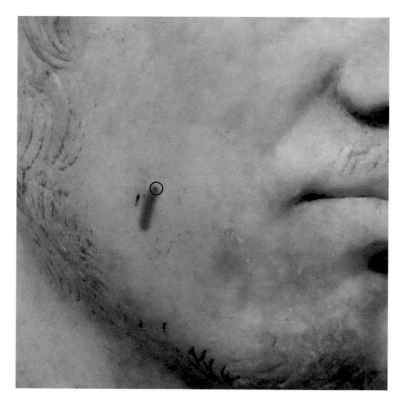

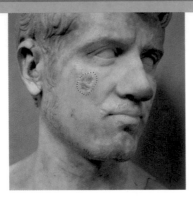

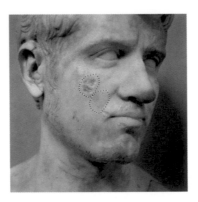

LEFT AND BELOW
The Patch tool is another method for retouching a sampled area. Draw a selection around the part to be removed, and then drag this to the area to be sampled. This will blend in to the original area when the mouse is released.

Patch tool

This tool is a clever combination of the Healing Brush and the Lasso tool. It is used to make a selection of part of an image and then repair it with another section. To do this, there are two choices in the Tool Options Bar. With Source, you make a selection around the area needing retouching and then place the cursor within this area. Click and drag this on top of a similar clean area and release. This section is then copied and automatically blends into the original selected area. Alternatively, Destination takes a clean area to place over the part needing retouching. This is ideal with photographs with a lot of texture. Note that with skin tones there is a danger of retouching too much, making faces look unnaturally flawless.

Red-eye removal

This is a simple tool that you can use to click onto pupils suffering from "red eye" to turn them black. The only two options, Pupil Size and Darken Amount, should be set between 50 and 75% to avoid the eyes suddenly looking too dark and wide.

Clone Stamp

Clone Stamp takes a sample of part of a photograph and repeats it where brushed. It works in a similar manner to the Healing Brush, although it does not blend the sample with the target but simply replaces it. Again, the Alt key is used to select the sample point and the same controls for alignment are found in the Tool Options Bar. Opacity and Flow, however, can be adjusted to make the brushwork smoother and less noticeable. The Clone Stamp, unlike the Healing Brush, uses the main Photoshop brushes.

ABOVE
The dull marks in the sky were caused by dust marks on the camera sensor.

RIGHT AND BELOW
The Clone Stamp was used to copy a nearby area of clear sky that could be placed over the dust mark. This had to be repeated for each mark.

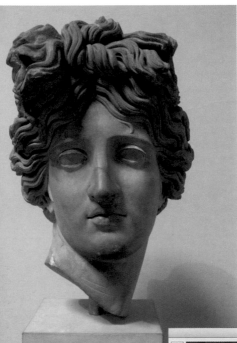

The various Blur filters become useful retouching tools when used in conjunction with Layers. Indeed, when applying any retouching, it is imperative to keep an original layer untouched, which can be toggled on and off to compare the photograph before and after. As more and more work is done to an image, it is easy to go too far and produce an oversanitized result. The original layer can also be blended back to reduce the effects of any retouching. Applying a Blur on a copy layer works in the same manner. Even if you deliberately do not want to retouch the details on a face so it is kept looking natural, a blurred copy layer that is slightly dissolved with the original adds just a little smoothing—in the same way that a slight diffusion can reduce digital noise. A variation of this technique is to have a blurred copy

underneath the top layer, then, with a brush set to Clear or with the Eraser tool, remove parts of the top layer using a low percentage of Opacity to show the softened version underneath.

Liquefy Filter
What you think of this filter will probably depend on your opinion on plastic surgery, as it produces similar results digitally! If used carefully, this tool can make a subtle difference, which a client or subject may appreciate without realizing that any corrective work has been carried out. This tool is designed to make an image totally pliable, allowing parts of the picture to be pushed around the canvas as if it were made of thick wet paint. The tool can be used to make silly caricatures from portraits by stretching noses and ears, enlarging eyes, etc., but can also be used with

ABOVE
The image before the Liquefy filter was used.

RIGHT
In the Liquefy palette, simple changes are made using the Mask brushes (Freeze Mask and Thaw Mask).

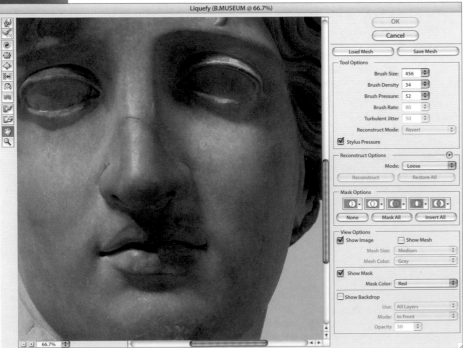

ABOVE
In this example, the cheeks were thinned by first applying a

Freeze Mask with a very large brush.

ABOVE
Using a smaller Thaw Mask brush, the area around the line of the cheek is removed—

very little on the background, mostly on the face.

ABOVE
Using the Forward Warp tool, the line of the cheek is moved inward. This is best

done with a very large brush to ensure the whole area moves together.

care to lift chins, straighten noses, reduce jowls, slim waists, and make other cosmetic modifications.

The Liquefy filter opens from the Filters menu as a separate window. The main tool is Forward Warp. This is shown in the small Toolbox in the Liquefy window as a finger poised ready to smudge. The options panel on the right controls size, density, and pressure. Place the cursor on the part to be liquefied; the image will start to change as you move the cursor. To control this, you can apply a Freeze Mask by selecting the brush and mask icon and then brushing in a red mask onto the areas of the image not to be manipulated. This need not be done on the whole image, just around the part to be nipped or tucked. To clear part of the mask away, use the Thaw Mask. The size of these tools is controlled via the options panel. You can move the small area now visible with the Forward Warp, and the rest of the image will not be affected. A large brush is recommended to make the Liquefy more gradual. You can also use Liquefy on a selection of an image.

RIGHT
Other changes were applied to the line and shape of the nose, the mouth, eyes, and eyebrows. With the Liquefy filter, it is easy to quickly turn an image into a caricature!

One feature that makes Photoshop such a versatile editing program is the ability to work in Layers. This allows you to manipulate and change separate components of an image individually. Layers are often compared to a collection of transparent cells or acetate sheets that are stacked on top of each other. When viewed together, the individual parts of each layer combine to form the complete image. Parts of one layer may obscure another, though the order can be changed, or even merged together. Often a single photograph consists of several layers, so different parts can be treated individually. You can also use Layers to make composites and montages from different images.

The Layers palette, opened from the Window menu, controls and orders the different layers in use. Some other commands are found in the Layer menu. When a single-layered photograph is opened, the palette shows this layer, which is named Background. You can drag another image (or just a selection) directly onto the main Photoshop Image window using the Move tool; this will appear in the palette as Layer 1. Alternatively, you can do this by going to Duplicate Layer in the Layers menu and selecting the correct image and its destination. As each layer is added, it will be shown as a new thumbnail image in the palette. (Thumbnail size can be changed under Palette Options, found by clicking on the top arrow in the palette.) It may be beneficial to rename each layer by highlighting its given title and replacing it with a more descriptive term.

There are seven small icons at the bottom of the palette. The Trash is used to delete a layer, either by clicking on the icon when the layer is active (that is, highlighted) or by dragging it down to the trash. Next is New. To open a new empty layer, click on the icon. To duplicate an existing layer, drag it down to the copy sign. Group is next; this is used to file batches of layers together in sets. It is theoretically possible to have several thousand layers open on one image, so keeping different parts of the image in order is important. After Group comes Adjustment Layers. These contain the main contrast and color controls, but are applied as separate layers. Unlike making a correction in the Adjustments submenu, an Adjustment Layer can be changed or deleted at any time, but will keep the image or selection below intact. If you are going to use an Adjustment Layer only on the layer beneath, you must select Create Clipping Path from the Layer menu to link it directly. This involves first opening the Adjustment Layer, closing it with no alterations, making the Clipping Path, then opening the Adjustment Layer again.

ABOVE AND RIGHT
Layers have many uses, such as combining artwork and photographs together in a design. In this example, the plain sky in the main image of the mask was cleared and then positioned over a more dramatic sky using Layers. Text was then added as another separate layer, above.

MASK

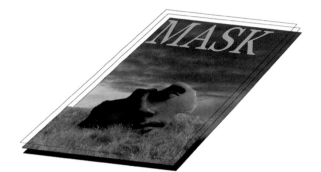

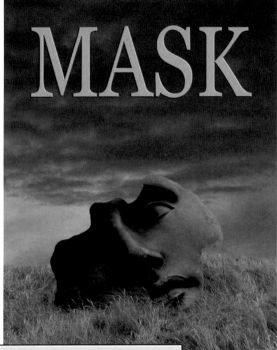

ABOVE AND RIGHT
Seen diagrammatically,
the layers appear as
separate cells, the
order governed by
the Layers palette.

The next two icons we look at in more detail later. Layer Masks (see pages 74–77) let you manipulate and control separate parts of different layers— important for making montages. Layer Style is used for adding effects such as drop shadows to text or selections (see pages 102–103). Lastly, the chain symbol is used to lock layers together. You can highlight any number of consecutive layers by holding the Shift key and then selecting each in the Layers palette. When the Chain icon is clicked, these layers will be locked together and can then be moved, transformed, or copied together.

Once you are familiar with the palette and menu, working in Layers becomes an integral part of digital imaging and an intuitive way to work in Photoshop. Many examples in this book feature Layers and show ways of using them, but you will probably find your own way to adapt Layers to the specific requirements of your photography.

LEFT
As well as displaying
the different layers,
the palette allows
changes and
additions using the
various commands
seen at the bottom
of the palette.
Left to right: Chain,
Layer Style, Layer
Masks, Adjustment
Layers, Groups, New
Layer, Trash.

The versatility of Layers is greatly increased by using Layer Masks to seamlessly blend different elements of adjoining layers together. The mask obscures parts of the top layer so the image underneath can be seen where it has not been masked. The benefit of using a mask, as opposed to making a simple cutout, is that each layer is preserved intact behind the mask; any changes are totally reversible in case mistakes are made or different areas have to be obscured.

The first step is to place one layer on top of another. Either drag the image with the Move icon from one open window to another, or open Duplicate Layer from the Layer menu. Then choose which image to send it to in the Destination dropdown menu. Clicking OK places this as a new layer on top of the other image. Both images should be the same resolution and, ideally, the correct size. Use a Scale Transform to make any changes (see pages 58–59). Place the top layer as close to the correct position as possible. Temporarily reduce the Opacity in the Layers palette if necessary to see the position of the two layers. You then need to make a selection around the area in the top layer that will remain above the

bottom layer. This does not have to be exact—precise changes will be made later. With the selection made and the top layer highlighted, click the Mask icon at the bottom of the Layers palette. Two things should happen: the selected area on top will appear as a cutout against the underneath layer, and a small black-and-white thumbnail will be shown next to the top layer in the Layers palette. If by chance the wrong part of each layer is visible, you need to inverse the selection. Go back in History, prior to the mask being made, and choose Inverse from the Select menu. When correct, the thumbnail should show white on areas that have been masked and black for those that have not. These two colors are then used to refine the mask.

ABOVE
The exposure was correct for the main part of this shot, except for the mirror, so a second photograph was taken that was overexposed by 3 stops.

RIGHT
A Duplicate Layer of the main image was made from the Layer menu, which was then placed onto the photograph of the mirror.

RIGHT
A quick selection was made of the mirror. The selection was then inverted from the Select menu.

The mask is purely black and white (or, more correctly, black and clear). The black parts obscure the layer, while the clearer sections let the image be seen through the mask. As the selection was made quite hurriedly, the mask will probably not look very good. To refine the edges, apply brushes using black and white directly to the mask. The mask thumbnail has to be highlighted and active. Set a brush to Normal, and apply black to remove the mask or white to add to it. Bear in mind that nothing done to the mask will affect either image, so you can use any combination of brushes to try out various ways of brushing in black and white. If there are any other colors shown in the Foreground and Background colors in the Toolbox, click on the two small boxes on the bottom left. To switch the Foreground color between black and white when brushing the mask, click the arrows on the top right.

LEFT AND ABOVE
In the Layers palette, the Add Layer Mask icon was clicked. This turned the area of the dark mirror on the top layer into a mask showing the lighter image below.

The mask can be seen by holding down the Alt key and clicking on the Mask thumbnail in the Layers palette. As it is a pure black-and-white image,

changes can be made using any brushes colored either black or white.

The skill in blending images together using a Layer Mask lies in achieving the right amount of softening on the mask's edge. A very hard brush will show as a juddering line as the pixels from each layer are combined by the sharp border between the two. Naturally, a softer-edged brush gives a more convincing and subtle blend. The size will be determined by trial and error, and also the resolution of the images being used. Depending on how the composite is to appear, it may look best with a very soft diffusion, as if the image is emerging from the background. For a more realistic effect, use a brush with a very slight softness to take the edge off the top layer. You can change the Opacity of the brush to vary the effect. Refining the mask may sound time-consuming, but you can make the process quicker and more efficient by enlarging the screen with the Navigator and doing the brushing piece by piece at very close magnification.

It is very satisfying to watch the image come together as the mask is improved. However, it can sometimes appear confusing if the tones where the two layers join are of similar shades or hues. If so, you can apply a Rubylith to the mask to differentiate between the two layers. Traditionally, this was a red translucent acetate sheet used in the darkroom for masking out areas when making composites from several black-and-white negatives. The Rubylith in Photoshop acts in a similar way. It gives the mask a strong red color, and is applied by holding the Shift and Alt keys and clicking on the Mask thumbnail currently being worked on in the Layers palette. To remove it, simply repeat this action. To change its color and opacity, double-click on the thumbnail for these options. The Rubylith can also be shown purely in black and white, removing the actual images by holding just the Alt key and clicking in the thumbnail.

With the mask now refined, you can manipulate the top layer to ensure that it looks convincing against the background. Clicking the image thumbnail in the Layers palette makes it possible to use the Move tool to drag the cutout layer and the mask around the frame or to apply any Transform to it. You can make a duplicate layer by dragging it to the Copy icon. An important consideration is what further work needs to be done to the two layers to ensure they appear natural together. Some tonal or color correction may be required on both layers to balance the two. Selectively applying the Dodge and Burn tools to the top layer can also give it a degree of modeling to replicate the direction of light that occurs on the background layer. If the shot involves movement, adding a very subtle Motion Blur to the background may increase the impression of speed.

ABOVE
The position, size, and angle of the correctly exposed mirror were changed using the Move tool and various Transforms. This would not have been necessary had the two images been taken using a tripod.

ABOVE AND RIGHT
When applying brushes to change the mask, the Rubylith option, which shows the mask as an opaque colored overlay, is useful to differentiate between the two layers.

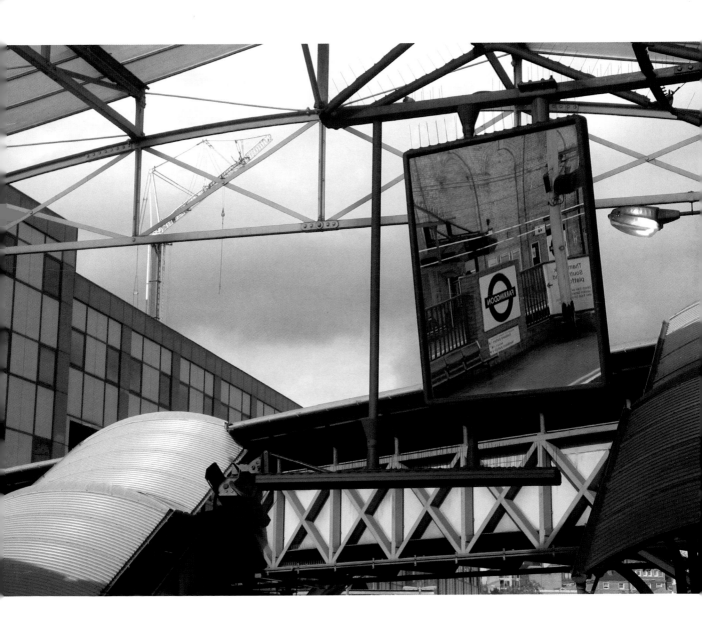

Any numbers of layers, each with a different mask, could be added to build up a composite image, which could look very natural and convincing or could be a fantasy image. It is advisable to work on the file as a Photoshop document (PSD) to ensure all the layers can be saved intact. When the composite appears to be finished, and before flattening all the layers and converting it to a TIFF, make a duplicate of the PSD file in case you need to make further changes in the future.

ABOVE
The Layers of the finished image can then be flattened.

The Dodge and Burn tools can be used to selectively lighten and darken areas. Although these are very efficient tools, similar modifications can be made using Layers and blends, which offer even more control. With Layers, you can also make selective changes to contrast and color as well as shade and tone.

One method is to manipulate a copy layer underneath the top layer and then carefully remove parts of the top layer to reveal these underlying sections. This involves either using a brush or making a selection with a large feather and then choosing Clear

from the Edit menu. The principle is the same with both methods. Two layers with different tonalities are combined to show the best of each layer. An example would be to brighten the eyes in a portrait taken in low light. After making a copy layer, you temporarily hide the top layer, then change the contrast on the layer underneath with Levels or Curves until the eyes are bright. Reselect the main layer and remove the darker eyes on top to reveal the lighter eyes beneath. Use a relatively small brush, and set Clear as a Blending Mode. The Opacity and Flow can be quite low, perhaps between 20 and 40%, so the

RIGHT
To lighten the deepset eyes of this sculpture, two layers were required. The top layer appeared normal while the bottom layer was brightened so the eyes were more visible. Photograph © Huw Walters.

BELOW LEFT
Top layer.

BELOW RIGHT
Bottom layer.

work can be done in stages. An advantage of this method is that the eyes are both brighter and contrastier; if the Dodge tool were used, it would only make the eyes brighter. The Eraser tool can also be applied and will work in exactly the same manner.

With the ability to work between Layers, any choice of blending is possible. You can make subtle color changes by changing a copy layer, which will show through when the top layer is selectively cleared. An example would be to make the clouds in a copy layer of a sunset warmer so the shot appears more golden when

parts of the top layer are brushed away. Another method is to use the History Brush. First you need to make a snapshot in the History palette (see page 17) that has been corrected in the areas that have to be changed. When the relevant snapshot is ticked, you can use the History brush on the active layer to bring in the detail from the saved snapshot.

For changing larger or more complicated areas, you can make a selection on the top layer and then choose Clear from the Edit menu. You can use any method to make a selection. In most instances you

will need to apply a large feather to smooth the blends between layers. You can create gradations by making a straight selection with the Polygonal lasso with a feather of more than 100 pixels. For removing certain colors, try the Color Range picker from the Select menu. Save the selection before applying so you can use different rates of feathering.

LEFT AND BELOW
A mask was made for the top layer in the Layers palette. By using a soft brush set to black, the dark eyes could be removed to show the bright ones beneath.

The Opacity of the brush was set to 20% so the brushwork would be gradual—although, as it was on a mask instead of the image, any mistakes could easily have been rectified.

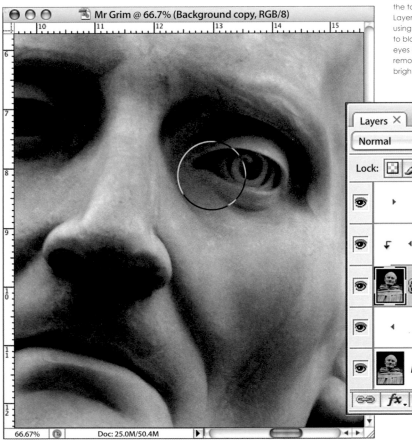
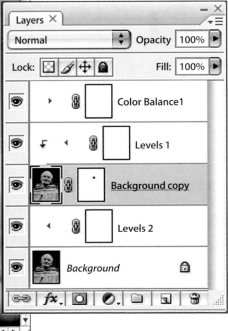

A layer obscures all the other layers beneath it unless part of the image has been cleared using a Layer Mask or Eraser tool. However, it is possible to blend layers together so varying amounts of each are seen. This can be very useful when working with duplicate layers of the same image. You can decrease the effects of manipulations (such as applying a Blur, Sharpen, or Noise filter, or changing the Color Range) by blending the altered layer with an unchanged layer by decreasing the level of Opacity.

There are 23 blending modes available in the Layers palette, with Normal set as the default. These are the same blending modes used for working with various brushes, so many of the listed modes are more suitable for graphic applications. You can make a dissolve between a highlighted layer and the one beneath it by reducing the percentage of Opacity. Normal is the most frequently used mode, as it reduces the opacity in a standard fashion. As the level is decreased, the complete top layer disappears at the same rate as the bottom one emerges. It is worth experimenting with the other blends; the most commonly used ones after Normal are Overlay, Multiply, Lighten, and Darken.

Normal Blending Mode

By reducing the level of Opacity when using the Normal blending mode, the top layer will fade into the next layer underneath. From left to right: 100%, 75%, 50%, and 25% Opacity.

Above: Overlay

This superimposes the top layer over the one beneath, but keeps the tonal range of the bottom layer visible. This is particularly useful when applying a brush to color an area, but also keeps detail in the original image.

Above: Multiply

The top layer becomes opaque over the bottom, though both retain full information, except for the brightest highlights on top. In other words, any white area will become clear and fully show the layer underneath. This mode is ideal for combining black-and-white illustrations with images, as they will appear as pure black on top of the photograph.

Above: Lighten

With Lighten, any areas of the top layer that are darker than the bottom layer will become translucent to show what is underneath.

Right: Darken

This is similar in action to Lighten, except parts of the top layer that are darker then the corresponding area below remain while the highlights on top lose their opacity.

LEFT
The Unsharp Mask filter cannot make an out-of-focus photograph sharp. However, when used carefully it can improve images that lack fine definition, such as this architectural detail shot. The filter is especially useful for use on scanned images.

It is possible to increase the apparent sharpness of a digital image using the various Sharpen tools found in the Filter menu. Such tools do not add any more detail to a photograph, but instead selectively increase acutance (edge detail) to give the impression of improved sharpness. This process derives from a traditional darkroom technique—the confusingly named "Unsharp Mask." This is a very faint, slightly blurred, positive film, which when sandwiched in perfect register with the negative holds back detail in the darkest shadows, which in turn increases the contrast at the edges of areas of detail. More contrast makes an image look sharper, while an Unsharp Mask appears to improve edge detail.

Unsharp Mask
Digitally, Photoshop's Unsharp Mask filter works on a similar principle, increasing the amount of contrast between different colored pixels. There are three sliders to adjust the Amount, Radius, and Threshold. The results of this filter can be hit and miss if you are unsure exactly what each slider does, so it is best to consider each slider separately. Changes are previewed in the filter's palette window as well as in the actual image window. It is useful to set this at a relatively large

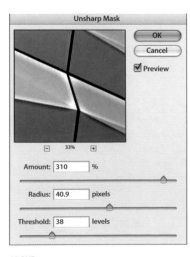

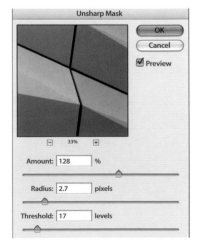

ABOVE
Oversharpening will show as an increase of contrast in edge detail, giving overexposed specular highlights.

ABOVE
Fine control of the Amount, Radius, and Threshold sliders is required.

magnification and position it on the computer screen next to the image so you can compare the two. Make changes to a copy layer so you can contrast the filtered image with the original, and if necessary, blend them together.

• Amount
The amount of sharpening can be controlled between 0 and 500%, although its effectiveness depends on the inherent contrast of the photograph. In most instances, between 150 to 200% is the most effective, as a higher level starts to show excessive contrast between adjoining highlights and shadows.

• Radius
This refers to the radius of pixels surrounding the sharpened edge detail that will be affected, ranging from 0.1 to 250. As it is increased, the shadows darken, and depending on the amount of sharpening, white patches, or halos, appear in the highlights. Usually only a low level of Radius adjustment is required, although this will depend on the image size.

• Threshold
Threshold is used to adjust the level of brightness change that will be recognized as an edge to be sharpened. A low setting provides sharpening to more pixels, while a higher level may help to avoid oversharpening. This is useful for ensuring that a definite edge is recognized as an area to be sharpened, and softer edges, such as areas of texture or skin tones, are not affected.

The Filter menu has three preset default settings: Sharpen, Sharpen Edges, and Sharpen More. These can produce satisfactory results, but the Unsharp Mask is recommended for practically all sharpening requirements because of the finer control it provides. Further sharpening control is possible by using the Smart Sharpen filter. This has more options to separately control the degree of sharpening in the highlights and shadows. It can also very slightly reduce the appearance of different types of blur, namely Gaussian, Lens, and Motion Blur. As any sharpening changes the contrast and definition of an image, it is advisable to apply these filters (and any of the other specialist sharpening programs available as Photoshop plug-ins) as the final stage when processing images.

RIGHT
With just a small degree of sharpening, the detail now appears far more focused.

REDUCING DIGITAL NOISE

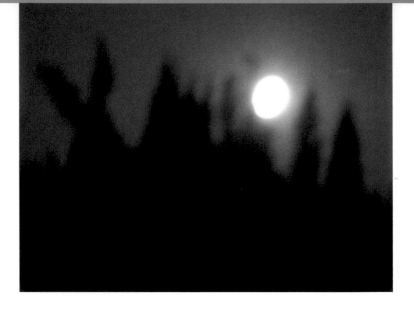

RIGHT
This night shot was handheld for a half-second exposure at 400 ISO. The movement caused by this has added to the mysterious atmosphere, but it displays a lot of colored digital noise.

Shooting on a high ISO setting may produce noticeable digital noise, although it can also be caused by lengthy exposures. It is less of an issue with more expensive cameras, which have larger sensors and are less prone to displaying noise, but it can be a problem with cheaper models. Initially noise looks similar to photographic grain, adding texture to a photograph, but when examined closely specks of colored interference can be seen. Although a grainy photographic print can look graphic and atmospheric, a noisy digital print seldom has the same appeal.

One way to deal with digital noise is to ensure that it is not there in the first place, by shooting only on lower speed settings. However, even though the recording quality of digital cameras is constantly improving, there will always be occasions when we have to photograph in unfavorable conditions. There are several ways to reduce the effect of noise, although it is impossible to remove it totally without affecting the quality of the image.

Photoshop has a Reduce Noise Filter in the Noise submenu, although this may not be the most effective method. Noise is often most apparent in open areas of tone such as skies, and these can be selected and treated separately. Amendments should be made to a copy layer that can be blended with the original layer in case the effect needs to be reduced. Blurs in this situation can work well (see pages 86–87), especially Surface Blur, which softens large areas of tone together while keeping some definition in the edge detail. Before you make the blur, the area selected should

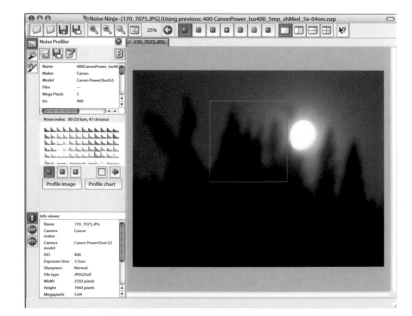

LEFT
Dedicated noise-reduction programs such as Noise Ninja can be an effective way to reduce this interference, though it is advisable to do this on a copy layer.

have a feather of at least 10 pixels (this will depend on the actual size of the image), so there is a smooth transition between the original and blurred areas.

When there is very little difference in color within an area, and no sharp detail, a Median filter (from the Noise menu) can be used to smooth the tones together. Because the pixels will be so similar, they appear to vanish, but this will look unnaturally smooth compared to the rest of the image. Blending with the original unfiltered layer will bring back some texture.

Another effective way to reduce noise is to use a separate program, such as Noise Ninja from Picture Code. This can be purchased and downloaded from the internet and can be used as a separate application or as a Photoshop plug-in. The program has very precise settings for controlling the strength of noise reduction without removing too much surface detail or apparent sharpness. Again, it is best applied to a copy layer so it can be blended with the original for finer control.

ABOVE
The image should be enlarged and carefully examined to see the effects of the reduction.

BELOW
The filtered layer was blended slightly with the original to keep some of the texture of the noise.

RIGHT
Some images may benefit from applying a Surface Blur.

Blur filters (also known as soft-focus filters) are used to reduce the definition of an image. This can be done to soften a surface, especially skin, or to give a photograph a misty or romantic feeling. You can also use Blur filters to reduce the appearance of noise. These filters are usually best applied to a copy layer that can be blended with the original for finer control. When working in layers, you can also selectively brush in blurred areas by using the Eraser, or a Brush set to Clear, on a normal sharp layer stacked above a softened layer.

There are two generic settings: Blur and Blur More. However, in most instances, it is best to set the amount of softening yourself using the Gaussian Blur. This is measured by the radius of pixels affected, from 0.1 to 250 pixels. The highest setting will diffuse the whole image into a single tone and color (you can also do this by using the Average Blur filter). You can also apply a blur to a selection or, if you use Color Range (see pages 50–51), to a particular color—skin tone, for example. This may appear odd, even with a very slight blur, as facial features will look very sharp in comparison when sitting on a blurred face, but you could reduce the effect by blending it with an unsoftened layer.

The Surface Blur filter softens comparable tones together while retaining edge detail. The Radius slider sets the size of the area to be blurred, and Threshold (similar to the Unsharp Mask) restricts the extent of blur within this setting. If you use this sparingly, it can give very painterly effects, similar to the work of artists from the photorealist movement who carefully copied and painted a photograph onto canvas, usually greatly enlarged.

ABOVE AND RIGHT
A Gaussian Blur applied to a copy layer can be blended with the original layer to give finer control of the filter.

LEFT AND ABOVE
Surface Blur leaves edges relatively sharp while applying a blur to similar tones.

Motion Blur adds a feeling of movement and speed to a photograph, similar to the effect of "panning," or exposing while the camera is moving. You set an angle of movement and then select the distance of blur as a number of pixels. If you take a photograph of a moving object, such as a car, and the camera follows the vehicle at the same speed, the shot should show the car in focus with the background appearing as a blurred movement. The Motion Blur

filter cannot exactly recreate this look in one step. However, if you use a Layer Mask (see pages 76–77) between a sharp layer and a layer with a Motion Blur, you can select the car so it appears sharp on top of the blurred background. For a more realistic result, you could apply a very slight blur just to the car, as it may look too perfect being so sharp. As the two layers are joined by a Layer Mask, you can apply different brushes to blend the two layers together.

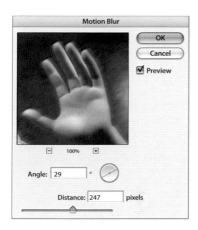

LEFT AND BELOW
If using Motion Blur, apply it to a copy layer and then, with a Layer Mask, combine elements of the sharp and blurred versions. If using CS3, this can all be done by applying the filter as a Smart Filter.

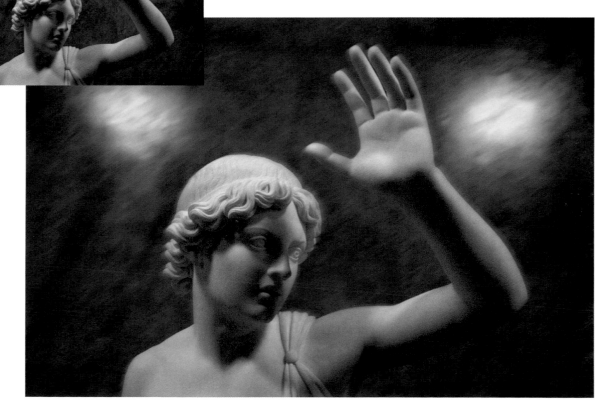

Lens Correction, found in the Distort submenu, is a very useful filter designed to correct the faults common to some lenses. The optics supplied with cheaper cameras, especially zooms, are often prone to such aberrations, although these are not always apparent until you see the difference between an original and a corrected photograph.

The filter opens as a separate window with the image shown at full frame size (this can be changed from the dropdown list of sizes beneath the image window). The filter will also show a grid that can be useful for alignment. If you find this distracting, you can hide it by unticking the Show Grid option beneath the main window. Next to this there are controls for changing its size

and color. There is a small toolbox to the left of the screen that includes a Straighten tool; you can use this by drawing a vertical or horizontal line over a slanting edge or object such as the horizon or a building. On releasing the mouse, the shot will be corrected by rotating the frame to set this line at a straight angle. The other main controls are found to the right of the window.

ABOVE
Barrel distortion is
very obvious in the
foreground detail
of this shot.

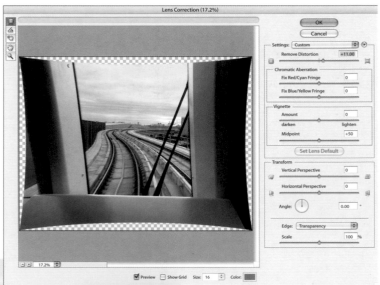

ABOVE AND LEFT
Using Lens Correction,
the distortion can be
corrected, but the
photograph requires
cropping around
the edges.

One of the principal lens faults is distortion, when the image appears either to contract inward (pincushion distortion) or bow outward (barrel distortion). The Remove Distortion slider corrects this, although when the slider is pulled to the right to remove barrel distortion the shape of the photograph will close in on itself, so will need to be cropped. There is an Edge Extension slider at the bottom of the window that will fill out the missing areas by copying and stretching edge pixels, although this works only with edges of pure color and little detail.

Chromatic Aberration is used to correct any slight shifts of color seen in edge detail due to a lens not focusing all the colors exactly onto the camera sensor. You can achieve a similar result by manipulating and carefully moving the individual RGB channels. Chromatic aberration can also sometimes occur with scanned images if the scanner lens is not perfectly aligned.

Vignetting is a common fault where the edges and corners of a frame appear darker. The Vignette slider can lighten the edges to remove this problem, but it must be done very carefully to avoid the corners appearing too bright and displaying a color shift. This control is more useful for purposely adding a vignette to increase the atmosphere of the photograph and draw the eye toward the center of the shot.

There are also two sliders for correcting the vertical and horizontal perspective seen when a photograph is taken at an angle, most commonly when shooting upward. This is similar to the Perspective Transform tool. It is not only used for correcting photographs; it can also be purposely applied to add impact and drama by giving a false sense of heightened perspective.

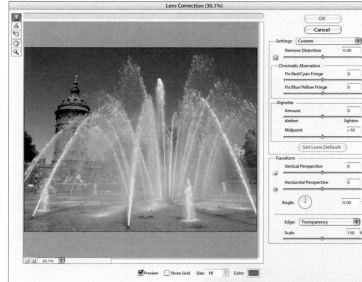

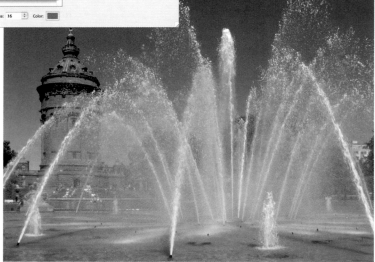

ABOVE AND RIGHT
Vertical perspective is easily controlled using the Perspective controls in the Lens Correction filter.

ABOVE AND BELOW
When an image is opened in the Filter Gallery, many different filters can be applied for different effects.

The filters demonstrated on the previous pages have very useful functions for correcting and enhancing photographs, and these comprise a very small selection of the commands found in the Filter menu. Most filters have more esoteric uses, often to recreate diverse artistic styles; some do this successfully, others not so. Many of these started as plug-ins (software developed by independent programmers) and have since been incorporated into Photoshop. These filters can be fun to use, but tend to have few professional applications. Nevertheless, it is worth exploring the contents of the various submenus to find out what each one does. Filters listed under Artistic, Brush Strokes, and Sketch tend to replicate styles of painting and drawing, whereas Distort, Render, Stylize, and Texture make more physical changes to the image.

When selected, most filters open from a separate window, the Filters Gallery. The window shows the image at full frame (you can use the dropdown menu underneath this to change the size of view). On the right-hand side are controls to manipulate each filter; these will vary according to which one is in use. Above this is a menu containing most of the filters, so you can select a different one and try it out instantly without going back to the main Filters menu. Alternatively, if you tick the arrow at the top right of the window, a separate palette containing all the folders of different filters opens, showing an icon representing each one. You can then select these to change the filter. When you are saving any changes made using a filter, it is prudent to save it on to a copy layer.

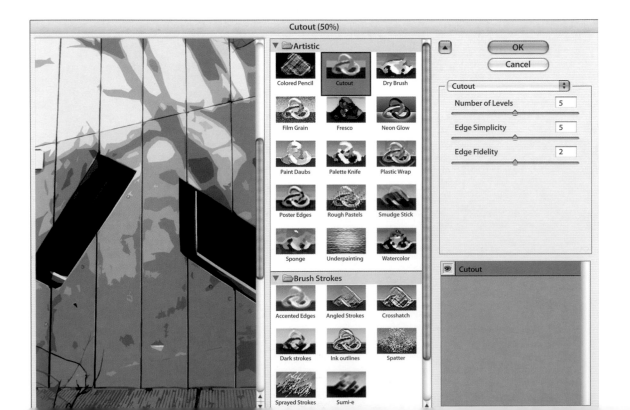

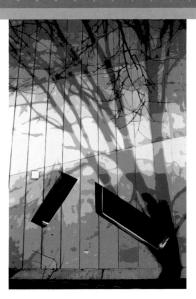

ABOVE
Cut Out.

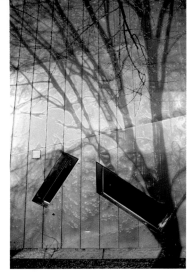

ABOVE
Plastic Wrap.

ABOVE
Poster Edges.

ABOVE
Sponge.

RIGHT
Vertical Grain.

One of the main innovations of CS3 is Smart Filters, a feature that allows all filters to be applied nondestructively. Any changes made to an image by a filter will not affect the original file and can be modified or removed at any time. To do this, you must first convert the file to a Smart Object. You can do this from the Smart Objects submenu in the Layers menu or by selecting Convert for Smart Filters in the Filter menu. Once changed, a small icon will appear in the corner of the

thumbnail image in the Layers palette to indicate that the layer is now a Smart Object. Note that although this gives you more flexibility when using filters, many Photoshop commands—primarily those that alter individual pixels, such as brushing, cloning, and applying Transforms—cannot be used on Smart Objects. In such a case, you would need to convert the layer back by selecting Rasterize from the Smart Objects submenu.

Filters are still applied in the usual manner (see pages 90–91), although the Layers palette will show the filter as a small subdivision under the highlighted layer. On the left is an Eye icon that will hide the filter when clicked; on the right is another icon showing sliders. This opens the Blending Options palette, which allows finer control of the filter. A dropdown menu at the top offers all the usual Layer blending modes (see pages 80–81). The default setting of Normal suffices for most applications. The Opacity is set to 100%, which will be the strength of the filter as initially applied; you can then reduce it as required. It cannot

increase the effect of the filter, although it is more usual that you will need to reduce it than increase it anyway. When using Smart Filters in this way, it is advisable to start with too much filtration and then reduce the Opacity.

Any number of filters can be applied to a Smart Object; all have their own slider for controlling the strength of their effect. Using filters in this way is similar to making a copy layer, applying the filter, and then changing the blend between the two layers. The results will certainly be similar, although Smart Filters may be more convenient to use. Smart Filters are comparable to Adjustment Layers, another nondestructive method of image control, and also prevent the need to copy layers, which increases the file size.

A further benefit of Smart Filters is that the original layer has an empty Layer Mask (see pages 74–77). This allows localized manipulation of the filter by applying a black or white brush directly to the mask or adding a Gradient. Brushing in black removes parts of the filter, while adding white reinstates it. This can be used very effectively when using blurs to compliment a portrait. The strength of the filter could be reduced using the Blending Options palette, and then areas such as the eyes, which should be as sharp as possible, can be highlighted by brushing black onto the layer mask. As it is a mask, any mistakes can be corrected by brushing on the opposite color.

ABOVE AND RIGHT
The original color file was changed to black and white, the contrast adjusted using Curves, and a warm tone applied with Color Balance; this was all done using Adjustment Layers.

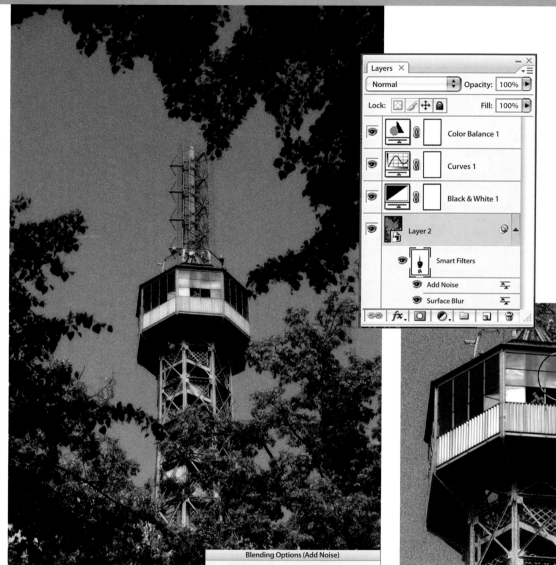

ABOVE
The file was
converted to a
Smart Object, and
Noise and Surface
Blur were applied
to add texture
and atmosphere.

RIGHT
Smart Filters are
nondestructive, so the
effect of the filter can
be changed at any
time without altering
the original file.
The Preview window
will show the
image without any
Adjustment Layers.

ABOVE
In the Layers palette,
the original file
appears with a corner
icon to show it is a
Smart Object. A black

brush was used on
the open Layer Mask
to reduce the effect
of the blur on part
of the shot.

Black and white remains a very popular medium for photographers to work in, even though almost all digital photographs are shot in color. The quality of black-and-white inkjet printing has increased rapidly over the last few years, and many photographers who had previously printed exclusively in the darkroom now produce much of their work on the computer. Most cameras have a mode for capturing in grayscale, but only the most dedicated follower of monochrome would choose to shoot this way. In most instances, unless an image has been taken on black-and-white film and subsequently scanned, it is normal to desaturate a color RGB file using Photoshop. There are several ways to achieve this. The simplest is to select Desaturate from the Adjustments submenu; this will instantly remove all color from the file. Remember that an RGB image consists of three grayscale images, each viewed through their respective colors. When desaturating, the tonal qualities of the three grayscales are blended together to form an average black-and-white image. To take advantage of the different tonalities each channel contains, you can mix the channels together with more precision using the Channel Mixer.

Channel Mixer

The Channel Mixer palette is opened from the Adjustments submenu or as an Adjustment layer. It has an option for monochrome, which when ticked will remove color from all the channels. You can then adjust the percentage level of each to change the tonality, so different colors will appear lighter or darker when converted to black and white. The way each channel reacts is the same as using colored filters on a camera when shooting black-and-white film. A red filter blocks out most of the blue light of the sky (or, to be accurate, the cyan part of it), making the sky appear very light on the negative. When printed, it will look dark. Similarly, if just the red channel is viewed as monochrome using the Channel Mixer set to 100% Red, the blue sky will be much darker than if 100% Blue was set, which would lighten the sky. A standard setting for a monochrome conversion is 30% Red, 60% Green, and 10% Blue, though this should be determined by the colors of the original file. Levels of each color can be lowered or increased depending on whether these tones, when converted to monochrome, will need to be emphasized or reduced. Skin tones can be brightened by adding red, while foliage is accentuated by an increase of the green channel. When using the Channel Mixer to convert to black and white, it is still important to ensure that the levels of all the channels add up to 100%.

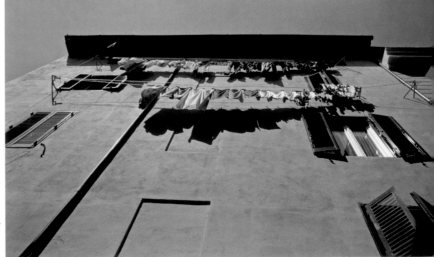

ABOVE AND RIGHT
This image was desaturated using the Channel Mixer set to 30% Red, 60% Green, and 10% Blue.

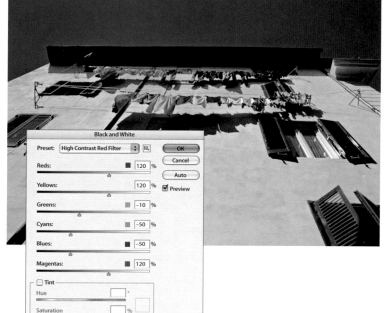

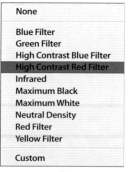

Black and White command

Photoshop CS3 has a dedicated Black and White command for converting images to monochrome that offers far more flexibility than any previous method. It is found in the Adjustments submenu, though it is preferable to use it as an Adjustment Layer. Once open, it converts the image to a standard black-and-white conversion. The tonal value of this can be changed by moving the six sliders representing all the primary and secondary colors. There are also several presets in the dropdown menu that simulate the effect of using different colored filters with monochrome film, or even shooting on infrared film. You can save a particular setting to use on other files by clicking on the Preset Options icon, next to the Preset menu.

When the Black and White palette is open, you can make very precise changes to the depth of a tone by moving the cursor (which appears as an Eyedropper) onto the image, clicking on it, and holding down the mouse. The eyedropper then turns into a hand with two arrows facing left and right. By dragging the mouse in the direction of these arrows, you can darken or lighten the monochrome tone selected. The command can also be used to add a colored tone by ticking the Tint box and applying the Hue and Saturation controls.

Grayscale

Another method to convert an image to black and white is to select Grayscale from the list of modes in the Image menu. This will convert it from RGB to a single channel, so the file size will then contain only a third of the amount of megabytes. If the image is being printed on an inkjet printer with high-quality settings for black and white, the quality should be as good as using RGB. Also, as it is a far smaller file, the printer will take less time to process the digital information prior to printing. However, if the image is for reproduction, it will have to be converted back to RGB. When using Duotone to apply a colored tone to the image (see pages 100–101), the photo must first be in the Grayscale mode.

LEFT
The Black and White command in CS3 offers a very precise degree of control when converting to monochrome. Different tones can be altered using the various sliders or by clicking on the actual image and dragging the mouse to the left or right to darken or lighten.

BELOW
The list of Presets offered with the Black and White command includes various colored filters, an Infrared effect, and Maximum White and Black, which, depending on the original contrast, will make the tonality higher- or lower-key.

ABOVE
When converting using the Channel Mixer with only the red channel, the intensity of the blue sky will be greatly increased.

One of the strengths of monochrome photography is the ability to use contrast and tonality creatively to enhance an image. In conventional black-and-white photography, the contrast of photographic paper is measured in grades, from a very soft Grade 0 to a very hard Grade 5. This is useful for matching the right contrast to a particular negative; a contrasty negative requires a softer grade of paper, and vice versa. This choice of grades is also used deliberately to increase or decrease the inherent contrast of a photograph to give a particular mood or feeling while still looking natural. We are used to the visual language of photography in which black and white has a level of acceptance as being "straight" or real. If a color image were manipulated to the same extent, it would be regarded as looking false.

Levels or Curves usually provide the best methods to adjust contrast, although the Shadow/Highlight command can be useful if used sparingly to bring out more detail from black-and-white images that have had a strong increase in contrast. If shooting film and then working from scans (see pages 22–25), you will inevitably need to increase contrast if the scan was purposely made at a lower contrast to ensure that there is detail throughout the tonal range. Dodging and burning is often necessary in black and white, to ensure that the image is tonally balanced and to emphasize different parts of the photograph. You can do this very effectively via Layers rather than using the Dodge and Burn tools.

Another option that can give a digital image the look of a conventional black-and-white photograph shot on film is to add noise to replicate grain. This should be done sparingly (if at all), as most prints from black-and-white negatives are not particularly grainy, especially in reproduction when the dot screen usually masks the grain. Applying the Add Noise filter (Filter > Noise > Add Noise) gives a similar texture to grain (tick the Monochrome option to avoid colored noise appearing). For more extreme effects, there is a dedicated Grain filter (Filter > Texture > Grain), which gives the impression of different photographic and scanning imperfections. There are 10 grain types, the most useful being Regular. You can adjust the Intensity and Contrast of the grain in the Filter Gallery window. Even if the image has been desaturated, color noise will be very noticeable, so it is best to convert the image to Grayscale and then apply the Grain filter.

RIGHT
Black and white remains a favorite medium for many photographers. The ability to vary the mood and atmosphere of an image by manipulating the contrast is one of its strengths.

ABOVE

Adding digital noise can give the impression of photographic grain, although it is probably more honest to purposely shoot on a grainy black-and-white film and scan the negative.

BELOW
A sepia tone is not a set color, but can be used to describe a variety of brown shades. The color for this image was set to 17 Red and 11 Yellow in the highlights. Increasing the yellow would add more warmth to the image.

ABOVE
This is the original photograph, scanned from a 120 black-and-white negative before toning.

Adding a colored tone to a digital black-and-white image is another technique borrowed from the conventional darkroom. Prints are usually toned to add extra visual emphasis to the photograph. Most commonly, a brown sepia tone imparts a feeling of warmth or, in mind of 19th-century photographs, a sense of nostalgia. Alternatively, a blue tone adds coldness and austerity. There are several easy ways of adding color in Photoshop, and this is best done with subtlety so the image is enhanced by the color instead of being dominated by it. Most color controls are found in the Adjustments submenu within the Image menu; they can also be applied as Adjustment Layers. This is useful if you want to tone a series of photographs to the exact same shade, as you can simply drop the Adjustment Layer on to each file to apply the color.

Color Balance
This is normally used to correct the tonality of a color image (see pages 42–43), but is also effective for toning desaturated RGB files. Individual control of the shadows, midtones, and highlights is possible, although in most instances only one needs to be used. To create a sepia tone, use a combination of red and yellow. Blue tones may need the addition of Cyan as well as Blue. If the highlights or midtones have been lightly toned, a darker color can be added to the shadows. Sepia and blue is a classic combination of split toning in the darkroom and also works effectively in Photoshop.

BELOW
Here, equal amounts of Blue and Cyan were used to create a colder blue tone.

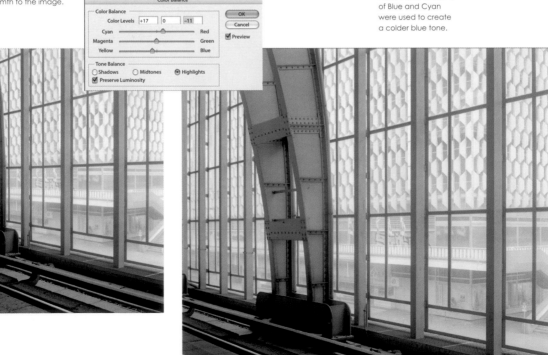

ABOVE AND RIGHT
This digital image was desaturated and the contrast reduced using Levels to compensate for the effects of toning.

BELOW
Here, the whites were given a slight sepia tone and the neutrals a blue tone to create a split tone. Both the contrast adjustment and Selective Coloring were done as Adjustment Layers.

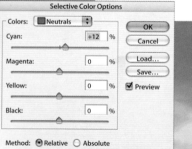

Selective Color

More definite split tones can be achieved with Selective Color. Apart from the six primary and secondary colors, it allows individual manipulation of whites, neutrals (that is, grays), and blacks. If working with two colors, it is prudent to tone just the whites and neutrals, as adding color to the black usually lightens the shadows. The image should not be too contrasty, as the color combination will increase the apparent tonal contrast. Using a Curves or Levels Adjustment Layer helps to make slight modifications, ensuring the contrast is suitable. At the bottom of the palette are two options for coloring. Absolute gives very vibrant and strong colors; Relative provides a more subdued and balanced range of tones.

Hue/Saturation

To add overall color to a photograph, Hue/Saturation has an option named Colorize that works on an RGB file even if it has not been desaturated. When ticked, the image initially appears coarse with overblown colors, but by reducing the Saturation a softer tonality will appear. You can then change the color by moving the Hue slider until you find the desired color. Depending on the vibrancy of the tone, you may have to adjust Saturation again to increase or decrease its strength.

Other methods

Duotone is a way of coloring images in the Grayscale mode, and is based on the mechanical reproduction technique of the same name. It uses different colors, often combined with black, to create a single shade or split tone. When using Duotone, the palette has two boxes for controlling the depth of tone and the contrast of each color (Tritone and Quadtone are also possible). Tick on the first box and the contrast can be adjusted using Curves. The second box provides access to a wide range of industry-standard colors. The difference in contrast between the two curves will govern the predominance of each color.

Duotone

This is a method of coloring images in the Grayscale mode, based on the Duotone mechanical reproduction process. It uses different colors, often combined with black, to create a single shade or split tone. The Duotone palette offers a choice of up to four possible "inks" that are overlaid to form the color and tone of the image. Each has two boxes that are used to control individual color and contrast. The first, when clicked, opens a Curves palette to set the depth of tone and contrast, while the second box controls the color of the selected ink. These ink settings have nothing to do with the colors used in an inkjet printer, but rather to the colors used in photomechanical reproduction on an offset printing press. The Color Libraries palette contains a dropdown list of different catalogs of industry-standard colors—mostly Pantone colors. When you select one, the scrolling swatch of colors in the palette changes to that catalog. Thousands of shades are listed, each with a set name and reference number. When you click on the relevant swatch in the left-hand column, this color is chosen as the ink. The standard Color Picker can also be accessed from the Color Libraries palette. This has an option for selecting from a far smaller range of colors that are reproducible online when preparing graphics for a website.

BOTTOM
The density and contrast of each color is controlled using an individual Curve adjustment.

ABOVE AND OPPOSITE
Duotone can be used to add an infinite combination of colors and tones to black-and-white images.

Although it is possible to use up to four inks (this is known as a Quadtone), standard Duotone, which uses just two inks, normally suffices, unless you require particular split tones. This involves careful shaping of the Curves to color different tones within the grayscale image. When the color is correct, you can convert the image back to the RGB mode from the Image menu. If you keep it in Duotone, you can select the Curves and color palettes at any time to make further changes.

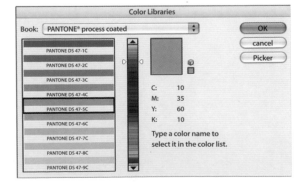

ABOVE
Up to four "inks" can be selected in the Duotone palette.

BELOW
The Color Library contains thousands of swatches of industry-standard colors.

RIGHT
The Text tool is ideal for adding captions or titles to images, especially when preparing presentations and reports.

You can use the Type tool to add text to a Photoshop document, whether as a title, heading, or caption. This tool is not recommended for design that predominantly involves text, such as page layout, as this can be done far more efficiently using a dedicated program such as QuarkXPress or InDesign. Like Photoshop, InDesign is part of Adobe's Creative Suite, which allows files and documents to be opened or imported from any CS program.

The Type tool has four options. The standard default is Horizontal, in which the letters appear in the normal reading order from left to right. Vertical Type enters the letters downward, while the other two modes form letters (horizontal or vertical) as a selection.

These can then be used, modified, and saved as any other selection. To use Type, place the cursor on the Image window; a new empty layer will automatically open onto which you enter the text. Settings for font, style, size, and color are found in the Tool Options Bar. To alter the placing of the text, select the Move tool and drag it to the correct position. To change any of these properties once the text has been saved, choose the correct layer (which will be named after the first words), select the Type tool, highlight the word(s), and make any required alterations. A large selection of fonts is supplied, and you can check spelling from the Edit menu.

As each section of text is on a separate layer, you can treat these as any other layer; you can use transforms to change the size, rotation, or shape of the letters. You can also apply filters, such as adding a blur or texture—however, text is a vector illustration file, so its quality and definition will not change if enlarged or reduced. To use a filter on text, it first has to be rasterized (converted to pixels), which will prevent any further editing of the text (a box will appear asking if this should be done). You can make further changes to the text via the Warp palette in the Tool Options Bar; you can use this to bend the letters to different shapes.

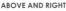

ABOVE AND RIGHT
You can change the style and shape of the lettering by applying a Transform or using the Warp palette.

DROP SHADOW

A

Layer Effects

You can add effects to lettering using Layer Effects, which is opened from the main Layers palette. It contains a list of different styles, such as Drop Shadow for adding a shadow under the text, Outer Glow to give it a soft surrounding light, and Bevel and Emboss to add a three-dimensional impression to text. The size, spread, depth, and color of the effect are all controlled and refined from this palette, as well as the angle of light. Layer Effects are normally used primarily for text, although they also work with any image within a layer.

OUTER GLOW

B

BEVEL & EMBOSS

C

ABOVE
Different Layer
Effects include:
A. Drop Shadow.
B. Outer Glow.
C. Bevel and Emboss.
D. Stroke.

STROKE

D

Most prints have a white border, which is useful for handling and for presentation. Some photographers like to add an extra border round the image, usually a thin black keyline (although any color and thickness is possible), to make the photograph stand out from the paper and give it a definite edge to hold the frame together. There is a tradition of adding black borders in the darkroom by printing the complete negative plus a thin edge of the clear film rebate that is then reversed to black on the print.

This is partly a design decision, but is also used by some photographers to show that the photograph is uncropped and has been composed in the camera. There is no digital parallel to this particular technique, but borders can still be applied to unify the work, whether cropped or not.

The simplest method of adding a border is to apply a Stroke from the Edit menu, although this works only on a layer or a selection. You set the border size in pixels and select a color

(this can also be chosen using the Foreground Color Picker). The choice of Location refers to whether the border will be placed inside, outside, or at the center of the edge of the image. If you are applying the Stroke to the complete image, as opposed to a selection, you will have to set it to Inside. In most instances, a border measuring between 5 and 10 pixels is sufficient without becoming too dominant. Alternatively, you can select the Border option in the Print with Preview palette when making the final print (see pages 150–151).

You can create a more stylized, soft-edged border by manipulating a selection in a layer. You need first to drag the image onto another plain white (or empty) document, which will appear on screen as a larger border. You want to open another empty layer and place it between the main image and the background.

ABOVE AND RIGHT
Using Stroke from the Edit menu is a simple and practical method of applying a keyline to a photograph.

Stroke

Stroke

Width: 4 px

Color: ▮

OK

Cancel

Location

◉ Inside ○ Center ○ Outside

Blending

Mode: Normal ▼

Opacity: 100 %

☐ Preserve Transparency

Make a selection, slightly larger than the image above, and fill it using the Paint Bucket so that just a thin border around the top layer is visible. The easiest way to make the selection is to use the Rectangular Marquee tool. You can change the size by using Expand or Contract from the Modify section of the Select menu (see pages 54–57). Before applying the Paint Bucket, enter a rate of feathering in the Select menu. When the selection is filled, it will appear as a soft edge. If the image or the border appears too large or too small, you can make slight modifications by using a Scale

Transform. If you require just a soft edge rather than a colored border, you can do this by making a feathered selection on the image, slightly smaller than the full frame, inverting the selection, and applying Clear from the Edit menu.

You can make more extreme-looking borders, with the effect of a painted edge, by using a combination of selections, layers, and different styles of paintbrushes. Alternatively, there are programs and plug-ins available that offer a range of borders and edge effects.

BELOW
Soft-edged borders can be applied by feathering the edge of a conventional border.

The Gradient tool can be applied to make a smooth blend, either between two or more colors, or to add a gradation to a photograph. The most common way of using a gradient is to add one to a plain sky that then gradually darkens toward the top of the frame. To apply the Gradient tool, you click a point with the mouse, usually at the edge of the frame, and drag it toward the opposite edge. The size of the gradation depends on

when the mouse is released. There are five modes under the Tool Options Bar: Linear, Radial, Angle, Reflected, and Diamond. Linear is the mode most commonly used, and provides a straight diffusion. The style, color, and intensity are determined in the Gradient Editor, opened at the top left of the Tool Options Bar.

At the top of this palette there are a number of icons representing different preset gradients. The first is called Foreground to Background and makes a gradient with colors depending on what the Foreground and Background color pickers are set to in the Toolbox (although this would then obscure the image below). More useful is the next preset, Foreground to Transparent. This overlays a gradation directly onto the photograph with the color governed by the choice of Foreground. If you use black, this will darken the image to a neutral shade. However, the next consideration is the Opacity setting, also in the Tool Options Bar. At 100%, the gradient will be completely clear at one end (so the image underneath can be seen) and totally black at the other. As this will undoubtedly be too strong, it is normal to use less opacity—perhaps as low as 5 or 10%. However, once the gradient has been made, and before any other changes take

place, you can modify the opacity by opening Fade Gradient from the Edit menu and darkening or lightening the tone by changing the percentage of opacity.

You can control the smoothness of the gradation via the Gradient Editor by adjusting the top sliders on the main bar near the bottom of the palette. The smoothest gradient is possible when both sliders are at either end of the bar. The bottom sliders open up individual Color Pickers. When the

ABOVE
The Gradient Editor can save any particular gradients with different ranges of colors or tones so they can be applied to subsequent images.

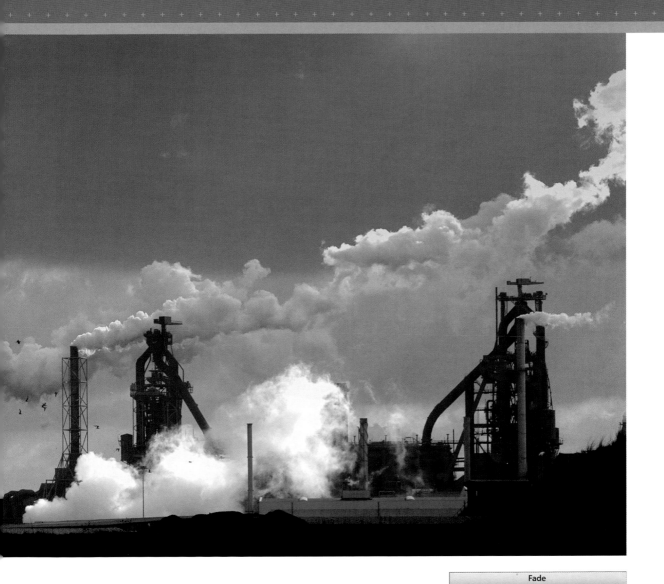

Gradient Editor is opened, it shows the colors currently in the Toolbox's Color Picker; you can change these by clicking on one of the sliders and choosing a new color. You can select more than two colors by clicking beneath the bar to open a new Color Picker. All these can then be moved independently to alter the order and spacing of the colors. To save a particular gradient, click on New and it will be placed with the rest of the presets.

Gradients are also useful when used subtly, often just to slightly darken the edges of an image (similar to using the Burn tool). Needless to say, this is best done on an empty layer so the original background layer is not affected.

TOP
Using the Gradient tool can be an effective method of adding atmosphere to a photograph. Photograph © Huw Walters.

ABOVE
Changes can be further modified by selecting Fade Gradient from the Edit menu, but only directly after the gradient has been applied.

RIGHT

Although five images were used to form this panorama, it could have been done with only three. However, as the shots were taken with a wide-angle lens, the extra frames between the middle and end images help to control the distortions caused by the perspective of the lens.

The most straightforward ways to create a panoramic photograph are to shoot with a panoramic camera, or to crop a wide image from a full-frame photograph. Panoramic cameras are relatively expensive, so unless you specialize in panoramics, you would normally hire one when needed. When cropping an image to a panoramic shape, large-format 5x4 or 10x8 film cameras usually give the best results.

An alternative method is to create a panorama from several images in Photoshop using the Photomerge command (File > Automate > Photomerge). This function has been greatly improved in CS3 and now features five modes for assembling the images. It works by blending together the overlapping edges of photographs that have been shot in succession. It also applies Transforms to straighten parts of the image so they merge

together more convincingly. For Photomerge to work successfully, there are several points to consider when taking the photographs. The same fixed lens must be used for all images. If it is a zoom, the focal length should not be changed during shooting. Extreme wide-angles are best avoided, as they are likely to create edge distortion that may be tricky to correct from image to image. (However, the example used here shows that effective panoramas can sometimes work from wide-angle photographs if the subject is very angular.) The edges of each frame should include approximately 25% of the next and the progression from photograph to photograph must be

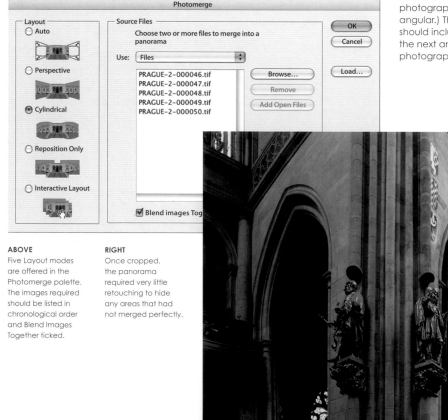

ABOVE

Five Layout modes are offered in the Photomerge palette. The images required should be listed in chronological order and Blend Images Together ticked.

RIGHT

Once cropped, the panorama required very little retouching to hide any areas that had not merged perfectly.

BELOW

When the Photomerge has been completed, the new file will show the extent of the applied Transforms. The placement of each individual image can be seen at the bottom of the frame.

balanced and shot from the same viewpoint. Ideally, all shots should be taken with the camera on a tripod. It is important to use the manual settings to control focus and exposure to ensure it is constant throughout. If the camera was in an automatic mode, the exposure (and probably the focus)

would be reset from one image to the next, making the shots difficult to blend successfully. If shooting digitally, it is easy to preview the correct exposure (often in the middle of the scene), which is then manually set on the camera for all the frames.

There are two main Layout modes used in Photomerge. Perspective takes the middle frame to center the panorama, which then bows outward as the perspective is controlled. Cylindrical works in a similar fashion but reduces the effect of the bowing. If the results of these are too exaggerated, they can always be modified using the Lens Correction filter (see pages 88–89). When using the Auto mode, Photoshop will choose either of these two modes depending on an analysis of the individual shapes of the different components.

The first step is to select the images to merge using the Photomerge palette. Choose the Layout mode, and click OK. A series of automated actions are performed to create the panorama. When finished, the different elements will be on separate layers, each with its own Layer Mask, so further changes could be made to parts of the finished image. If it is likely that more manipulation will be required in general, the other two Layout modes may be preferred. Reposition Only will move all the images into place, but does not apply any Transforms, while Interactive Layout will allow manual changes made subsequently to the positioning of the separate layers.

The tonal range of a photograph, especially taken under contrasty lighting conditions, will inevitably be different from what we would have seen with our eyes. High Dynamic Range (HDR) is a term used to describe the possible tonality that is visible from highlight to shadow. Our eyes can adapt to strong lighting so we can perceive detail throughout, but a camera is less sophisticated and can capture only a limited range. What this range is will depend on many factors, the initial one being whether the photograph has been shot on film or digital. Film has always traditionally had a higher dynamic range than digital, although the quality of electronic sensors has rapidly improved in the last few years, and will doubtless keep increasing in quality. In addition, while a color or black-and-white negative may be able to record up to 10 stops of information, photographic paper will usually have a lower dynamic range and cannot reproduce this amount on a print without manipulation.

Whether shot on film or digital, lighting always affects tonality. A photograph taken on a bright sunny day, such as the example used here, will naturally appear more contrasty and vibrant than if shot with flat lighting. However, the shadows will be darker and the highlights brighter, so less information can be seen at these ends of the dynamic range. A photograph with dull lighting will not have the same contrast or bright colors, but will usually contain more visual information. To create a photograph with a higher dynamic range, it is possible in Photoshop to combine several images of the same scene that have been purposely shot with a range of exposures. This is particularly useful for architectural work, especially interiors. In this case, it is advisable to use photographs that do not contain people, as they may appear translucent when the different images are combined.

Open the Merge To HDR command (File > Automate > Merge to HDR) and select the individual files or folder of images. Needless to say, they must be the same size and should ideally have been shot using a tripod. It is possible to use a series of exposures that have been handheld if they are all quite similarly placed in the frame by ticking the Attempt to Automatically Align Source Images option. This will apply Transforms to each image to try to unify them—it can only "attempt" to align and its success depends on how close the original files are. It will take longer for the HDR image to be generated, but it is still worth using this option with images shot on a tripod just in case a slight movement between frames occurred. This can happen if the tripod used was quite light, especially if shooting with a long focal length lens.

ABOVE
When taking photographs specifically for HDR, it is important to vary the shutter speed and not the aperture to ensure the depth of field remains consistent. In this example, the middle exposure was best overall, though the main part of the monument was underexposed and the golden statue overexposed.

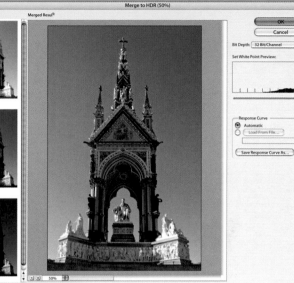

ABOVE AND LEFT
Using Merge to HDR, the three images were blended to extend the tonal range. The slider below the histogram can be moved to adjust the White Balance, which will then change the dynamic range. Once the merge has been completed, further changes can be made by opening the Exposure palette from the Adjustments submenu.

Press OK to start the sequence of automated actions, and the HDR image will be created as a 32-bits-per-channel file (which should retain the complete tonal range). It is possible to change this later to 8- or 16-bit. While still in 32-bit mode, you can make further changes to the tonality by selecting Exposure from the Adjustments submenu. From this palette, you can use Offset to adjust the strength of the midtones and shadows, and Exposure to modify the highlights. Gamma changes the overall brightness.

The term "workflow" has been adopted by photographers to describe the sequence of events, from capture to storage, that occurs when shooting digitally. Prior to the digital era, photographers had two choices when a shoot was finished: to go into the darkroom and process the film themselves, or to pay a professional lab to process it. For commercial jobs, this cost would normally be charged to the client, often with an additional markup for handling.

After the prints had been made, the negatives could be stored. Some photographers were very efficient with negatives, carefully filing each job in its own folder, complete with full details of the subject, client, date, and which images had been printed. Other professionals were less efficient, often misplacing negatives or simply leaving them with the client or at the lab.

A digital workflow follows a similar pattern of events, except that most of these occur electronically. The photographs are taken, processed digitally, manipulated in Photoshop, supplied as files or prints, and then stored. As there is no physical image to file, and because different copies of the same photographs may be generated, it is imperative to work out a system that will efficiently process and file your photographs, as well as making backup copies for security. If you adopt such a workflow, there is less chance of things going wrong during or after a shoot, or of images being lost or misfiled.

An efficient workflow should start when taking the photographs. The first thing to consider is the format of files. In most instances, RAW is a must for professional work, although some photographers shoot high-resolution JPEGs if storage space is low or files need to be supplied instantly for press.

Many professionals, especially if they are studio-based, shoot directly onto a tethered computer or external hard drive. Create dedicated folders on the computer before taking any photographs so you can store the files immediately. If the images are downloaded later from the camera, or from an external card reader, it is worth checking first to see if there are any photographs that can be deleted.

It is best to have a dedicated section of your computer, or even a separate internal hard drive, just for files of downloaded images, so all the original files are stored together. Computer hard drives can usually be partitioned to allow for this, or additional drives installed. With unprocessed RAW files safely held in a clearly titled folder, you can make a backup copy for filing elsewhere, either on an external hard drive or on disk (although some photographers wait until the images are processed before making copies).

LEFT AND ABOVE
Carefully filing folders of images on a computer requires the same discipline as storing negatives safely in job bags to ensure they can easily be found—but it takes up much less space.

When converting RAW files to TIFFs or PSD documents, you should give the files a job title, renumber them, and possibly date them, depending on the controls of the processing program. Most of the more tedious and repetitive operations during processing and storage can be done as a batch process. Once set, the computer will take over the task of converting and copying files. Finally, to help identify and edit what has been shot, you can make contact sheets of the processed images; these will be very helpful for editing without having to search through countless files on the computer.

When working in Photoshop, you will frequently repeat many processes or series of commands, such as changing the image size, saving as a JPEG, or applying a filter. A useful way of saving time as well as reducing the monotony of digital processing is to record these functions as an Action that can be used again on different images.

The Actions palette, which is opened from the Window menu, features several preset Actions that are used for changing the Photoshop workspace. You can make a new Action by selecting the Create New icon at the bottom of the palette. This opens up a box that asks for the Action to be named. Click Record, and a red dot appears in the Action palette to show it is recording; then make your changes to the document. As it is recording, the name of the new Action appears at the bottom of the list, and as each step is made, a descriptive title is given to each change made. When this is complete, click the Stop icon next to Record, and the Action is stored.

You can record almost anything as an Action, from a simple change of image size to a complex conversion involving multiple steps. To use the Action on another file, simply select the Action in the palette and press the Play icon. If part of the Action is to save the changes to the image as a copy, leaving the original file intact, open Save As from the File menu as the last part of the Action, and tick the option for As a Copy.

Actions ✕

- gaby jpg
- tool up
- up square
- upup
- 70%scale transform
- lith
- lith2
- test
- dd
- save as
- save as a copy
- copyright
- rome horiz
- romevert
- rome hor jpg
- rome ver jpg
- twirl
- assign rgb
- size to 17.8
- size to 14 @ 300
- London 30cm @300

New Action

Name: London 30cm @300

Set: Default Actions

Function Key: None ☐ Shift ☐ Command

Color: ☐ None

Record

Cancel

LEFT AND ABOVE
An Action records a sequence of Photoshop commands and manipulations to be used again on other images.

Batch processing

The same Action can be applied to a number of files as a batch, which will help greatly when processing images. Select Batch from the Automate submenu in the File menu. This opens a palette allowing any of the saved Actions to be chosen. Pick one from the dropdown list of Actions, and then underneath, in the Source section, choose a folder of images to be processed. Next, you need to set up a destination folder. As this will probably be a new folder, it is important to make and label one before opening the Batch palette. There are several other factors to consider before starting the batch processing. When selecting the Source folder, there are different options to click that will override or suppress part of the action being performed. Tick "Suppress Color Profile Warnings" to avoid the Color Profile warning box appearing with each image being processed, which would slow down the conversion considerably. In the Destination section, tick the option for "Override Action 'Save As' Commands" to prevent the first image in the folder being overwritten by each newly processed image.

Finally, you need to give images a new reference name. Up to six suffixes can be entered in the File Naming section, including the original document name, a separate serial number or letter, and a date. Once you have completed these sections, press OK. The computer will take over and rapidly process the selected batch of images.

RIGHT
Once saved, an Action can be applied to a complete folder of images using batch processing. This is ideal, for example, for converting a complete shoot from TIFFs to JPEGs.

File browsing

Once you have a workflow that ensures files are processed and stored effectively, it is important to be able to search through images held on a computer or external hard drive. Photoshop uses Adobe Bridge, an efficient browser that opens as a separate program. The concept behind Bridge is to link together the various Creative Suite programs, such as Illustrator and InDesign. A TIFF saved in Photoshop, for example, can be found with Bridge and opened directly as part of an InDesign document.

Bridge opens from the File menu, under Browse. In the top left of the screen are two dropdown menus, Favorites and Folders, which give access to the computer's hard drive, desktop, external hard drive, or CD. Frequently used folders can be placed in Favorites for quick access. A folder highlighted from these menus will then appear on the main screen. If they are image

files, photographs will be shown; if they contain other folders, icons of these will appear instead. Click on these folders to view their contents.

The browser is very easy to navigate. The size of the displayed images is controlled by a slider at the bottom right of the screen. It is often useful to start with small images to quickly look through a folder's contents and then enlarge them to compare different shots in closer detail. To open in Photoshop, double-click on the relevant image; right-click with the mouse and choose open; click, hold, and drag onto the Photoshop icon; or press the Enter key if the keyboard has one. (Open With from the File menu is used to open the image with another Adobe program.) There are two other display modes next to the size slider. Filmstrip presents a movable strip of the folder's contents at the bottom of the screen, with a large version of the

highlighted image above. Its size can be controlled with the slider and more than one image can be selected and displayed together. The other mode, Metadata Focus, shows a vertical list of the images, with technical information to the right of each document.

In the default setting there are several other palettes that open automatically. Filters can change the criteria by which images are viewed, such as Date Created or Keywords. Metadata shows the technical information tagged to the file. Preview displays an enlarged thumbnail of the chosen image, and Keywords displays any search words stored in the image using File Info from Photoshop's File menu. How useful these palettes are depends on your needs. A photo-librarian will find Keywords essential, while most photographers will not need it when editing a shoot. As these palettes take up space on the main display window,

LEFT
Here the Adobe
Bridge window is
shown in the default
mode with large
thumbnails and
displaying the Folders,
Preview, and
Metadata palettes.

RIGHT
The Filmstrip option
can be useful for
quickly viewing a
folder. The main
photograph can be
changed by clicking
on any image in the
filmstrip. In this
example, all other
palettes have been
hidden so they do
not distract from the
main window.

they can be hidden by unticking each item from the Bridge Window menu. In the Workspace submenu, you can save a particular Workspace by selecting Save Workspace.

Using a file browser is similar to viewing contact sheets, which are often marked by the photographer to indicate favorite shots. With Bridge, ratings can be added to a highlighted photograph by selecting a number of stars (from 1 to 5) in the Label menu. Once you have viewed all the images and rated the best ones, you can change the viewing order from the View menu. Select Sort to move the top choices to the beginning or end of the folder so they can be examined together. You can also use Bridge to move files to different folders by clicking on an image (or holding the Shift key and clicking on multiple images) and then dragging to a folder in the left-hand menus, desktop, or hard drive.

Bridge also has a facility (providing you are online) to view photographs from image libraries. This has caused controversy among professional photographers, who feel that the more libraries are used, the less likely they are to get sales and commissions from their clients. Having selected Adobe Stock Photos from Favorites, you can enter a search word. The results are displayed in Bridge, and should you wish to purchase a photograph (and there are strict conditions on how it can be used), you will then be linked to the relevant library's website.

BELOW
In the Window menu, you can temporarily hide palettes and save custom Workspaces, such as "full screen strip" and "full screen icons."

ABOVE
Andrew Atkinson.

Digital technology has completely changed the way in which most professionals in the photographic industry work. Here, a photographer, retoucher (pages 118–121), and fine art printer (160–163) give their opinions on digital photography and how it has affected their work practice.

Andrew Atkinson, Photographer
www.andrew-atkinson.com

Andrew Atkinson works within many areas, but specializes in still-life studio photography. He started shooting digitally in 2001, primarily for one client who appreciated not only the quality of the work but also the convenience of digital. "Previously I had used mostly a 5x4 film camera with some 10x8 and medium format," Andrew remembers. "Starting with a Nikon D100, the reaction I got was very positive, especially as the client could get the work so quickly. I soon realized that digital was going to replace a lot of the work I had been previously shooting on film." Since then, Andrew has invested in larger, more powerful equipment. He now uses primarily a Phase One digital back in the studio, providing far bigger files. "I haven't shot film for a client in the last five years," he admits, "nor have I come across a situation where the files have not been large enough."

It is inevitable that files will continue to increase in size. "It seems we always want bigger files," says Andrew. "I recently did a car shoot using the 39-megapixel Phase One back, which would previously have been shot on 5x4 film if not 10x8. In the future, I expect 80M files opening at 200MB will become the norm, though as well as file size, transfer rate between a tethered camera and computer is important. Currently there are limitations in certain situations regarding transfer time, but usually it is possible to shoot at a fast rate. Most shoots I do will keep up with the recharge time of the flash, so by the time the file has transferred, the flash will be ready. In such a situation, the client can be sitting at the computer so I will get an instant reaction, which is especially useful when shooting a model."

In many ways, the digital revolution has been led not only by photographers (not forgetting the

camera manufacturers), but also by the demands of clients. Knowing that work can be produced far quicker digitally than on film, unless extensive retouching is required, clients have soon become used to the convenience of digital. "For more than half the shoots I do now, the client does not need to attend as low-resolution JPEGs can be emailed directly for approval," Andrew explains. However, while film has the drawback of needing to be processed (not to mention the extra expense), digital files of course also require processing, converting RAW files to TIFFs and applying any necessary correction or manipulation. "After a shoot, there may well be 12GB of 45MB images to be edited. If the art director or client is not precise, it is possible to take far more photographs then required, although shots that don't work, such as out-of-focus ones or ones taken when the eyes were shut, will often be discarded during the session. From each section, perhaps 20 images will then be selected for presentation, although there is still the option to go back to the files later if more have to be seen."

The role of photographer's assistant has also changed. During a shoot, the assistant will often be on the computer checking the quality of files as they are being captured, while previously they may have been working close to the photographer, ready with another roll of film. "Assistants have to be visually and technically more responsible," Andrew states, "although digital hire companies now employ assistants specifically for photographers hiring their backs who will be on the shoot with a laptop processing the files. However, I prefer to have my own equipment, which gives me the freedom to do my own tests whenever I want. Digital can speed up the creative process and has given me more freedom to play with ideas, perhaps more than was possible with film. Its immediacy provides the possibility to see whether something works and, if necessary, allows me to make a print during the shoot. With the right equipment, including a good printer, the whole process from shooting to the final printed result is under the photographer's control. Of course mistakes happen, although not in the same way as with film, which can have a more fortuitous charm at times."

North Light models; Chris Levine
These scale models were photographed for the artist Chris Levine (www.chrislevine.com). They illustrate how an architectural and sculptural installation, commissioned for the town of Blackpool, will appear once completed. Levine's work uses light as a primary component, so Andrew photographed the model using multiple exposures of lasers that have then been blended together in Photoshop.

Film remains popular with many photographers and has its own advantages, in the same way that digital has its own benefits. As a tried-and-tested technology, film has a long heritage and has reached a level of quality that would be difficult to improve on. Digital, despite the very high standard it has today, is still relatively new. In 10 years' time, the equipment and file sizes captured may well far supersede what we use today. Photoshop, of course, is now used by almost every professional photographer, even those who shoot only film.

Technology (and clients) demand that all images can be processed, transmitted, and reproduced from electronic data, and it is often asked whether the convenience of processing images digitally has led to photographers dropping standards, knowing that many problems can be corrected on the computer. "There is an argument that digital can make photographers lazy," Andrew acknowledges. "On many occasions you know that a problem can be resolved very quickly using Photoshop, although this could also be seen as doing the job more effectively. As an example, a recent shoot I did of port bottles comprised of 10 separate

bottles, each with a similar look and design, which had to be presented in the same manner. The shape of each bottle was particularly awkward, and some had bright shiny labels while others had very dark ones, which limited the amount of light that could be used. Instead of trying to capture each bottle in one shot, different lights and carefully placed reflectors were used for different parts of the bottle. Each was then shot in different stages and later assembled in Photoshop. From the basic shot, there would be three elements to add, each taken from different captures, but all staying in perfect registration as nothing would have shifted on the set. This is a very simple but fundamental way of retouching; the different elements are in place already, and just require a simple cut out and blending, which is easier than cloning and brushing in extra detail. This process was repeated on each bottle. Half a day was spent on the lighting and half a day to shoot the bottles, and then almost a day on the computer was required to put them together. Using film, it would have taken three or four days, though each would have to have been more complete before it was shot. Working in this way could be seen by some as laziness, or as another way to achieve

Andresen Port Bottles
Black bottles, especially next to reflective objects, are notoriously difficult to light. Andrew worked out a system whereby individual parts of each shot could be lit, an exposure made for each, and then the completed image assembled in Photoshop.

a certain result. As the postproduction then becomes another part of the process, this should hopefully counteract any accusations of laziness!"

Although Photoshop is a very big program that expands with each new version, Andrew believes the more experienced you become with digital photography, the less you actually need to make corrections. "Professionally, very few situations require radical alterations—any major changes are normally done by retouchers unless there is a particular technique or style that a photographer uses, or is known for." Andrew concludes that although Photoshop is a fantastic tool, photographers need to learn to use it subtly, so it is the

photograph that is noticed and not the processing. "When first using the program, it is natural to go to extremes in image manipulation. Gradually, as one becomes more experienced, alterations become much more delicate. Often just the smallest changes are needed, similar to when using film. Photography is a very particular and precise craft and requires a lot of attention to detail, which is part of the reason why we enjoy doing it. Photoshop is perfect for complementing such an approach, where the smallest and subtlest changes are the ones that make an image work."

ABOVE
Christopher Peabody.

LEFT
The retouched image.

**Christopher Peabody,
Retoucher at Saddington & Baynes.
www.saddingtonbaynes.com**

Established in 1991, Saddington & Baynes is a photographic postproduction studio regarded as a pioneer in the field of digital retouching. Based in London, the company has a worldwide clientele, primarily within the advertising industry. A retoucher may be required to correct a photograph, removing flaws and improving on the quality of the original image, or, in the case of much of Saddington & Baynes' work, they

might be responsible for the creation of new imagery, by compositing together several different photographs. Christopher Peabody, one of the company's creative retouchers, explains the background behind the company and discusses the nature of his work.

"When the company started, photo comping was just that—piecing together images in the darkroom using masks and several different negatives before the first versions of the Barco computer systems were introduced by Silicon Graphics."

Digital retouching had begun in the late 1980s, before the arrival of Photoshop, using programs such as Barco, which was originally designed for the newly digitized reprographic printing industry. Another forerunner was Quantel Paintbox, a computer system that had been used since 1981 in video manipulation and editing. "We still use the Barco today because it has such a fantastic warping system and there are a lot of things it can do better than Photoshop," says Christopher, "even though they stopped developing the system some time ago."

Like many of his colleagues, Christopher started in traditional film-based photography. "I used to do a lot of black-and-white printing at college, which means you spend a great deal of time looking at a picture and working out how it could be improved and what effect you are having on it. In the darkroom you can bring it together by darkening and lightening areas, which relates directly to working on the computer. You may have a toolbox of technical skills to help, but you also need to be able to read the image and decide how to take it forward." In addition, Christopher had already started to use the earliest version of Photoshop. "My family had a secondhand computer that had Photoshop 1 installed on it. We also had computers at college, although at that time it wasn't part of the syllabus and none of the lecturers knew much about it. However, with Photoshop's instruction manual and some sympathetic teachers, I got a useful overview."

After college, Christopher began working in London as an assistant to the advertising photographer Desmond Burdon, just at the time when digital was starting to take a hold in the industry. Digital capture was still in its infancy and it was routine for film to be scanned and then

manipulated in Photoshop. "Macs were just on the threshold of being suitable and powerful enough for retouching. As an assistant I was involved in scanning, spotting, color correction, and cut out. I then freelanced for several years working for different advertising photographers, which really inspired me creatively."

Given this background, it is natural that as a retoucher Christopher has continued to work within the advertising industry. The image a photographer supplies for an advertisement will often have been preplanned and designed by a team of creatives from the advertising agency. However, when a photograph can only be created on the computer, it is up to a retoucher such as Christopher to bring the different images together. This requires far more than just technical skills; a visual and aesthetic understanding is essential so the separate elements when combined appear natural, even if the resulting image would be impossible to photograph in real life. "With some jobs, the art director will not know what it is going to look like, so he is relying on us. In a recent car advert I worked on, the original shot was taken in a favela in Brazil, but I then had to drop the car into a modern glass and steel location in Germany," he says.

Client; Mercedes-Benz. Agency; MBA, London. Art Director; David Read

As part of a campaign for Mercedez-Benz, Christopher created a complete new image from shots supplied by the client. The steps shown here display how its initial composition was formed by using a reversed copy of the original background. A car used as a positional guide in the original photograph was removed and the new model inserted in

its place. A sphere was made using 3D modeling software, which was then blended with the car to give the impression of it being in a bubble. While this involved careful control to fuse the different elements together, the skill of a retoucher such as Christopher lies in changing the tonality and lighting of the image to give it photographic realism, even if it would have been impossible to shoot in real life.

As an indication of the atmosphere wanted by the art director and photographer, Christopher will refer to a mood board, which displays different images sympathetic to the required feeling. With this in mind, he then has to work out how to change parts of the image so they will have the same lighting or perspective, as well as creating different visual effects on-screen. "I may need to adapt static backgrounds and add new elements such as blurred lights, streaks, and motion blurs to create a futuristic look for the shot. In this instance, it required quite a bit of modeling to fit the car in with the background, and as the image was mostly developed by me in the retouching stage, I had to visualize how these different elements would fit together, like painting a picture. Other times I will be working with photographers who will want to completely oversee the job to ensure the finished work is how it was originally perceived. They have a very clear idea in their head, and I have to be able to understand what that is."

Although Photoshop is now the most popular program for manipulation, Christopher explains that he uses many other programs in his work to achieve different results. "Aside from Photoshop and Barco, Shake, which is compositing software, is often used. This allows a very precise control of warping, defining exact areas to be manipulated, something Photoshop cannot do. There are also a variety of

plug-ins used for various effects such as Alien Skin and Knoll Light Factory. The industry is always changing and different products and software are always becoming available."

As sophisticated as the technology is to produce such work, Christopher emphasizes the importance of understanding and studying visual imagery, not just in photography, but within a wider appreciation of the history of art. "I have spent a lot of time in galleries and museums looking

at paintings to see how artists have combined elements in the past. The work of painters such as Claude Lorrain and the Dutch masters reveal how they managed the problem of the transition between a line of trees, grass, and the sky." The relevance to retouching and compositing is obvious. "If the tree was backlit, how would they treat the light that falls on the leaves? This is the same problem when retouching if, for example, there is a tree composited over a background with different lighting.

These artists had similar problems to us if the painting was not completed from life, but instead drawn from individual sketches. Not only regarding lighting but also perspective. Retouching is a bit like standing inside the camera and painting on the film.

Take the camera out of it and it is not that far removed from the easel. The camera may have made things very instant, but retouching feels as if you are going backward, returning to 'painting,' so more time is spent creating the picture."

One subject upon which all photographers who shoot digitally agree is the importance of archiving work. Perhaps it is because there is no physical object to file such as a photographic negative or transparency that photographers are so worried about long-term storage. Archiving involves making backup copies of both unprocessed RAW files and TIFFs, which can then be safely stored outside of the computer. Simply keeping the original files on a PC's hard drive and not backing up elsewhere would be foolhardy. In a relatively short time, the drive can fill up with thousands of images, despite having a capacity to store more than 250GB per drive. Computers may also break down, short circuit, and be stolen or damaged and inevitably need to be upgraded and replaced, requiring all the files to be duplicated again.

How many copies you should save, and where, depends on how securely archived you want your work to be. In general, most photographers save on to external hard drives and perhaps additionally on to a CD or DVD. It is not uncommon to have more than one hard drive with the same work stored at different locations; one set kept at home and others at a workplace or left with friends and family. Some photographers even keep hard drives in a bank safety deposit box.

One concern is how long methods of digital storage, especially on writable disks, will be in common usage. Another concern is the projected lifespan of this digital information. The first personal computers from the 1970s used 5-inch floppy disks capable of containing only 360KB of data. Should anyone still possess such disks, they would need the corresponding hardware to access the contents. As the favored method for disk storage today is CDs and DVDs, it is frequently asked whether these methods will also become obsolete in the future, thus necessitating copies to be made onto a newer form of storage. This is likely to happen at some point, but CD and DVD drives will be around for a long time. As there are billions of disks stored all over the world, such hardware would continue to be available long after the manufacture of the last CD.

ABOVE
Lacie manufactures a wide range of external hard drives. Its standard desktop model offers more than 300GB of storage.

RIGHT
The Rugged series of drives is specially designed for use on location.

LEFT
More stylish, yet still capable of 250GB of storage, are Lacie's drives designed by Porsche.

BELOW
The aptly named Biggest can store 1TB of information over four drives. (1TB, or terabyte, is equal to 1,024GB.)

A more pressing concern is the reliability of disks as a method of storage. Once written, a CD-R or DVD-R is a very delicate object—much more so than commercial audio CDs or DVD movies. They should be handled carefully, as scratches, marks, and fingerprints can easily corrupt files. You should also consider the storage condition in which the disks are kept. As with photographic negatives, a warm or damp environment is detrimental to disks and can cause the silver reflective layer that contains the data to corrode. For long-term storage, it is worth buying proper archival boxes made with acid-free boards and adhesives, and filing disks separately in polyester sleeves. Buy disks manufactured by a well-known and reputable firm rather than purchasing the cheapest ones available, as these are likely to have a far shorter lifespan.

There are conflicting reports as to how long a disk can survive. Accelerated aging tests suggest the figure can be anywhere between five and 90 years, depending on the quality of the disk and how it is stored. Professional archivists do not consider most CD-Rs as being of archival quality or recommended for long-term storage, and are suitable only as a "transfer" medium.

Because of these concerns, external hard drives may currently offer the most reliable method of storage—although even these can break down. Alternatively, there are many companies that offer virtual storage on their mainframe computers. This can be an effective, though possibly costly, operation if you have a large archive.

Out of all of our image files, which versions should be archived? It would make sense to duplicate all RAW files once shot, prior to processing them. RAW files are often described as "digital negatives," so should the finished images ever be lost, the RAW duplicates can be retrieved. As part of a workflow, some photographers prefer to save all files as TIFFs, while others select and convert only the most important shots. Whichever method you use, you should also save a copy of the processed images. Whether that will be all the photographs, or just the best ones, is your personal decision. Take care to name files as originals or copies. This can be done as part of a batch process, so you know what is a copy and which files have been processed. Although files are saved electronically, external hard drives will take up physical space. Even after just a few years of shooting digitally, many photographers have several shelves of hard drives lined up in their offices.

CONTACT SHEETS

Making contact sheets can prove invaluable for editing as well as for showing work to a client. Before the digital era, it was standard practice for photographers using negative film to make contact sheets from each roll of film. All the strips of negatives were "contacted" onto a sheet of photographic paper under glass, exposed to light, and then processed. The contact sheet would then show a positive image, the same size as the film, which a photographer would examine closely to decide which images to print.

Photoshop's function Contact Sheet II can make similar sheets from a folder of images in the Automate submenu, found in the File menu. Select a folder from Source Images, and then set a Document Size. A4 (8¼ x 11¾in) and A3 (11¾ x 16½in) are the usual sizes at which a contact sheet is printed, although you have to enter the dimensions and resolution individually in centimeters, inches, or pixels. The number of images per sheet is controlled under Thumbnails. Below this, you can set the size and font of the filename added as a caption. It is usually best to set this at 12pt or smaller—if the font is too large, it will be abbreviated and may not include the identification numbers at the end of the name. With everything set, press OK, and the contact sheets are generated as a series of actions. Unless it is a very small folder, several sheets will be made, with the images shown in chronological order.

ABOVE AND OPPOSITE
Contact sheets are essential for film photographers. Similar proofs for digital photographers can be made from a folder using Photoshop's Contact Sheet command.

173_7346.JPG
173_7348.JPG
173_7349.JPG
173_7351.JPG

173_7353.JPG
173_7356.JPG
173_7357.JPG
173_7365.JPG

173_7391.JPG
173_7392.JPG

173_7366.JPG
173_7367.JPG
173_7368.JPG
173_7369.JPG

174_7417.JPG
174_7418.JPG

173_7376.JPG
173_7377.JPG
173_7378.JPG
173_7379.JPG

174_7425.JPG
174_7426.JPG

173_7380.JPG
173_7381.JPG
173_7382.JPG
173_7387.JPG

174_7431.JPG
174_7432.JPG

174_7435.JPG
174_7436.JPG
174_7438.JPG
174_7439.JPG

Photoshop is a very big program, and additional features and commands are added with each new version. Photoshop also accepts plug-ins, separate programs that once installed can be used in the main program. Although it is useful to have so many features, commands, and effects, it is very rare for a photographer to use all of these functions. At times, having so many items in the menus can become distracting. It is possible, however, to customize the menu, removing commands you never use and highlighting your favorites. This customization can be done from the Menus palette, found in the Edit menu.

Customizing menus

Menus is a large palette, which is also used for displaying and editing keyboard shortcuts (see pages 134–135). The palette contains two dropdown lists. The top one should display Photoshop Defaults (select this at any time to return the program to its default settings). The second one is Application Menus. Nine menus are listed in the main section of the palette. To open the contents of any, click on the triangle next to the name and the different commands are shown. You can remove an item from a menu by clicking on the Eye logo. To return it, go back to the Menus palette and click on the empty space. As a

reminder that there are commands hidden, Show All Menu Items appears at the bottom of any menus with hidden items, which will then revert it to the default state.

This palette is also used to apply color to the command titles. Next to the Visibility icon is the choice of color. If no color is selected, it will appear as None. Clicking on this will present a list of seven colors to highlight the item. Although this may sound purely decorative, it is quite a useful function. For example, commands in the Adjustments submenu used for contrast control could be given a different color from those used for

ABOVE AND RIGHT
Unwanted items from any of the Photoshop menus can be hidden temporarily using the Menus palette. In addition, color coding can be applied to remaining commands.

changing color. It is also useful in the Filters menus to identify the ones you use regularly, while you could remove many of the more esoteric filters to make the lists easier to scroll through. You can save any changes to a menu in the Menus palette by clicking on the Create New Set icon. A name is given and it will then be placed in the Set dropdown list. In this way, different customized Menus can be stored and then recalled later.

Tool Presets

Many of the Photoshop tools, such as the Crop, Brushes, Selection, and Marquee tools, can be customized and saved as a preset. The Tool Preset Picker is at the left of the Tool Options Bar and will show the current presets when opened. If you need to save the settings for a particular tool—a particular size and font of text, or an exact Marquee Selection shape, for example—click on the Create New Tool Preset icon. Save the setting with its given name, or enter a new one.

ABOVE

The Menus palette offers seven different colors to be used to color code various commands. The Visibility icon can be ticked on or off to either display or hide these commands in the menu.

Anyone used to working on a computer will probably already use keyboard shortcuts or "hot keys" to speed up functions such as cutting and pasting, printing, saving, and duplicating a file. Photoshop has a huge number of shortcuts. It is unlikely anyone could remember them all, but it makes sense to learn the ones you use most often. PCs and Macs have different keys for controlling some functions. The following list (which is not comprehensive) is based on the Mac keyboard. For PCs, replace Command with Ctrl and Option with Alt. Photoshop stores a directory of shortcuts in the Edit menu, which can be accessed from the Menus palette or by using the shortcut Opt+Shift+Cmd+K.

Edit menu

Clear a Selection	Delete
Copy	Cmd+C
Cut	Cmd+X
Paste	Cmd+V
Paste Into (selection)	Cmd+Shift+V
Paste Outside (selection)	Cmd+Opt+Shift+V
Free Transform	Cmd+T
Fill with Background Color	Cmd+Delete
Fill with Foreground Color	Opt+Delete
Fill with Background and Preserve Transparency	Cmd+Shift+Delete
Fill with Foreground and Preserve Transparency	Opt+Shift+Delete
History; Step Backward	Cmd+Opt+Z
History; Step Forward	Cmd+Shift+Z

Image menu

Color Balance	Cmd+B
Curves	Cmd+M
Levels	Cmd+L
Hue/Saturation	Cmd+U
Invert	Cmd+I
Desaturate	Cmd+Shift+U

Layer menu

New Layer	Cmd+Shift+N
Next Layer	Opt+]
Previous Layer	Opt+[
Delete Layer	Cmd+Shift+-
Group Layers	Cmd+G
Flatten Image	Cmd+Opt+Shift+O
Group Into New Smart Object	Cmd+Opt+Shift+H
Merge Layers	Cmd+E
Merge Visibles	Cmd+Shift+E

Filter menu

Add Noise	Cmd+Opt+Shift+Z
Gaussian Blur	Cmd+Opt+Shift+G
Lens Correction	Cmd+Opt+Shift+Y
Unsharp Mask	Cmd+Opt+Shift+U
Vanishing Point	Cmd+Opt+V

Tools palette

Brush/Pencil/Color Replacement tool	B
Rotate Brush/Pencil/Color Replacement tool	Shift+B
Crop tool	C
Default Colors	D
Eraser tools	E
Rotate Eraser tools	Shift+E
Select Screen Mode	F
Gradient/Paint Bucket tool	G
Rotate Gradient/Paint Bucket tool	Shift+G
Hand tool	H
Eyedropper/Sampler/Measure tool	I
Rotate Eyedropper/Sampler/Measure tool	Shift+I
Spot Healing/Healing/Patch/Red Eye tool	J
Rotate Spot Healing/Healing/Patch/Red Eye tool	Shift+J
Slice tool	K
Rotate Slice/Select Slice tool	Shift+K
Lasso tool	L
Rotate Lasso tools	Shift +L
Marquee tool	M
Rotate Rectangular/Elliptical Marquee	Shift+M
Notes/Audio Annotation tool	N
Rotate Notes/Audio Annotation tool	Shift+N
Dodge/Burn/Sponge tool	O
Rotate Dodge/Burn/Sponge tool	Shift+O
Pen/Freeform Pen tool	P
Rotate Pen/Freeform Pen tool	Shift+P
Standard Quick Mask Mode	Q
Blur/Sharpen/Smudge tool	R
Rotate Blur/Sharpen/Smudge tool	Shift+R
Clone/Pattern Stamp tool	S
Rotate Clone/Pattern Stamp tool	Shift+S
Type tools (Vertical/Horizontal)	T
Rotate Type tools (Vertical/Horizontal)	Shift+T
Shape tool	U
Rotate Shape/Line tools	Shift+U
Move tool	V
Magic Wand tool	W
Switch Colors	X
History/Art History Brush	Y
Rotate History/Art History Brush	Shift+Y
Zoom tool	Z
Zoom In	Cmd+Space
Zoom Out	Opt+Space

Custom shortcuts

There are many Photoshop commands that do not have a shortcut, especially in the Filters menu. You can create a custom shortcut for any item in the palette by clicking on its name. It will be highlighted and a box will appear in which the shortcut is entered. However, this is not as simple as it sounds, as the most likely sequence of letters will probably have been used by an existing shortcut. While you may eventually find an unused shortcut, it is easier to overwrite a preexisting one that you are unlikely to use. For example, to give the Surface Blur filter a shortcut, look through the list of existing shortcuts and choose one you don't use often, such as Auto Color (Shift+Cmd+B), and type this into the space. A warning will come up in the palette to alert that this is in use and that the old shortcut will be lost if selected. Providing you agree to this, click Accept. You will now be able to use Surface Blur directly by typing in the new shortcut.

Shortcuts For:	Application Menus		
Application Menu Command	Shortcut		Accept
Shape Blur...			Undo
Smart Blur...			Use Default
Surface Blur...	Shift + ⌘ + B		
Brush Strokes>			Add Shortcut
Accented Edges...			Delete Shortcut
Angled Strokes...			Summarize...
Crosshatch...			
Dark Strokes...			
Ink Outlines...			

⚠ Shift +⌘+B is already in use and will be removed from Image> Adjustments > Auto Color if accepted.

LEFT
Creating a keyboard
shortcut for a filter
such as Surface
Blur allows it to be
used instantly.

As well as the creative skills and technical knowledge that a professional photographer should possess is the ability to understand and satisfy the demands of clients. Most commissioned photographs are taken for a specific purpose; in the case of advertising photography, to an exact and predesigned brief. Documentary and fine-art photographers may have more autonomy to produce work on their own terms, but they too have to satisfy a client, be it a picture editor, gallerist, or collector.

BELOW
Many commonly used sizes for photographic reproduction and printing date back to the original sizes in which conventional photographic paper was sold. This chart compares the required file size for normal print reproduction (300ppi); extra-fine (600ppi); and online (72ppi).

Before the digital era, photographs were usually supplied to clients as prints or transparencies, and this is where the photographer's responsibility effectively ended. Once the client had accepted and approved the work, it was the duty of the designers and reprographic printers to ensure that the photographs were properly reproduced. Prior to the early 1980s, when desktop publishing revolutionized the printing industry, prints had to be rephotographed onto sheets of film through a dot screen, which was then used to etch printing blocks. With the introduction of optical, electronic scanning, photographs were instead converted to a digital file that could then be used within a page design.

It is now the photographer's duty to supply files of their photographs, which in most cases will have been digitally processed and manipulated. This has become an important aspect of working with clients: not just to provide the images, but to provide them in a form that is practically ready for reproduction. Even photographers who prefer to shoot on film usually have a responsibility to organize scans and process the work in Photoshop. Many film-based photographers invest in a high-quality scanner such as the Imacon Flextight, which (after a period of time) becomes more economic and convenient than outsourcing scans to a professional lab. This is particularly true for photographers supplying work to picture libraries, who have very exact requirements as to the minimum acceptable file sizes and resolution.

File sizes and resolution
In general, digital images supplied to a client should be as large as possible, (unless a particular size has been requested) and, if interpolated from a smaller file, should show no loss of quality. A TIFF or PSD document with a resolution of 300ppi will be suitable for most methods of reproduction. An uncropped image supplied from a 12-megapixel camera, shot at 300ppi, will provide a 36MB file. Its dimensions in pixels would be 2,890 x 4,351, which would allow it to be reproduced at 9.6 x 14.5in (24.5 x 36.9cm) or at 100% magnification. In most instances, this

PRINT SIZE REQUIREMENTS IN PIXELS

Print Size	72ppi	300ppi	600ppi
4x6in (10.2x15.3cm)	288x432 (364.5KB)	1,200x1,800 (6.18MB)	2,400x3,600 (24.7MB)
5x7in (12.7x17.8cm)	360x504 (531KB)	1,500x2,100 (9.01MB)	3,000x4,200 (36MB)
8x10in (20.3x25.4cm)	576x720 (1.19MB)	2,400x3,000 (20.6MB)	4,800x6,000 (82.4MB)
A4 (21x29.7cm)	595x842 (1.43MB)	2,480x3,508 (24.9MB)	4,960x7,016 (99.6MB)
11x14in (27.9x35.6cm)	792x1,008 (2.28MB)	3,300x4,200 (39.7MB)	6,600x8,400 (158.6MB)
12x16in (30.5x40.6cm)	864x1,152 (2.85MB)	3,600x4,800 (49.4MB)	7,200x9,600 (197.8MB)
A3 (29.7x42cm)	842x1,191 (2.87MB)	3,508x4,961 (49.8MB)	7,016x9,922 (199.2MB)
16x20in (40.6x50.8cm)	1,152x1,440 (4.75MB)	4,800x6,000 (82.4MB)	9,600x12,000 (329.6MB)
A2 (42x59.4cm)	1,188x1,692 (5.75MB)	4,950x7,050 (99.8MB)	9,900x14,100 (399.4MB)
20x24in (50.8x61cm)	1,440x1,728 (7.12MB)	6,000x7,200 (123.6MB)	12,000x14,400 (494.4MB)
A1 (59.4x84.1cm)	1,692x2,376 (11.5MB)	7,050x9,900 (199.7MB)	14,100x19,800 (798.7MB)

could easily be interpolated up to 125% or more with little loss of quality. If a file had to be supplied at a predetermined size of 10 x 8in (25.4 x 20.3cm), a photograph taken on such a camera could be successfully cropped and reproduced with no need for interpolation. At 300ppi, the dimensions, when cropped, would amount to 3,000 x 2,400 pixels, resulting in a 27.5MB file.

In reproduction, an image is printed as a series of dots that are measured, like inkjet printers, as dots per inch (the abbreviation "dpi" should not be confused with "ppi"). Newspapers print with fewer dots per inch than magazines. This effectively lowers print quality, but allows an image to be reproduced larger. Any perceivable distortion caused by increasing the file size would be lost (up to a limit) by the coarseness of the print. However, if the same image were reproduced in a fine-art book, which would be printed at a higher dpi than standard magazine reproduction, the file size would be more critical and ideally not enlarged. Just as when traditional photographic prints were supplied as finished work, the adage remains that it is always easier to reduce an image in reproduction than enlarge it.

Even though the specifications for DSLR cameras may seem impressive, the increased size of the sensors used in larger-format digital cameras (as well as digital backs) will provide far larger files, which is often essential for high-quality work. The cost of such equipment can be quite prohibitive to many photographers, so this equipment is often hired as needed (this cost can usually be charged to the client). Predigital, photographers were usually expected to own most of their equipment, which paid off because professional film cameras lasted for years, and sometimes decades. Photographers who have moved from analog to digital may have had to replace or upgrade their digital equipment at least once in the last five years, whereas a fully manual Hasselblad camera, taking 120 medium-format film, will probably work perfectly after 25 years.

Although cameras can capture increasingly higher file sizes, film should not be forgotten. Many of the leading fine-art photographers producing extra-large format prints, which can sell for thousands of dollars, still choose to shoot on film. The detail possible and the quality of enlargement from a sheet of 5x4 or 10x8 film still surpasses digital technology, although often the print will be scanned and manipulated in Photoshop before being printed onto conventional photographic paper using a digital RGB laser printer such as a Lambda or Lightjet machine.

Color management
Color management is now an important issue for photographers, and it means they often have a better understanding of profiles and color spaces than their clients. Ensuring a digital file is ready for reproduction is now more the photographer's responsibility, and it is naturally in their interest to see the image properly printed. Even though an image will ultimately be reproduced using CMYK inks, it is not advisable for photographers to convert to this format in Photoshop, even if specifically requested by a client. Instead, the finished files should be supplied in RGB.

Any changes or manipulations you make in Photoshop should be done in RGB, as it has a wider gamut, while for most forms of printing, the file must be in CMYK. To make a correct conversion, it is essential to know how an image is printed. The dots that form a reproduced photographic image contain different levels of cyan, magenta, yellow, and black ink, having been converted from levels of red, green, and blue. While a conversion, such as changing RGB to CMYK in the Mode submenu found in the Photoshop Image menu, will be purely mathematical, it can only be done with an assumption of how much of each color is required. It does not take into account the diversity of inks, printing presses, and, most importantly, the paper stock. A high-gloss, bright white paper, used for a museum catalog, requires different types of ink, set to different levels, than newsprint, which is softer, warmer in tone, and more absorbent. Photoshop can perform a generic conversion, and there are different standard profiles for use in Europe, Japan, and the US. However, a skilled reprographic printer should be able to select, or sometimes create, the correct color space, depending on how the work is to be printed. Sometimes they will even have to convert individually selected colors in Photoshop that they know are likely to be out of the range of the inks used, by manipulating the saturation of color as required.

RIGHT
When delivering work,
a CD cover is useful
for identifying the
images contained.

Supplying files

Digital photographs consist purely of data—a binary code of information that can be decoded precisely on any computer running the correct application. Because of this, the transfer of information from photographer to client can be made in several forms. A relatively fail-safe method is to burn the images onto a disk, either CD or DVD depending on the number of photographs. The disk can be posted, sent by courier, or delivered by hand, ideally with match prints (see pages 160–161) to give the printers a guide as to how the images should appear once reproduced. Alternatively, if you are meeting the client in person, you could download the work directly from an external hard drive, or (as is often the case for press photographers) straight from a camera.

The photographer may want to edit the images with the client, who may be a picture editor, designer, or art director, so they can both agree (or maybe not) on which are the best shots. Sometimes the client will want complete control to edit from all the shots taken; on other occasions, the photographer can make an initial edit first before submitting any images. This is particularly common in editorial fashion photography, where the photographer usually has a high degree of artistic control. The fees for this work are usually lower than for fashion advertising photography, where the photographer will usually be art-directed, have to work to a tight brief, and then await ultimate approval from the fashion house.

Electronic transfer (that is, sending digitized images over a telephone line) has a heritage far older than digital photography. Even in the 1930s it was possible to transmit a small monochrome image, suitable for very basic newspaper reproduction, "down the wire," although it could take several hours. Although the speed of transmission has greatly increased, until recently separate ADSL lines were required to send large digital files. Now, however, with broadband connections, most images can be sent using conventional telephone lines. In many cases, images can easily be sent as an email attachment, although it is often more efficient to use an FTP (File Transfer Protocol) service, where files are uploaded and stored on a separate server. These can be downloaded after a link and password has been forwarded to the recipient. The system will allow multiple downloads, although for most commercial applications a secure and private transmission is desirable. Large labs and digital bureaus offer this as a bespoke service; a complete shoot can be put online as "digital contacts," allowing a client or photographer to edit with ease, order prints, brief the lab on what is to be retouched, or request a CMYK conversion for reproduction.

Alternatively, many companies provide a free storage and download service, although each upload may be limited to a maximum size (typically 100MB), and the number of downloads per hour will be restricted. Nevertheless, this is a convenient solution for sending large individual files at no cost, and if the volume of transfers increases, the service can be upgraded to a paid account.

To speed transmission times, TIFFs can be saved as LZW files. This is a lossless method of compression (named for the program's inventors, Lempel, Ziv, and Welch) that saves the file at a third of its original size, although it will open at full size. For online usage or to send a smaller file for client approval, JPEGs can of course be emailed in seconds (see pages 142–143).

BELOW
When using an FTP service, files can either be sent separately, or multi-uploaded to send several in one transmission.

Protection

Protecting individual copyright is a very important issue. When work is commissioned, an agreement should be reached between photographer and client, ideally as a written contract, to list the terms of usage, the geographic locations where it can be used commercially, and for how long. This is an established work practice. However, due to the reproducible nature of digital photography, and the possibility of work being downloaded from the internet, stricter controls need to be taken to ensure that copyright is upheld.

Unless part of the agreed contract states that copyright will be given (or sold) to the client, it will always belong to the photographer. You need to take as many steps as possible to protect yourself, should you ever need to prove that work used illegally belongs to you.

Before the digital era, when a print was sent out, it was common to stamp the back, especially if it was being released by an agency. This would state the name and contact details of the copyright holder, and often request that the print be returned to the given address. Similar information can be embedded into a Photoshop file as metadata. This can list the photographer's details, state that the image is under copyright, and provide captions. Technical details concerning the camera, exposure, and time and date of exposure are also listed. This is all found in the File Info palette, which is opened from the File menu. There are various fields that can be entered, including Document Title, Author, Description, and Keywords, as well as a dropdown list to set the Copyright Status. When you choose Copyright, the © symbol will be added to the file name, which will be visible at the top of the image window whenever the file is opened. Under Copyright Notice, you can enter further information such as "© Mike Crawford 2008. All Rights Reserved." Below this is Copyright Info

ABOVE
When you use a watermark, it should be noticeable without dominating the image.

RIGHT
You can use several watermarks on a single image.

URL, in which you can enter a weblink, either directed to your own or your agency's homepage, or to a specific copyright notice on your website. It should be mentioned that another party could easily change this information in Photoshop. However, if you provide it in the first place, it will show anyone considering infringing copyright that you are serious about your rights and ownership.

Watermarks are often used on online images to deter people from downloading the image. These usually appear as a faint line of text, a logo, or the copyright symbol. You can create a watermark by creating a text layer, typing the information, usually in white,

or importing a symbol, and then reducing the Opacity of the top text layer so the words are not too obtrusive. There is a fine balance when doing this between allowing the image to be seen properly despite the watermark, and making the watermark so small that it could easily be removed with the Clone Stamp or Healing Brush. Alternatively, you could use a smaller watermark that is repeated all over the image. Both this, and applying the © symbol in File Info, can be set up together as an Action for files of the same size and orientation, and then applied when necessary or used as a Batch.

For increased protection, additional programs are available that embed copyright information within a file that can be traced if the image is used on an unauthorized website. Photoshop features a plug-In called Digimarc (found at the bottom of the Filters menu) that can either add a watermark that is visible online or one that is imperceptible when viewed on screen, but can still be traced by the photographer. It also provides copyright information to a potential buyer, and, similar to File Info, supplies a URL to link a potential buyer to the photographer.

LEFT AND BELOW
File Info embeds metadata in the Photoshop file; this can contain captions, keywords, who to credit, contact details, and copyright notices.

Although most professional photographs are shot as RAW files, the majority of photographs taken on digital cameras throughout the world (including on cellphones) are recorded as JPEGs. Methods of presentation and display within the consumer market have changed, and fewer prints are being made today because of the popularity of online galleries and image-sharing websites. Photographs are often taken, perhaps sent with an email, but never printed. Because of its compression, a digital photograph in the JPEG format is ideal for sending online or posting on a website, though often its quality suffers and the image looks noisy and distorted. This often occurs when a JPEG is saved as a JPEG. Each time it is copied, further compression reduces the quality.

However, if JPEGs are made correctly, they can be used online and retain good image quality while still being a relatively small file size. (As a JPEG is saved at 72ppi, which is the same calibration as a computer monitor, JPEGs appear fine on screen, but would appear pixelated if printed.) This is especially important for photographers' websites, where a potential client or buyer will consider not only the aesthetic quality of a photograph, but also how the image appears technically. Photoshop's Save For Web command is designed to provide JPEGs at the maximum quality but at the smallest image size to allow for quicker uploading.

When you open the Save For Web window, there is a choice of four screen settings to contrast the original file and how it will appear once converted to a JPEG. Original shows the photograph as it is, and Optimized after the compression is applied. It is probably more useful to select 2-Up, which shows two versions of the photograph side by side as a before-and-after comparison. At the bottom of the window is a dropdown menu to change the size on screen. Fit On Screen will show the complete image—if only an enlarged section is visible when using a high percentage setting, move the image using the Hand tool from the small toolbox on the left of the window. Directly beneath each image its file size is displayed in MB or KB. The right-hand Optimized image also displays a projected transmission time. The 4-Up mode also shows images at higher

and lower rates of compression as well as the Original and the Optimized image as it is currently set.

These settings are controlled at the right of the window. The quality of JPEG is either set from a small list from Low to Maximum, or by moving the Quality to an exact percentage. There are also presets that include the PNG and GIF formats specially used for illustrations. As the size is changed, the quality and transmission setting will change beneath the optimized images. If you need to make a JPEG a particular size for a website, it is advisable to use the Image Size box beneath these settings. Enter the height and width as pixels and the JPEG will reduce to the correct size. The Quality settings above will still affect the quality of the compression, but not the number of pixels. When making a JPEG, you need to decide

RIGHT
Save For Web enables you to make accurately sized JPEGs, although the quality of compression can be changed to allow faster transmission times. The viewing window can be set to show a single photograph, or—as in this example—two before-and-after images.

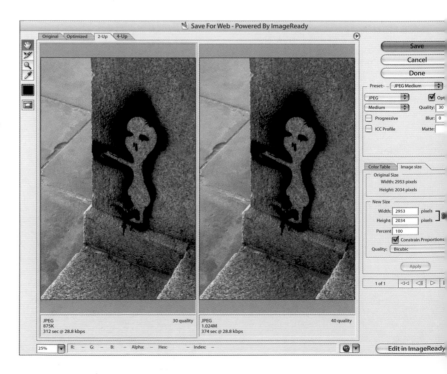

LEFT AND BELOW
The resolution of a
JPEG should look fine
on screen, although it
will deteriorate in
quality if enlarged.

on the balance between the best
possible quality on screen and the
extra time it will take for the image
to appear on the website page
(although this is less of an issue now as
most sites are viewed via broadband).

Alternatively, if you require a simple
JPEG, with no set image size, you can
do this easily using Save As from the
File menu. Select JPEG from the list of
Formats and choose a Quality
percentage before saving. It is useful
to make a selection of different-sized
JPEG conversions as Actions (see
pages 116–117) so you can use these
quickly when required, or apply them
to a folder of images as a Batch.

SECTION 4

PRINTING

BELOW
If printing a large volume of work on a smaller printer, a continuous ink system significantly reduces the cost of inks.

RIGHT
Although large inkjet printers require far greater quantities of ink, the cost will be proportionally lower than buying smaller cartridges for smaller desktop printers.

The sophistication and quality of inkjet printing has developed rapidly in the last 10 years, although the cost of printers has effectively dropped in price. While this makes it easier for photographers to invest in the latest printing technology, the cost of ink can be relatively high. It is worth noting that inks tend to be cheaper when bought in large quantities for the bigger machines.

When buying inks, there are three main options. Manufacturers, such as Canon, Epson, and Hewlett Packard, recommend their own brand of ink sets, which are specifically formulated for their own machines. Used properly, these will provide excellent results.

The second option is to use smaller companies, such as Lyson and Piezo. They make high-quality inks, often at slightly cheaper prices. They can also supply continual ink systems that

contain large bottles of ink, housed outside of the printer, which provide substantial savings when printing large volumes of work. Some photographers prefer to use these inks, especially black-and-white specialists, although in recent years there have been many technological improvements with the monochrome inks supplied with larger printers. It is common now for printers larger than A4 (8¼ x 11¾in) to have eight or nine inks, including three types of black. While a standard printer uses

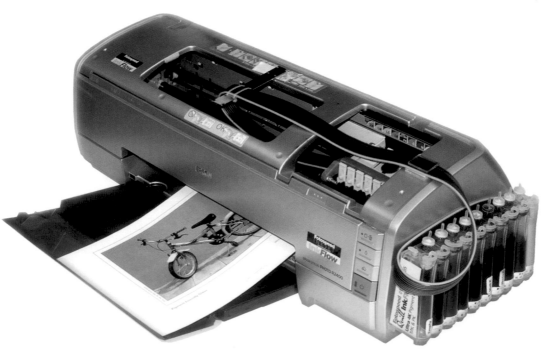

one black and a cyan, magenta, and yellow ink, a larger machine may use: black, light black, light light black, cyan, light cyan, magenta, light magenta, and yellow. For both the major and specialist firms making inks, the inks' longevity is as important as their print quality, and much research has been done to ensure that prints made today will not fade or discolor.

The last option is to use cheap inks sold by lesser-known companies, often in refillable cartridges. It is best to avoid these, as their colors may not be accurate or light-fast. According to the terms and conditions of a printer's warranty, a guarantee may be affected if third-party inks are used

(although this is now being questioned as unconstitutional, under US law at least).

In general, inks fall into two categories: dyes and pigments. Most inks for general use are dyes, in which concentrated ink is dissolved in water. Pigment inks have microscopic particles of colored pigment suspended in a chemically inert solvent. Dyes can provide a slightly wider range of colors than pigments (the range is known as its "gamut"), but are not considered to be archival. Professional-quality ink today tends to be made from pigment, whereas dyes are used more for cheaper office printers.

BELOW
A prepared file with color and monochrome images as well as block colors is useful for testing new inks and papers.

DATE _____

PAPER _____

PROFILE _____

PRINTER _____

COMMENTS _____

Choice of paper is as important as choice of inks when making digital prints. There is a wide variety of materials available, with many different surfaces. The major companies making inkjet printers all produce their own papers, although it is often the smaller names, making specialist papers, that produce more interesting and often higher-quality results.

Standard papers tend to have either a glossy or matte surface and are relatively lightweight, between 120 and 200gsm. (Paper weight is measured in grams per square meter; standard office paper is 90gsm.) While these may be fine for making reports and presentations, the gloss papers tend to have a very high surface sheen, whereas matte often produces

a quite dull and flat print and is best avoided for fine photographic work. These papers will make acceptable prints—good enough for proofs and contact sheets—but specialist papers give prints a more distinctive and individual appearance.

Specialist papers are aimed at photographers producing prints for commercial clients and for sale in galleries. Among the companies making such papers are Da Vinci, Fotospeed, Harman Technology, Hahnemühle, Innova, and Permajet. The papers tend to be heavier—about 300gsm (although Hahnemühle produces a smooth fine-art paper of 460gsm). There are also some thinner papers available. These have the same high-quality surface, and are ideal for placing in sleeves in a portfolio. Double-sided papers are particularly useful for making bespoke books and folios.

ABOVE
All digital papers have different coatings to ensure that ink is applied evenly.

RIGHT
While watercolor paper can be used quite effectively for printing, the ink will be absorbed into the paper and will appear softer and less saturated.

Specialist papers are also available in matte and glossy, but have a far more luxurious feel and better color saturation than their standard counterparts. Many are modeled after traditional fiber-based darkroom papers, often using the same paper base. This is particularly true of the gloss papers: these do not have a plastic sheen, but instead look similar to exhibition-quality black-and-white photographic paper. As well as being ideal for monochrome photography, they give color prints the same surface and depth. Needless to say, these papers are more expensive than standard materials (often twice the price), but there should not be too much wastage if the computer and printer are properly color-managed (see pages 154–159).

Other surfaces can be more textured, sometimes resembling rough watercolor papers, and are often used by artists selling prints of their paintings or artworks. All inkjet papers are coated with different layers so they receive the spray of ink evenly. This also helps to produce prints with better definition, color, and contrast. If an uncoated paper, such as normal office stationery, is used, the intensity of color will be reduced, and the inks will often bleed into the paper, producing a smudged print. As an alternative to inkjet paper, uncoated art papers can sometimes be used for a print with a softer rendition, but you will need to use a Hue/Saturation adjustment layer to increase the intensity of the colors. Indeed, it was photographers and printers using these uncoated watercolor papers in the late 1980s with Iris printers (an earlier method of high-quality inkjet printing) that led to the production of specialist inkjet papers in the first place.

ABOVE
Although many papers are advertised as drying instantly, it is still advisable to spread a batch of prints out to ensure they are fully dried before stacking them together or placing them in frames or folios.

Print/Print with Preview window

When you are printing, Photoshop offers a number of controls to fine-tune how an image is presented on a sheet of paper. Take care at this stage to make sure the image is properly positioned and complemented by the choice of border. This is all managed from Print in the File menu or, on versions of Photoshop prior to CS3, Print with Preview.

Before you make any changes, select Page Setup from the File menu, or access it directly from the Print window. This will ensure that the right printer is connected, the page size is set, and the orientation of the print, whether landscape or portrait, is correct. Image size can be enlarged or reduced under Scale, although this is best done in Print.

On the left of the palette is a representation of how the image will appear on paper; any changes made to the image size or its borders are shown in this box. The main considerations are the position of the image and its size. When opened, the photograph is displayed centered on the page, its size determined in Photoshop. Under Position, you can change this by typing new settings for the border's measurement, or by clicking on the image in the Preview box and dragging it to the desired position. You have to untick Center Image first. As you move the position of the photograph, the measurements in the boxes will change automatically.

There are several ways to alter the size under Scaled Print Size. You can change the percentage from the default 100% setting, or enter exact dimensions under Height and Width. These are linked together so only one measurement need be given. If the print has to be as large as the printing paper allows, tick Scale to Fit Media and it will be enlarged to the maximum printing size. Alternatively,

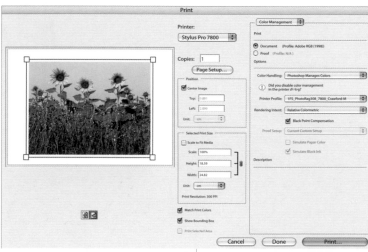

ABOVE AND RIGHT
The Print window will allow many changes to be made to the presentation of the print. Earlier versions of Photoshop use the very similar Print with Preview.

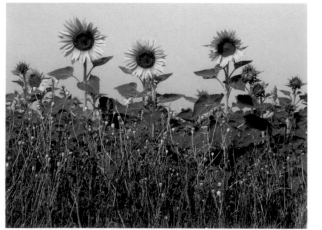

click on one of the bounding boxes of the image and drag it diagonally to enlarge or reduce it.

On the right of the window is a dropdown menu with settings for Color Management (see pages 154–159) or for Output, which enables more modifications to be made to the presentation of the print. Many of these are guides for designers and printers concerning reproduction. However, Background is useful if a color is required on the sheet of paper instead of a normal white. This opens the Color Picker to select the tone that will appear in the Preview box and on the print. Border is a very convenient option that adds a keyline to the

photograph up to 3.5mm in width. Having made all these changes, click Print to see the finished result.

BELOW
Page Setup should be used before printing to ensure that the right printer is connected, and the orientation and size of the paper is correct.

BELOW
A border and background color were added from the choices in Output.

The layout of the print is controlled in the Print/Print with Preview palette, but the final settings regarding resolution, color management, and specified paper type are made in the Print dialog box that appears when Print is clicked. There is a bar for the choice of printer at the top of the box. If software is installed for more than one printer in the computer's Applications folder, you will need to select the correct model from this dropdown menu. It is possible, providing there is enough RAM available, to have different printers running at the same time.

The control for Print Settings is found in the dropdown list at the bottom of the box. Within this, choose the type of paper you are using from Media Type. The number of choices will depend on the sophistication of the printer. Cheap desktop printers will list a few standard surfaces, while large-format printers used for producing fine-art prints will have a large variety, such as Photo Quality, Archival Matte, Textured Fine Art, and Singleweight Matte. It is important to match the setting to the correct paper, as it will change the distance from the ink nozzles to the paper, and can therefore result in either over- or undersaturated prints or possibly an uneven spray. Color is chosen next. This is normally set to Color unless you require pure black ink. Larger printers have an Advanced Black and White setting for fine control of monochrome printing (see pages 164–165). Lastly, Mode controls the fineness of the print. There are three choices, although you should choose Advanced Settings to enter the correct resolution. Depending on the printer, the output quality can be set to 360, 720, 1,440, and 2,880dpi (dots per inch). This should not be confused with pixels per inch, which is the resolution of the digital file. You can save a particular setting for a certain paper at a set resolution in the list of Presets by selecting Save As from this dropdown list.

Print

Printer: Stylus Pro 7800

Presets: col archival matt 1440

- Photo Quality Ink Jet Paper
- Singleweight Matte Paper
- Doubleweight Matte Paper
- Enhanced Matte Paper

Page Setup:

Media Type: ✓ Archival Matte Paper
- Watercolor Paper – Radiant white
Color: - Textured Fine Art Paper
- Velvet Fine Art Paper
Mode: - UltraSmooth Fine Art Paper
- Canvas
- Enhanced Matte Poster Board
- Plain Paper
- Plain Paper (line drawing)
- Singleweight Matte Paper (line drawing)
- Tracing Paper

☐ Flip Horizontal
☐ Finest Detail

? | PDF ▾ | Preview | Supplies... | | Cancel | Print

Dpi expresses how much ink is sprayed onto the paper. However, if an inch of a print were examined under a strong magnifying glass, you would not be able to isolate and count 1,440 separate ink drops. The drops are sprayed to overlap and appear as a random pattern, which gives a more realistic and photographic rendering in a print. 1,440ppi is recommended for high-quality work, especially if the print is quite small and will be looked at closely. The print medium will make a difference; papers with a strong texture can probably be printed at a lower setting. This will depend on the quality of the printer as well, so you should make tests at different settings. If two A2-sized (16½ x 23½in) prints of the same image were made at 720 and 1,440ppi and examined at a normal viewing distance (3–6ft/1–2 m), there would probably be no discernible difference providing the ink heads were clean. On closer inspection, the ink spray may be detected on the lower resolution. Occasionally the highest setting may be required—although be warned that the printing time will double with each increment in quality. This will slow down printing times considerably if using very large-format printers.

ABOVE AND LEFT
Choose the most appropriate paper description from Media Type in Print Settings. When trying a new paper, especially one with a matte surface, it's worth experimenting to find which is the most suitable paper setting.

BELOW
If you are likely to use a particular print setting again, choose Save Preset As from the list of Presets in the Print dialog box. Give the setting an appropriate name, and press OK.

Print

Printer: Stylus Pro 7800

Save Preset

Save Preset As:

col archival matt 1440

Cancel | OK

? | PDF | Preview | Supplies... | | Cancel | Print

Before looking at the finer details of inkjet printing, we should consider the subject of color management. This is a system used to control and unify the range of colors that are recognized and reproduced by all the digital equipment used by a photographer, from shooting to final output as a print or a reproduction in a magazine or book. This involves calibrating and setting the color controls of a camera, scanner, computer monitor, and inkjet printer. While this is relatively straightforward as a concept, in practice it can be difficult to achieve without a good understanding of color spaces and profiles.

Color spaces

The color space to which a camera or monitor can be calibrated represents the complete range of colors that each device can hope to record, display, or reproduce. Known as a "gamut," a color space is usually an industry-recognized standard such as sRGB, or—more common with digital photography—Adobe RGB (1998). When seen diagrammatically, the range of possible colors blends from a primary color to a secondary and then back to another primary. Within this color range, almost any shade of color can be found. The colors shown in such a diagram are a visual representation of digital information, each color being a mathematical calculation of different levels of red,

ABOVE
This illustration shows a representation of the possible colors within an RGB color space.

RIGHT
A CMYK color space, which has a smaller gamut, is shown within the same RGB space. The colors placed outside the CMYK color space will not be reproduced or printed accurately.

CMYK
COLOR SPACE

green, and blue. (This is what allows the same color space to be recognized by different devices; see pages 18–19.) However, when a digital image is reproduced as an offset litho print, for example in a magazine, or it is printed on an inkjet printer, the RGB color space has to be converted to CMYK. This uses a different color space, and—as the diagram shows—the CMYK space is smaller than the RGB. This discrepancy arises because transmitted light (which is how we view an RGB image on screen) can display far more colors than a print reproduced from four different colored inks. Colors that cannot be accurately printed or reproduced are referred to as "out of gamut."

ICC profiles

A color space is assigned and recognized by a digital coding known as an ICC profile (abbreviated from the International Color Consortium, an industry body founded in 1993 by several leading digital companies to set universal color-management standards). A Photoshop image will usually be set to Adobe RGB (1998), which ideally will be the same profile setting for the camera or scanner. If not, Photoshop will show a window when opening a file to ask if it should be converted to this "working" profile (see pages 30–31). However, successful color management demands that separate profiles are generated for the monitor, to view the image on screen, and also for the printer, so it can reproduce the color range as accurately as possible. Although these will be different profiles, their aim is to match the different codings so the same color space is used throughout the digital workflow. The steps on the following pages should help you to ensure successful color management.

RIGHT
From Printer Profile in the Print with Preview window, (or the Print window in CS3) you can choose the correct profile from all those stored in the Color Sync library.

Dot Gain 20%
Dot Gain 25%
Dot Gain 30%
Gray Gamma 1.8
Gray Gamma 2.2

1290 IlfordSmooth Pearl pg D65
1290 Pearl Fontonic D65
1307. icc
✓ 1FS_EGDWFB_7800_Crawford
2002-11-15-G2.2 D65
3307.icc
CIE RGB
CPLD 7800 Fotospeed DW matte
CPLD 7800 hahnemuhle 1
CPLD 7800 Ilford Gallerie pearl
CPLD 7800 Olmec Glossy
e-sRGB
electr19b3
electr19b3 -26/2/07
electr19b3_1.icc
EPSON Adobe RGB (1998)
EPSON Apple RGB
EPSON CIE RGB
EPSON ColorMatch RGB
EPSON NTSC (1953)
EPSON PAL/SECAM
EPSON SMPTE–C
EPSON sRGB Color Space
EPSON Wide Gamut RGB
Generic RGB Profile
HarmanMatteFB
HFA78-9800PhotoRagMK
HFA78-9800PhotoRagPK
IGSPP9_E789800 PSGPP_1105v05.icc
LD Epson7800 Harman Matte FB
LD Epson7800 Harman Matte FBv2
Monitor_10-6-06_1
Monitor_11-3-05_1

Monitor calibration

Ideally, clients, designers, reprographic houses, and anyone else who may view your work on screen will also be operating within a fully color-managed workflow. This will mean that the finished image should appear with the same degree of precision on other computers. Problems can arise when the color balance or contrast of a file that you supply is changed by a client or designer because their own monitor is not calibrated correctly.

Computer monitors must be carefully calibrated to ensure that the color and contrast they display is accurate. All computers have inbuilt calibration controls to change the color settings; although these can give very good results, you should really use a separate screen calibrator. This is a small color-sensitive measuring device, supplied with its own software, which when placed on the screen runs through a series of tests on color

ABOVE AND RIGHT
A monitor calibrator is essential for accurately calibrating computer monitors and scanners.

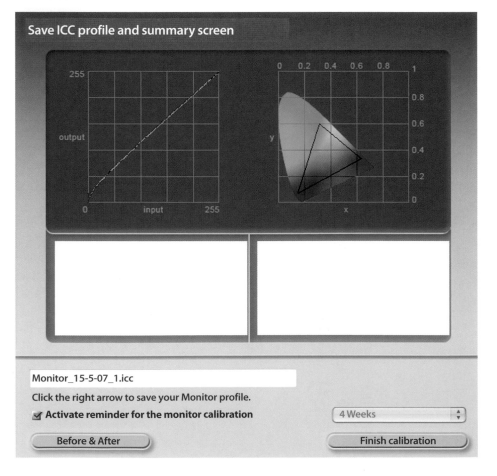

Save ICC profile and summary screen

Monitor_15-5-07_1.icc

Click the right arrow to save your Monitor profile.

☑ **Activate reminder for the monitor calibration**

4 Weeks

Before & After

Finish calibration

swatches projected on the monitor. These will be recorded and analyzed by the software, which will change the levels of brightness for the three separate color channels. This is saved as a new profile in the computer's Color Sync library, which will then be used each time the computer and monitor are switched on. However, color settings on monitors will shift slightly; if you are in front of the screen almost every day, you may not notice this as the change will be very gradual. The monitor should be calibrated regularly to ensure that it stays accurate—once a month is

recommended for LCD screens, and at least every two months for CRT. A reminder can be set in the calibrator's software so a warning window appears when the time is due.

Consideration should also be given to viewing conditions. If a monitor is used in a room with no other lighting, the contrast and brightness of an image on-screen will differ from one used in an overly bright room, especially if it is placed near a window. Ideally, the ambient light should be at a slightly lower level than the light emitting from the screen.

A screen shade is a useful accessory, especially in a room with overhead lighting. Many calibrators take into consideration the brightness and color temperature of the viewing conditions, as well as the color of the monitor.

BELOW
A supplied color chart has to be printed accurately, with no color management, to be assessed for creating a custom profile.

i1 TC 9.1B RGB Testchart part 2

Printer profiles

One of the prime concerns of color management is to ensure that an inkjet printer (or any other output device) produces very accurate results. A file may be saved with an industry-standard profile, having been viewed on a properly calibrated monitor, which is fine if this is going straight to a client, but if a print is required, either as a guide to a designer or as finished artwork, and the inkjet printer is not calibrated, it may take several wasteful attempts changing color and contrast settings each time to get a good print. Again, a separate profile has to be used, so

the printer can take the Adobe RGB color range and convert it to correspond not only to the printer, but also to the particular inks and paper that are being used. Even though papers may all look similar, they can vary in image color (from a cold to a very warm white), surface, and texture, which will affect the way the ink is sprayed on to the paper.

A printer's driver will be supplied with many generic profiles for using different papers, often with different ink sets, and these can be used to greatly improve the standard settings.

Similarly, because color management is such an important issue, many paper manufacturers supply readymade profiles for their products to be used with different printers and inks. These are usually found online and can be downloaded directly to the computer's profile library.

For greater accuracy, a profile can be made individually for each type of paper used. Although supplied profiles can give excellent results, individual printers can differ slightly, even if they are the same model. Making a profile involves printing out one or more color

charts that are analyzed with a photospectrometer (this is similar to a screen calibrator but measures reflected color as opposed to the monitor's transmitted color). Using these readings, a new profile is generated that adjusts the levels of ink outputted so they are much closer to the standard Adobe RGB color space.

Many photographers now buy the equipment required to make their own custom profiles, whereas others use the services of a lab or bureau. Some paper manufacturers offer this as a free service. When outputting the color

charts, the instructions for printer and profile settings must be followed accurately—they all differ slightly depending on the make of printer and the computer's operating system.

To use the profile, you first need to install it in the correct library, and then choose it from the Print with Preview palette before printing (see pages 150–151). In the Color Management section (which is accessed from Output if not already visible), Document should be highlighted in the Print section. This will show the working profile the image is saved in.

Beneath this is a larger section titled Options. Under the choices for Color Handling, select Let Photoshop Determine Colors. From Printer Profile, which is beneath this, you can select the correct profile from the dropdown list. There are four choices under Rendering Intent, which are selected depending on the color range (descriptions of each are given in the palette by holding the mouse over each word). Perceptual normally gives the most accurate colors for color photographic images.

After you have clicked Print, there are two more important settings to make. The Print palette will appear, and under Print Settings you should enter the same information regarding paper type and color that was set for the print charts. Lastly, in the Printer Color Management dropdown menu, select Off (No Color Adjustment). This ensures that the profile previously selected is used, and not a different one from the printer driver. Both of these settings can be saved as a Preset in this palette. With all this in place, the computer and printer should now be successfully color-managed.

OPPOSITE
Photospectrometers are used in several industries where color accuracy is important. A range of models is available for creating profiles to be used in digital photographic processing.

ABOVE
When using a profile as part of a color-managed system, it is important to ensure that the printer's color management is off, and to select the correct profile in Photoshop instead.

The technical capabilities of inkjet printers, which can produce prints from the size of a postcard to huge photomurals, have greatly improved over the last decade. Digital prints are now comparable to conventional methods of photographic printing, not only in quality but also in print longevity. The first professional printers were an offshoot of the reprographic printing industry, which had been using digital technology for many years before photographers. These printers were required for making proofs of pages or individual images in CMYK before the final job was printed on an offset litho press using the same color inks. Many of Photoshop's functions, including profiling and color management, come directly from the printing industry.

Although the effective cost of printers has come down, the cost of ink remains high. As ink is proportionally cheaper to buy the bigger the printer is, it could be worth investing in a machine capable of A2 (16½ x 23½in) prints or larger if office space allows. However, if you never make prints larger than A4 (8¼ x 11¾in) or A3 (11¾ x 16½in), a midrange printer is more practical. Even a cheap A4 printer can produce reasonable results, especially if the prints are being used only as a guide and not as finished artworks.

Printer maintenance

With up to nine ink heads, printers have to be looked after carefully to make sure they continue to work efficiently and that print quality does not suffer. The printer will be supplied with maintenance software that can run procedures to correct most problems. Ink nozzles are tiny, and clogging is one of the most common faults. A nozzle check and subsequent clean should correct any blockage, though it may have to be applied two or three times. If this doesn't work, a more thorough clean using special cleaning cartridges may be required. A printer used regularly should be less likely to suffer from clogging or ink

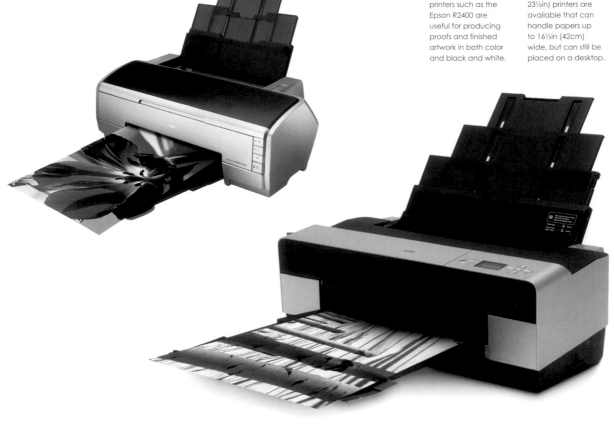

LEFT
A3 (11¾ x 16½in) printers such as the Epson R2400 are useful for producing proofs and finished artwork in both color and black and white.

BELOW
Larger A2 (16½ x 23½in) printers are available that can handle papers up to 16½in (42cm) wide, but can still be placed on a desktop.

drying. Switch the machine off when not in use so the heads are returned to protective pads that keep the nozzles clean.

Match prints

When photographers only had the option of shooting on film, prints had to be made from negatives for scanning before they could be reproduced, unless the job had been shot on transparency. Although most work today is supplied as digital files, prints are still often made (albeit on an inkjet instead of in the darkroom) specifically to show the printer or designer the expected quality of the final reproduced image. Known as match or aim prints, these are only useful if they have been produced on a properly color-managed system, as otherwise the print will not be an accurate reflection of the file's tonality. It can happen, however, that a client scans the print instead of using the file, which rather defeats the purpose of supplying the images on CD or DVD. To prevent this, it is a good idea to prepare a text document with words such as "match print only, RGB files supplied," next to your name; you can then print this on every match print you send to a client.

ABOVE
Maintenance is very important, and most printers have their own programs for checking and rectifying any faults.

RIGHT
A match print should give an accurate rendition of a file's expected color tonality, but it should also state that the print is just for reference and not to be reproduced.

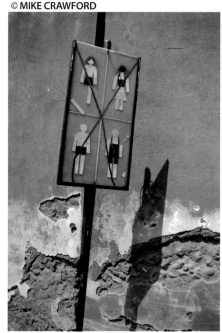

© MIKE CRAWFORD

MATCH PRINT ONLY; RGB FILE SUPPLIED

While a good printer, the correct inks, and the most suitable paper stock are essential to produce a fine print, visual awareness and an understanding of composition are also important skills. Using a color-managed system takes some of the guesswork out of printing and allows you to quickly achieve acceptable results. Without correct profiling, much time will be spent making color and contrast adjustments on print after print to try to match the image seen on-screen.

Even when using a profile there will be occasions when you need to make further modifications to a print. This is best done using Adjustment Layers, so the original file is not affected. Adjustment Layers can also, if required, be dragged and placed onto other images. An example of this would be using Hue/Saturation to deliberately lower the depth of color, giving a print a softer and more nostalgic rendition, or using Color Balance to add a particular color tone to a desaturated image. The skill of traditional photographic printing, especially black and white, has always been to interpret a photograph and produce a print that augments and improves the image, not just making a straight rendition of it. While most visual changes to an image are now done in Photoshop, it is sometimes possible to make further improvements when printing.

There is also a visual difference between looking at a print and seeing the image on screen. The print is viewed by reflected light, whereas the image on screen is seen by transmitted light. After a time, we become used to this discrepancy and make concessions for it when making adjustments. As an aid, there is a facility to see a "soft proof" on screen. This changes the tonality slightly to give the impression of how the image will appear when printed. In the View menu, select Proof Setup > Custom and enter the correct profile from a dropdown list. Choose Proof Colors, again from the File menu,

ABOVE
Large-format inkjet printers are ideal for producing fine-art prints up to A1 (23½ x 33in) or A0 (33 x 47in), depending on the model. Roll paper is used for prints larger than A2 (16½ x 23½in).

ABOVE AND RIGHT
While an image may look correct both on screen and as a print, there will be a difference in how each is perceived when compared together. One is viewed by transmitted light, the other by reflected light.

and the image will flatten to how the colors are anticipated to appear when printed. Using the shortcut Cmd/Ctrl Y, you can toggle the soft proof on and off as you manipulate the photograph in Photoshop.

It may be wasteful to print out a full-size print without any testing, especially if working on a large-format printer. Tests can be made in several ways. To save paper wastage, the image can be duplicated and cropped so just a strip—perhaps a quarter of the original photograph—remains. Adjustment Layers can be applied, and with each alteration, the image is printed on the same sheet of paper, moving the position of the strip each time using Print with Preview. This way, each stage can be viewed and directly compared to the previous one. When a strip looks correct, you can drop the Adjustment Layers onto the original file, which is then printed full-frame.

Alternatively, if it is important to see the full frame, you can make tests of the complete image at a reduced size,

perhaps at 25%. As the image starts to improve, you can increase the print size. Using this method, I often print two tests at 25% and the final test at 50%, all on one sheet of paper, before making the final print. This means I use only two complete sheets of paper. However, it is best not to limit yourself by trying to economize too much. Many prints will require very little testing, so these should compensate for all the tricky prints that take many attempts to get right.

As there is such a wide choice of papers, conducting some research into the most suitable surfaces will prove useful. Photography magazines regularly feature comparison tests on papers or reviews of new products. There are also several internet forums dedicated to digital photography that will offer many opinions and recommendations of different papers. Visiting a professional photographic shop that has samples of different papers on display may also be beneficial. Some companies produce sample packs containing a few sheets of several different surfaces or types of

paper that you could try out. However, the most practical way is to talk to fellow photographers, look at their work, and find out which papers they use.

Paper should be handled with care; the printing surface should not be touched before or after printing. Fingerprints on the paper base may prevent ink from coating evenly, and once printed, the sprayed surface will be very delicate, especially immediately after the print is made. Any dust should be removed gently with a very fine brush or with compressed air—do not wipe it off with a hand or a cloth. Some papers will need a short time to dry properly; it is probably best to assess a print at least 10 minutes after printing. If you are stacking prints together, putting them into sleeves, or framing them, many manufacturers suggest waiting for 24 hours until the print is perfectly dry and stable. For extra protection, use an archival protection spray.

ABOVE
Proof Colors is useful for previsualizing on screen how the colors will print depending on what profile is used. Before using Proof Colors, choose the profile by first selecting Custom from Proof Setup, and then highlighting the correct ICC profile.

RIGHT
Adjusting the position of a test strip in Print with Preview (or the Print window in CS3) allows you to print a series of comparable tests on the same sheet of paper.

If printing for exhibitions or portfolios, not only is the quality of print very important, but also the presentation of the image on the sheet of paper. Some photographers prefer large borders; others small. Some show the work trimmed flush, sometimes mounted onto foam board or aluminum to keep the print straight. The examples on this page show various possible methods, although personal choice will inevitably decide which is most suitable. Exhibitions usually benefit from the work all being presented in the same manner unless the images are by different artists.

ABOVE AND RIGHT
The same image printed with different-sized borders, or no border at all, will offer very different styles of presentation.

When printing, it is best to view prints under daylight conditions. This is especially important when supplying match prints to a client, as designers and printers will often use carefully balanced viewing booths to compare prints to the image on-screen. When printing, the room should not have any direct sunlight, (which is never consistent); daylight-balanced bulbs are recommended instead, if only used just in a viewing area. Prints can look different depending on the color of light (this is known as matemerism)—whether it is daylight, tungsten, or fluorescent. Inks, however, have

greatly improved in quality, especially for black and white, and there is less of a tendency now for monochrome prints made using CMYK inks to appear magenta under tungsten illumination.

Historically, some of the most classic photographs and expressive prints have been shot on black-and-white film and printed in the darkroom. Creating monochrome prints digitally requires special attention, and it has taken many years for black-and-white inkjets to achieve a quality close to traditional prints. Many photographers

and printers have preferred to use dedicated monochrome ink sets in the past, which gave better results than using CMYK or just a single black ink. Printer manufacturers have responded to this demand by increasing the number of black inks in their larger, professional models to include several different black channels, making it possible to produce both high-quality monochrome and color prints on the same machine without having to change inks.

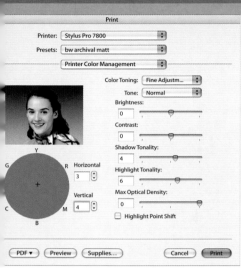

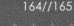

Epson printers with such inks now include an Advanced B&W Photo mode to give finer control. This is selected in Print Settings under Color, and the control palette is opened under Printer Color Management. This not only allows fine adjustment to be made to the Brightness, Contrast, and the Shadow and Highlight Tonality, but also the addition of a color tint by plotting a set point on the color wheel. If you apply this subtly, you can achieve a similar feel to warm- or cold-tone photographic papers. These will still be black and white, but with just a hint of tone in the blacks. Often this is done to either counteract or complement a

paper base with a noticeably colder or warmer tone. To create stronger-toned prints, it is advisable to print in full color using more conventional digital toning techniques.

LEFT AND BELOW
Advanced black-and-white print controls can fine-tune the depth of tone as well as changing the "color" of black to make either a warm- or a cold-toned print.

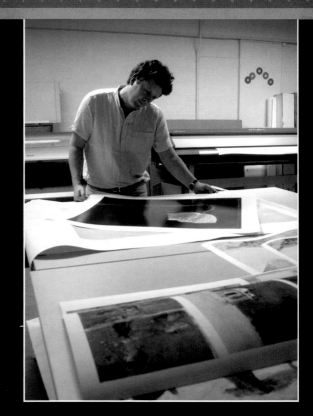

Ian Cartwright, Printer.
www.theprintrooms.com

The quality now possible from inkjet printing is in part due to the skilled work of printers such as Ian Cartwright, who for years have been involved in the research and development of the most suitable inks, papers, and machinery used.

Like many in the industry, Ian's background is in traditional photography, although he moved into working digitally in the late 1980s using Iris machines. These were used in the reprographic printing industry to produce accurate color proofs from digital files before the work went to press. Starting with the Iris, Ian explained to me some of the history leading up to the digital printers we use today. "I have always had an interest in all types of printing, not just photographic, although I began working in digital around 1988. The firm I was with took on the first laser copiers, and later the first Iris machines."

The printing industry used CMYK inks to produce color reproductions long before digital technology was introduced, so naturally the Iris worked using the same colors. "It is probable that development money came originally from NASA, as they required better quality prints from satellite pictures. Iris Graphics then took on this technology as a proofing machine for the printing industry," explains Ian. It was at this point that photographers and printers started to take notice of the quality of prints. "People like myself, Graham Nash, and Jon Cone

in the US encouraged them to develop it further as a fine art printer. From the point of view of a color photographic printer, I had been quite frustrated with the available technology. The possibilities of printing onto different papers led to my involvement in the development of digital fine-art printing, working closely with the manufacturers either to improve the archival qualities of inks, or to ensure the papers could receive the inks in a certain way."

The Iris print was the first major development in photographic printing for many years. As it was usually printed on a fine-art paper, there was less of a feeling of being "digital," and even appeared more handcrafted than a conventional photographic print. "There was a fantastic response to it among photographers as we

could print on to fine-art papers," remarks Ian. "This was at the end of the 1980s and even now inkjet printers are only touching the quality of the Iris. By the mid-90s I was doing a lot of work for artists, photographers, and architects, although there were issues over the longevity of the prints."

For a printer working with such artists, the archival quality of a print is extremely important. Ian and other printers soon became involved in testing new materials and advising ink and paper manufacturers on changes required to their products. "I got involved as an evaluator but also as a consumer for whom image quality and longevity is critical. To begin with, we printed on art papers with the Iris, papers made for litho or for etching. The problem was that in using noncoated cotton-based paper,

RIGHT
Whirligig Beetle
by Giles Revell
Ian worked closely with photographer Giles Revell on his series 'Insect Techtonics,' a body of work revealing the sculptural qualities, intricate fine detail, and biological engineering of 12 insects native to Britain. Though very pure in their appearance, the images have been carefully assembled from hundreds of scans made with an electron microscope, each detailing individual sections of the insect and pieced together with Photoshop.

the ink was absorbed, leading to muted colors. At the beginning this was fine because there was a fashion for such a look, but after two or three years, photographers wanted more out of it, so we had to look at changing the inks and papers."

This required a lot of research in how the paper is treated, especially regarding its "sizing," which gives the paper its physical strength. "Somerset papers were the leaders at the time and had put a lot of money and time into testing, changing the sizing of the paper before considering postcoating the papers. They were the first to coat a paper after its initial production," says Ian. The coating applied to such papers then allowed the inks to be sprayed evenly onto the paper and not soak into the paper base. "This was far better," Ian confirms, "although the

coating then seriously compromised the archival qualities of the inks. At that point, pigments, which offer a far greater longevity, started to be used rather than dyes, although initially they produced a compressed color gamut. The pigments, like a dye, have to be printed onto a coating, so they are not absorbed by the paper."

Eventually a balance was found to bring out the best in both papers and inks. This research was then used by manufacturers producing inkjet machines, which had rapidly improved in quality by the late 1990s. "An inkjet applies ink to a paper using very different technology to the Iris," Ian explains. "With people like Epson and Hewlett Packard involved, there was more money going into research. The inks being produced by these companies now have an incredible gamut and lifespan, which leads us to where we are now. Additionally, many companies are producing inkjet papers, so a lot of new coated materials are coming out offering us plenty of choice. The quality is now almost as far as it needs to go. They can develop it further if they want to, but improvements will probably be more about printing speed."

Much of Ian's work involves producing limited-edition prints to be sold in galleries. While many of his clients are photographers, others are artists working in different media. They commission him to make editioned prints where previously they may have used litho or screenprinting. "Some artists do not want to be involved in the technicalities of producing prints,"

says Ian. "In fact, it is very common for an artist not to run their own editions, whereas photographers are often from a more technical background and prefer to have control. While many will have learnt Photoshop and are very good at it, it does not mean that they know so much about printmaking. They need to have their editions produced by a specialist printer."

Naturally, this has changed through the popularity of inkjet printing, which can give photographers and artists the opportunity to produce prints themselves. However, Ian believes that in doing so, it is important to maintain quality not only in the production of the prints, but also in how they are sold and marketed. "Editions of work should be published correctly. If I am a collector buying a print, I want to know that it has been properly published and editioned, otherwise what am I buying?" This he believes applies particularly to the many online galleries selling work through websites. "Inkjet printing certainly lends itself to printing on demand, but it should be done with the same considerations as any other type of printing. Whoever is buying a print should know that the edition is finite, and will not be repeated. Publishing houses and galleries build up a reputation, and buyers have to be able to trust them to ensure that when buying a print, it will have a value."

RIGHT
Photograph by
Tim Hall.

SECTION 5

EQUIPMENT

Although this book has been primarily concerned with the uses of Photoshop as a professional tool for processing, editing, and printing digital photographs, some final consideration should be given to the wide range of cameras and computers available.

Cameras

Similar to film cameras, digital cameras are produced in a range of formats, each with different applications. It used to be easier to classify cameras as they were usually categorized depending on the size of film: 35mm, medium-format, or large-format. Digital cameras have generally been fashioned after their film counterparts, so we think of compacts and DSLRs as being equivalent to 35mm cameras, and the larger digital studio cameras and backs as comparable to 120 medium-format. There are no digital versions of large-format cameras, although still-life photographers tend to use very powerful digital backs, often with an adapted film studio camera.

Grouping all similar cameras into the same format can be misleading. For example, two DSLR cameras, made by the same company, may look very similar, but could have very different

specifications and prices, due to the size and resolution of their sensors. One may have a 6-megapixel sensor, while the other could be double this, at 12 megapixels. Which would take the best photograph? The more expensive 12-megapixel camera would be able to take a photograph that would open in Photoshop at 36MB. This could be printed or reproduced far bigger than a file from the other camera, which would provide a Photoshop file of 18MB. However, if the cameras both used the same lens, and relatively small prints were required, at 18MB or less, there would be little difference in quality—although the larger camera may be four times the price of the other.

As an aside, if the same test were done on two 35mm cameras, one top of the range, and the other the cheapest in the shop, but again using the same lens, the quality of both the negative and print from each camera would be identical. The film is exactly the same size, but with digital it is the sensor that makes the difference. This is an important consideration when buying a digital camera. If A4 (8¼ x 11¾in) or 10 x 8in were to be the maximum print sizes ever required

ABOVE AND RIGHT
Although the size of sensor is important, the quality of lens should also be considered. Many cheaper optics, especially zoom lenses can suffer from barrel distortion, as in this example. Often this can be corrected using Photoshop's Lens Correction filter.

A

B

C

ABOVE
Digital single lens reflex cameras are available with different specifications, such as this series of Nikons. The D40 (A) has a 6.1 megapixel sensor while the D80 (B) sensor is larger at 10.2M. The D2Xs (C), aimed at professional photographers, is slightly larger at 12.4M.

(with interpolation, larger prints could easily be made), a 6-megapixel camera with a good lens would be an excellent choice and a far cheaper option than a 12-megapixel model.

File size is important for professional photographers, so 10 or 12 megapixels is usually the smallest size considered, even if most work is not actually printed larger than A4 (8¼ x 11¾in). DSLRs are very versatile and can be used both in the studio and on location. Consideration should be given to the choice of lenses. Camera bodies are often sold as a package with mid-price (and often low-price) zoom lenses. These have their uses, but tend to be optically inferior to fixed focal length lenses. Photographers

often use only two or three lenses for most shoots (some use just one), so a small set of good-quality prime lenses gives far better results than even a relatively expensive zoom. Some manufacturers such as Nikon use the same mounts on their digital range of cameras as their film models, so photographers who have used Nikon all their professional lives have the option of continuing to use the same film lenses with their digital gear. Some people maintain that digital cameras should be equipped with specifically designed lenses, although the thousands of professionals who continue to use their old lenses disagree. On very wide-angle lenses there can be a problem with chromatic aberration and distortion,

although for normal use, film lenses will be fine. Focal lengths of lenses differ between film and digital formats, usually approximately to the factor of 1.5 on a standard-sized DSLR. A 28mm lens used on a 35mm film camera would have a focal length of about 42mm on digital, while a 35mm lens would translate as 52mm.

A professional DSLR is expensive, but should provide years of service. For anyone starting out, all the major companies produce cheaper consumer and so-called "prosumer" models. These give similar results, but do not have so many features, and may not stand up so well to the rigors of professional use.

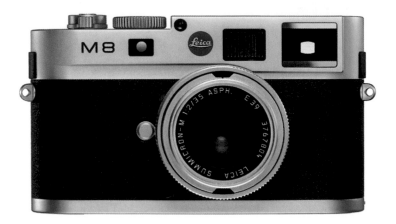

LEFT
Photographers shooting 35mm film are usually divided between those using SLRs or rangefinder cameras. The M8 is Leica's first digital rangefinder built to the same design as the classic M series of film cameras.

BELOW
Phase One digital backs have become an industry standard for top quality professional work. They can be used with most medium-format cameras which can take a film back, such as the Hasselblad shown here. The P45 back has a very impressive 39M sensor which will open files at 117 MBs in Photoshop.

Digital compact cameras have increasingly larger sensors, and some have very good-quality optics that will produce excellent prints. They should not really be considered for professional work, although they are useful to have around for taking snapshots and record shots. The heritage of film cameras has also led to digital versions being produced of such classic rangefinder cameras as the Voigtländer and Leica. These are aimed at two distinctly different breeds of photographers: the photojournalist, used to the simplicity and operational speed of a rangefinder as well as the high-quality optics used, and the wealthy enthusiast for whom a brand such as Leica is synonymous with photographic excellence and history.

One concern with all digital camera users is the number of images that can be stored on a memory card. Currently the largest cards are 8GB, although this figure will undoubtedly rise. Many photographers, for security, prefer to use several smaller cards of 1 or 2GB so not all their shots are stored on one card. With a 12-megapixel camera, approximately 150 photographs can be saved on a 2GB card. Alternatively, the camera can be linked to a portable hard drive, even on location, or tethered to a computer, to download the images directly.

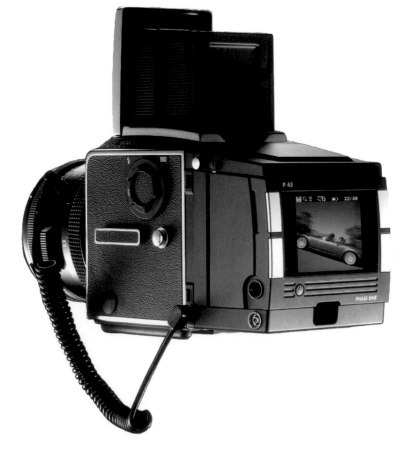

Larger Formats

For larger files and increased quality, many professionals use larger-format digital cameras and backs, although their size dictates that the largest of these are used primarily in the studio. However, both Mamiya and Hasselblad, two names famous for their medium-format film cameras, make 22-megapixel cameras that are ideal for location as well as the studio, provided enough spare batteries and backup storage media are taken on the shoot. Although digital may initially have seemed a blessing to the photographer who was used to taking boxes of film on location, the reality is that they are far more outweighed with laptops, hard disks, and the growing number of battery chargers required for all these devices.

Digital backs offer the largest images possible. Market leader Phase One produces backs capable of 39-megapixel files, opening in Photoshop at 117MB per image. These can be used with specifically designed digital cameras, but also support classic film cameras such as Hasselblads and Sinars. For many professional photographers, hiring this equipment by the day, along with the studio, is now a common working practice. If required, a skilled operative can be hired to assist with the shoot and process images as they are shot.

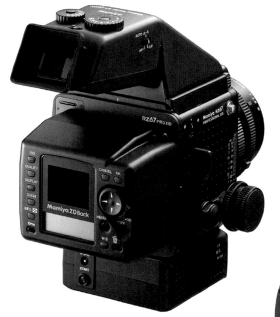

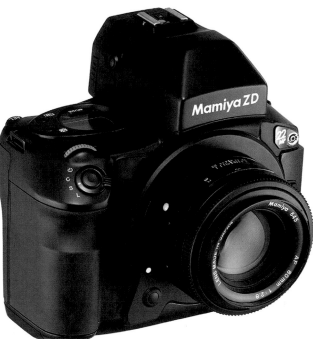

ABOVE
Mamiya now produce a 22M back specifically for their medium-format cameras.

RIGHT
The same technology is used in their Mamiya ZD digital camera, a relatively lightweight camera, ideal for both location and studio work.

Computers

In any book on Photoshop, the question arises whether an Apple Macintosh or a PC is the most practical and suitable computer to use with the program. This should perhaps be addressed by considering the operating systems used by each. While a Mac is solely the product of one company, the generic term "PC" covers every other make of computer, all of which will be running Microsoft Windows. Both Mac OS and Windows are equally able to support Photoshop, although most professionals working in design photography, and print use Macs. Traditionally, there have been more programs for the Mac suitable for professional photography and design, while PCs could support far more applications for the office or home.

This bias has slightly changed now, and as Macs now operate the same Intel Pentium processor as PCs, the Mac can be used as a virtual PC. While Microsoft may well desire the creative status of Mac products, Apple would undoubtedly appreciate the sales figures of Microsoft. Both systems run Photoshop, so perhaps the more important question is whether a computer has the required capacity to run the program efficiently. As the recording size of digital cameras increases, the need for a faster processing speed and more memory— both RAM for the desktop and storage for the hard drive—becomes more pressing. Most computers produced today have a 2GHz or larger processor, although 1GHz will still work, if more

slowly. Additional memory has dropped rapidly in price, and 2GB of RAM is now relatively inexpensive (some computers can support 16GB), and will make operating Photoshop far more efficient.

Monitor design has changed and LCD screens (Liquid Crystal Display) have practically taken over from the bulkier CRTs (Cathode Ray Tubes). While progress is inevitable, this is regrettable. Apart from the issue of their size, many professionals prefer CRTs as their transmitted light is easier on the eye over a long-term period, they can be easier to view with clients, and their expected lifespan is often longer than LCD screens, if calibrated regularly.

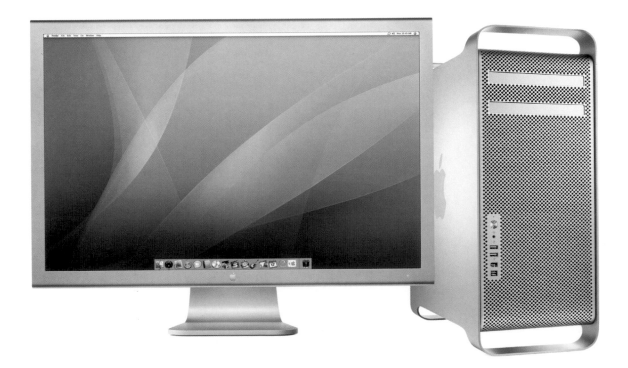

LEFT
Laptops are used by many digital photographers working on location as images can be either downloaded from the camera and processed immediately after the shoot, or they can be captured directly onto the computer if it is tethered to the camera.

BELOW
Several companies such as Lacie produce high quality computer monitors. They should ideally be used in a room without strong lighting and with a screen hood to shield out stray light.

OPPOSITE
Although Apple computers such as the Mac Pro G5 are used more in professional photography and design than PCs, most computers will run Photoshop providing there is enough memory and a high processing speed.

SECTION 6

APPENDIX

ACTIONS

There are often processes, functions, and effects that are repeatedly used in Photoshop, such as converting a TIFF to a JPEG or changing the image size. To save time, you can record a sequence of steps as an Action to apply to subsequent images.

ADOBE CREATIVE SUITE

Adobe Systems produce several programs aside from Photoshop, which are used for design, illustration, photo editing, web design, and video and film editing. Linked under the title of Creative Suite, all these programs can be integrated, and files from each can be easily transferred, opened, and manipulated by another program in the suite.

ANALOG

Film photography, as opposed to digital, is commonly referred to as analog.

BACKING UP

Files are backed up to an external hard drive (or onto CDs or DVDs) to ensure copies are safely stored and also to free space on the computer's hard drive. Even if there is plenty of storage space on a computer, it is still advisable to back up in case there is a technical problem in retrieving information from the machine, or if the computer is stolen.

BATCH PROCESSING

When processing digital images in Photoshop, an Action can be applied to a number of files as a Batch. This is especially useful for photographers shooting several hundred images in one session; they will need to convert each digital capture (either RAW or JPEG) to a TIFF, change their image sizes, and possibly apply a filter, before editing the work or sending it to a client.

BIT AND BIT DEPTH

Each piece of information in a digital image file (which is comprised of pixels) is described as a "bit," which can be read and translated by a computer. A 2-bit image would have only two levels of information and the most basic choice of tone: black or white. The computer can only operate mathematically in twos using a binary code, so an increase of possible information available to each pixel occurs in the form of 2 to the power of 2 or 3 or 4, and so on. This is known as bit depth. 2 to the power of 4 (described as 4-bit) would mean 2x2x2x2, therefore 16 possible levels of tonal information per pixel. In digital photography, 8-bit (2 to the power of 8) is probably the most common, which means 256 possible levels, or steps of information, per pixel. This is in fact just 256 shades of gray, known as a grayscale. When working in RGB, three separate grayscales are used. Each is seen as a primary color (red, green, or blue) instead of gray, but when combined they are seen as full color. To be precise, the 8-bit is now technically 24-bit, and the possible levels of visual information per pixel has multiplied up to over 16 million, but it is always referred to as 8-bit. 16-bit files are now common, especially with photographers using large digital backs.

BRIDGE

Bridge is a separate program supplied with all the software in Adobe's Creative Suite series, such as Photoshop and Illustrator. It is used for browsing images and editing and transferring files between Adobe programs. It also directly accesses online image libraries.

BYTE

All digital files are measured in bytes, which are made up from 8 bits of digital information. The series of measurements used to indicate increasing size are multiplied by about 1,000 each time (to be mathematically accurate, 1,024). A kilobyte (KB) consists of 1,024 bytes and a megabyte (MB) 1,024KB (or 104,8576 bytes.) A gigabyte (GB) is equal to 1,024MB; a terabyte (TB) has 1,024 gigabytes.

CHANNELS

A Photoshop image consists of several Channels, which can be accessed via the Channels palette. In the RGB there are three color channels (red, green, and blue), which are the colored grayscale images that make up the full-color photograph. (Four channels are used in CMYK.) An Alpha Channel, which is a pure black-and-white mask, is used for editing parts of an image or manipulating a separate channel.

CMYK

Printed digital images, which can be printed with an inkjet printer or mechanically reproduced for magazines and posters, use the CMYK format, standing for Cyan, Magenta, Yellow (the three opposite colors of Red, Green, and Blue), and Black. K is short for Kohle (German for Coal), as B is used for Blue.

COLOR MANAGEMENT

The range of colors that cameras, computers, printers, and scanners can display and recognize is controlled by using different profiles. Color management ensures that these devices are calibrated so they can reproduce the same colors accurately. Normally, specific profiles have to be set, or individual ones created, so that the image seen on screen will be accurate when printed, or viewed on another color-managed device.

COLOR SPACE

Different formats and modes, i.e. RGB and CMYK, have different color spaces, otherwise the range of colors that can be accurately portrayed. This can be a problem when converting from RGB to CMYK. Viewed on a backlit monitor, an RGB image has a larger color space than a CMYK space, which is replicated by printing four different colored inks onto paper.

CONTACT SHEETS

Traditionally, photographic film was contacted onto light-sensitive paper, exposed to light, and processed to provide a sheet of positive images the same size as the negatives showing the contents of the film. Photographers (and their clients) still find it useful to look at a reference sheet of digital images to quickly assess a shoot, as this is usually a quicker method of editing than going through each image on screen. Contact sheets can be made from digital files using Photoshop's Contact Sheet 2 function.

CONTINUOUS INK SYSTEMS (CIS)

When used for making large quantities of inkjet prints, a continuous ink system provides substantial savings in the cost of ink compared to buying individual ink sets. The system uses a separate bottle of ink for each color, which can be refilled when empty.

CROPPING

Despite carefully composing a photograph in the viewfinder, or on the camera's LCD screen, composition can often be improved by cropping out parts of the image. Although it is possible to make a very different image by selecting a smaller area of the shot, a crop is usually best applied subtly so the end result is similar to how you saw the image when shooting. This might require slightly changing the angle, or cutting off an unwanted area at one or more of the edges.

FEATHER

When you make a selection, you need to set a rate of Feathering to control the smoothness of the gradation between the edge of the selection and the layer or image underneath. The rate of the feathering will depend on the image size and is expressed in pixels.

FILTERS

Photoshop filters, like camera filters, alter or convert an image. Filters have many uses, from subtly changing a color cast, to completely replacing the image's photographic qualities with a nonphotographic representation resembling a different artistic medium.

FOREGROUND AND BACKGROUND

The colors and shades used in many filters and commands in Photoshop are governed by the Foreground and Background colors shown at the bottom of the Tools palette. The default setting is a black foreground and a white background (this can be reversed by clicking on the top right arrow). Different colors are selected by clicking on each of the boxes, and the default mode is reset by clicking on the bottom left icon.

GAMUT

The range of colors a digital device displays or reproduces is known as its gamut. Good-quality pigment inks are often described as high gamut.

GRAPHICS TABLET

A graphics tablet uses a touch-sensitive pen and pad instead of a mouse. This makes many of the features of Photoshop more accurate, such as making selections and using brushes, which require very fine degrees of control.

GRAYSCALE

A grayscale image is a monochromatic representation of a photograph's tonal range. It is also the range of tones used in a black-and-white photograph. A large grayscale has many different shades between black and white, whereas a short grayscale has very few.

HARD DRIVE

The largest section of digital memory in a computer is its hard drive. This contains the many applications used, as well as saved files. It will often hold more than 250GB of data, although this can be filled with large numbers of programs and files, especially digital images. Separate hard drives are often used for storage and security.

HELP

Similar to other programs, Photoshop has an extensive resource for guidance, reference, and instruction under Help in the Menu bar.

HISTOGRAM

A histogram is a graphic illustration showing the distribution of tones in a digital image, from shadows to highlights. This is displayed using Levels or by selecting the Histogram palette. Digital cameras can also display the histogram of a shot to check the exposure recorded the correct level of tones.

INKJET PRINTER

Inkjet printers receive digital information from a computer or camera that is translated into a series of minuscule dots. These dots are sprayed using different colored inks (cyan, magenta, yellow, and black) onto paper to form a photograph. Inkjet printers range from small desktop models up to large professional machines for producing exhibition prints.

INTERPOLATION

The size of a digital image can be increased using Image Size in Photoshop or with specialist software such as Genuine Fractals. Interpolating creates new pixels to make the file bigger, first assessing surrounding pixels to determine the tone and color of the new pixels. The new pixels are then added into the image.

ISO (INTERNATIONAL STANDARDS ORGANIZATION)

This is a universally accepted rating originally used to indicate the sensitivity of photographic material. ISO is calculated arithmetically to correspond with each stop of camera exposure. 200 ISO is 1 stop slower than 400, and 1 stop faster than 100. Digital cameras have adopted the same method of rating. This means that a faster ISO requires less exposure, but on the highest levels is more likely to display digital noise and interference.

JPEG (JOINT PHOTOGRAPHIC EXPERTS GROUP)

This is a format that compresses a digital image to reduce its file size and resolution by removing a percentage of its pixels. The quality of a JPEG depends on the amount and method of its compression. It is particularly useful for sending images by email and using on websites. Digital cameras often save images as very large JPEG files.

LAYERS

One of the most important features of imaging software such as Photoshop is the ability to work in Layers. This allows different elements of the shot, or other images montaged onto the photograph, to be worked on individually.

LEVELS

Along with Curves, Levels is one of the best methods to adjust the exposure and tonality of an image. It is also possible to adjust the Red, Green, and Blue channels individually for fine control, or for distorting the color range.

MEGAPIXELS

The recording power and resolution of a camera is expressed in megapixels (M), which as a unit is about one million pixels. Cameras normally start at 3M, though professional models currently go up to 39M.

MEMORY

Random Access Memory (RAM) is the desktop memory used to temporarily process open files. Photographic images sometimes require hundreds of MB of RAM when being processed and adjusted, so it is useful to buy extra memory that is easy to install.

MERGE TO HDR (HIGH DYNAMIC RANGE)

If a shot has been bracketed with a wide range of exposures, tonal values from each can be combined to capture the photograph's dynamic range by applying Merge to HDR (File > Automate > Merge to HDR). This is ideal for architectural work, especially interiors, where it would be impossible to get a full tonal range, from highlight to shadow, in one exposure. Needless to say, the camera must have been locked onto a tripod to ensure that the different images blend together.

MONITOR

Computers use two very different types of monitor, LCD (Liquid Crystal Display) and CRT (Cathode Ray Tube). LCD screens are standard with laptops, and are also a popular choice to use as a separate monitor for a PC. All monitors should be calibrated regularly to ensure color accuracy.

NOISE

Digital noise is usually caused by shooting with a high ISO setting or using a long shutter speed, especially in a dark area. Less expensive cameras, with smaller sensors, are more likely to display noise than larger professional models. This can be reduced by using the correct software. Alternatively, to give a grainy effect, it can be introduced in Photoshop via the Add Noise filter.

PDF (PORTABLE DOCUMENT FORMAT)

This is a format that can be recognized by all computers (provided the free Adobe reader has been downloaded). It compresses images and files so they can easily be displayed in a multi-page document. PDFs are convenient to send as an email attachment. A PDF is best viewed by selecting Ctrl (Windows) or Command (Mac)+L to display the PDF page full-screen. Then use the forward and backward keys to change the pages.

PHOTOSHOP ELEMENTS

Elements is a consumer version of Photoshop aimed at enthusiasts and hobbyists rather than professionals. It is often bundled with scanners and digital cameras. While it lacks some of the controls required in professional photography (such as advanced color management and soft proofing, 16- and 32-bit processing, Color Balance, and Curves), it is a very useful program considering its low price. It should be noted that students can buy the full version of Photoshop at a considerably reduced educational price.

PIXELS

Digital images are comprised of pixels—tiny colored squares containing the basic mathematical information that determines each pixel's tone and color. When viewed together, usually in millions, pixels give the impression of continuous tone, similar to the ink dots on a printed page that make up a photographic reproduction.

PLUG-IN
Software such as Photoshop can accommodate extra features known as plug-ins, which add extra functionality to the program. Many, especially in the Filter menu, end up becoming part of the main program.

PPI AND DPI
There is often confusion over these two terms. The most common, pixels per inch (ppi), refers to the resolution of a digital image, whereas dots per inch (dpi) is used to express the quality of a printed image.

PROCESSING SPEED
A computer may have a large amount of RAM, which is required for working on digital images, but it also needs to have a good processing speed, which is referred to in Gigahertz (GHz). This ensures that all the commands the computer has to process will be carried out quickly and efficiently.

PROFILE
A profile contains the digital information required to set the correct color space for all devices used in digital photography. RGB usually operates using Adobe RGB (1998).

PURGE
As many stages can mount up in the History palette, or be saved as Snapshots, this will use up a large amount of space on the Scratch Disk until the file is saved and then closed. This can affect the performance of Photoshop. Selecting Purge > Histories from the Edit menu deletes all these steps and frees up more RAM and space on the Scratch Disk.

RAW
Digital photographs taken as high-quality JPEGs or TIFFs will have had some processing and compression applied when saved on the memory card. However, RAW will have had none and can be saved as bigger files. These files require careful processing using either Photoshop or additional software to achieve the highest-quality images.

RESOLUTION
A digital image's resolution is expressed in ppi (pixels per inch). The higher the ppi, the higher the resolution. In Photoshop, it is advisable to work on images at a relatively high resolution (300ppi), although this will depend on the final output. JPEGs use a lower resolution (72ppi) which is the same as a computer monitor, and having fewer pixels makes them quicker to send as email attachments.

RGB
Red, Green, and Blue are the principal colors that when combined (as projected light) make white. This is the standard color mode used for shooting and working on digital photographs on the computer.

SCANNER
Scanners optically record prints, artwork, negatives, and transparencies and convert this information to a digital file, which can then be opened on a computer. Light is transmitted through film or reflected off a print, which is passed through a lens, digitally processed, and then converted into pixels. The quality of the scan depends on the resolution the scanner is set to and the quality of the optics.

SCRATCH DISK
A section of a computer's hard drive will be allocated as a Scratch Disk. This is used for temporary storage of data while a file is open and being processed. This is particularly useful when using Photoshop, as a large amount of memory space can be required. If there is not enough RAM to process a file, it will be taken from the Scratch Disk. In the Plug-ins and Scratch Disks preferences palette in the Photoshop menu, you can select other drives to be used temporarily as Scratch Disks, providing they have sufficient unused memory.

SMART OBJECTS
Photoshop files are Raster images comprised of a grid containing millions of square, single-colored pixels, which, when seen together, form an image. This is also referred to as a bitmap—a collection of "bits." If such a file is greatly enlarged, pixelation will occur, as the interpolated image will contain clumps of similar pixels showing as blocks. Illustrator and Text files are usually Vector files. These use curves, lines, points, and various shapes that can be enlarged and reduced on a mathematical scale without showing any change in image quality.
A Photoshop layer can be converted to a Vector file by opening it as a Smart Object (Layer Menu > Smart Object > Group). To indicate it as a Vector file, a torn corner will be seen in the thumbnail image in the Layers palette. Although this allows for greater interpolation, many Photoshop functions cannot be applied to Vector files so a file may have to be converted back to bitmap by flattening the layers.

SOFT PROOFING

When using a specified ICC profile, the expected colors and tones of a print can be viewed by soft proofing (View Menu > Proof Colors). The profile has to have been previously entered in Proof Setup, accessed from the same menu. While the same image on screen and monitor can never look exactly alike, soft proofing should give a fair approximation of the result.

TIFF (TAGGED IMAGE FILE FORMAT)

Most processed digital images are saved as a TIFF, which compresses the file as a lossless image and, unlike a JPEG, retains all the digital information.

UNSHARP MASK

An Unsharp Mask, like many of Photoshop's functions, began as software used in the reprographic industry to improve the edge detail of printed images. It gives the appearance of sharpening digital photographs by selectively increasing the contrast between two different tones.

USB (UNIVERSAL SERIAL BUS)

USB sockets and connectors are common to all digital hardware. They allow any digital device (printers, scanners, cameras, etc) to be plugged into the same port. As many devices are often connected at the same time, a USB hub can be used to provide multiple inputs.

VANISHING POINT

The perspective planes of a photograph (or a drawing) will have an unseen vanishing point, where lines would intersect if drawn onto the image. An image will normally have more than one vanishing point, which gives the impression of three dimensions. The Vanishing Point filter in Photoshop uses this theory to allow modifications to photographs to be made while keeping them within its perspective.

WHITE BALANCE

Different lighting conditions when photographing (e.g. daylight, tungsten, or fluorescent) require different settings on the camera to record the color range accurately. This is known as the White Balance. Often cameras have a default setting of Auto White Balance, which sets the color balance automatically.

WORKFLOW

Processing digital images requires a degree of discipline to ensure that all corrections are made and images are converted, stored, and filed correctly. A workflow is a structured sequence that a photographer adopts to carry out all these tasks, often using automated Actions and Batch Processing to speed up and unify the process.

INDEX

ACKNOWLEDGMENTS

I would like to offer my thanks and
acknowledge the following for the
contributions and assistance in
producing this book:

Andy Atkinson, Ian Cartwright, Tim Hall,
Nicola Hodgson, Chris Levine, Renny
Nisbet, Christopher Peabody at
Saddington Baynes, Giles Revell,
Spela Vrbnjak, Huw Walters, Michael
Wildsmith, and from RotoVision,
Jane Roe and Tony Seddon.